# THE ART OF DRAWING

# PEOPLE

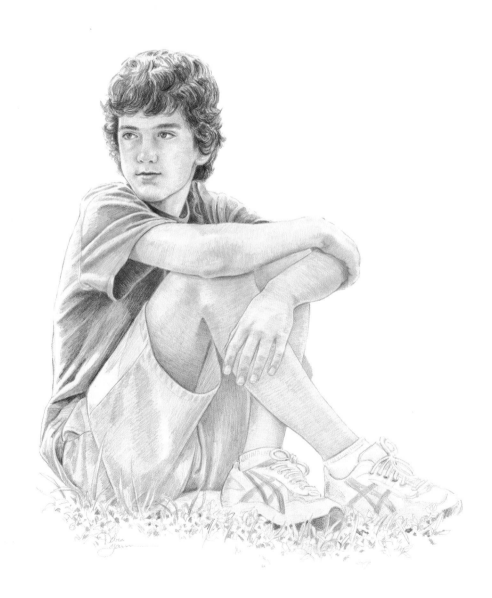

Walter Foster

Brimming with creative inspiration, how-to projects, and useful information to enrich your everyday life, Quarto Knows is a favorite destination for those pursuing their interests and passions. Visit our site and dig deeper with our books into your area of interest: Quarto Creates, Quarto Cooks, Quarto Homes, Quarto Lives, Quarto Drives, Quarto Explores, Quarto Gifts, or Quarto Kids.

First published in 2019 by Walter Foster Publishing, an imprint of The Quarto Group. 26391 Crown Valley Parkway, Suite 220, Mission Viejo, CA 92691, USA.
**T** (949) 380-7510  **F** (949) 380-7575  **www.QuartoKnows.com**

Walter Foster Publishing titles are also available at discount for retail, wholesale, promotional, and bulk purchase. For details, contact the Special Sales Manager by email at specialsales@quarto.com or by mail at The Quarto Group, Attn: Special Sales Manager, 100 Cummings Center, Suite 265D, Beverly, MA 01915, USA.

ISBN: 978-1-63322-795-8

Digital edition published in 2019
eISBN: 978-1-63322-796-5

Printed in China
10 9 8 7 6 5 4 3 2

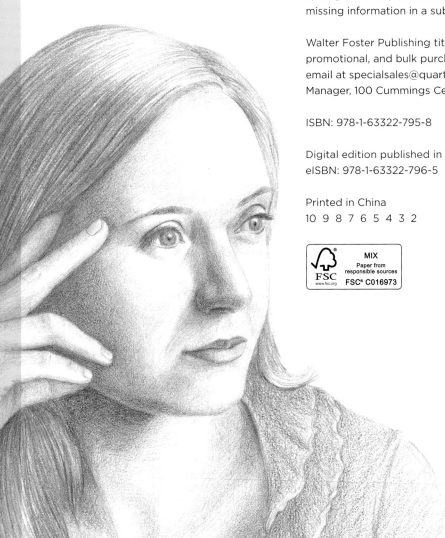

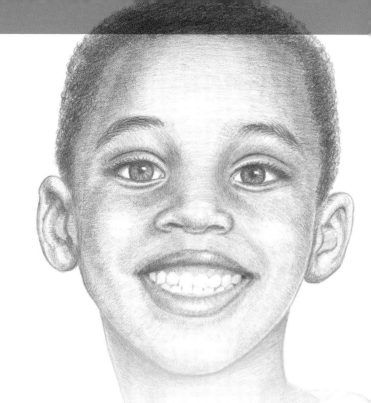

# THE ART OF **DRAWING**
# PEOPLE

# CONTENTS

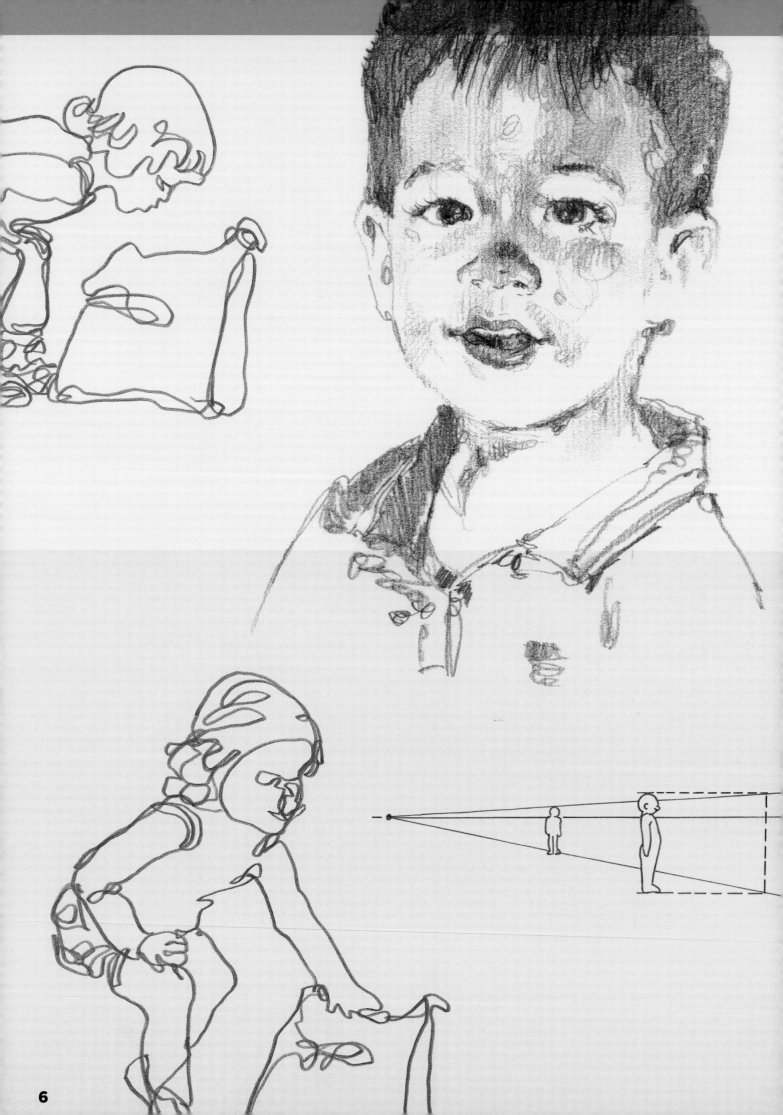

# GETTING STARTED

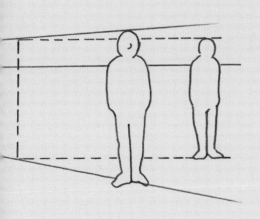

# TOOLS & MATERIALS

**Drawing Paper**
Drawing paper is available in a range of surface textures (called "tooth"), including smooth grain (plate finish and hot-pressed), medium grain (cold-pressed), and rough to very rough. Cold-pressed paper is the most versatile and is great for a variety of drawing techniques. For finished works of art, using single sheets of drawing paper is best.

**Sketch Pads** Sketch pads come in many shapes and sizes. Although most are not designed for finished artwork, they are useful for working out your ideas.

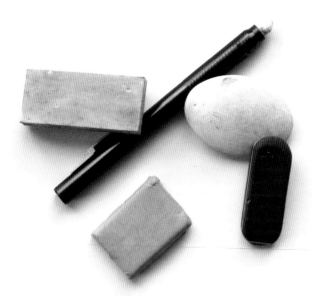

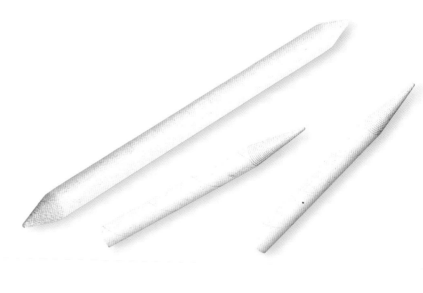

**Erasers** There are several types of art erasers. Plastic erasers are useful for removing hard pencil marks and large areas. Kneaded erasers (a must) can be molded into different shapes and used to dab at an area, gently lifting tone from the paper.

**Tortillons** These paper blending "stumps" can be used to blend and soften small areas when your finger or a cloth is too large. You also can use the sides to blend large areas quickly. Once the tortillons become dirty, simply rub them on a cloth, and they're ready to go again.

# DRAWING IMPLEMENTS

Drawing pencils contain a graphite center. They are categorized by hardness, or grade, from very soft (9B) to very hard (9H). A good starter set includes a 6B, 4B, 2B, HB, B, 2H, 4H, and 6H. The chart below shows a variety of drawing tools and the kinds of strokes you can achieve with each one.

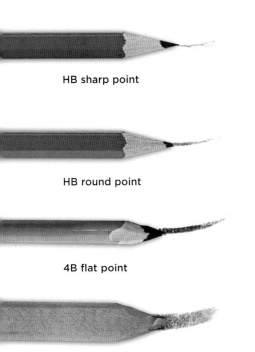

HB sharp point

HB round point

4B flat point

Flat sketching

**HB** An HB with a sharp point produces crisp lines and offers good control. A round point produces slightly thicker lines and is useful for shading small areas.

**Flat** For wider strokes, use a 4B with a flat point. A large, flat sketch pencil is great for shading bigger areas.

**Charcoal** 4B charcoal is soft and produces dark marks. Natural charcoal vines are even softer and leave a more crumbly residue on the paper. White charcoal pencils are useful for blending and lightening areas.

**Conté Crayon or Pencil** Conté crayon is made from very fine Kaolin clay and is available in a wide range of colors. Because it's water-soluble, it can be blended with a wet brush or cloth.

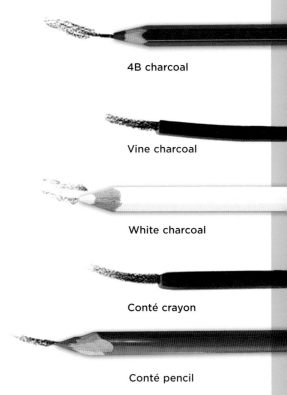

4B charcoal

Vine charcoal

White charcoal

Conté crayon

Conté pencil

## Sharpening Your Pencils

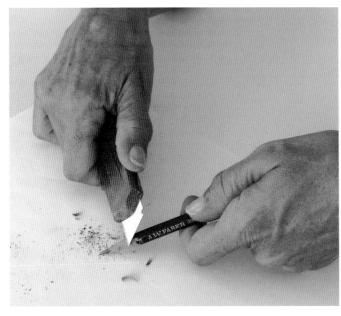

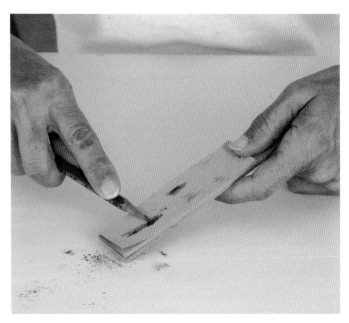

**A Utility Knife** Use this tool to form a variety of points (chiseled, blunt, or flat). Hold the knife at a slight angle to the pencil shaft, and always sharpen away from you, taking off a little wood and graphite at a time.

**A Sandpaper Block** This tool will quickly hone the lead into any shape you wish. The finer the grit of the paper, the more controllable the point. Roll the pencil in your fingers when sharpening to keep its shape even.

# BASIC PENCIL TECHNIQUES

You can create an incredible variety of effects with a pencil. By using various hand positions and shading techniques, you can produce a world of different stroke shapes, lengths, widths, and weights.

**Hatching**  This basic method of shading involves filling an area with a series of parallel strokes. The closer the strokes, the darker the tone will be.

**Crosshatching**  For darker shading, place layers of parallel strokes on top of one another at varying angles. Again, make darker values by placing the strokes closer together.

**Shading Darkly**  By applying heavy pressure to the pencil, you can create dark linear areas of shading.

**Gradating**  To create gradated values (from dark to light), apply heavy pressure with the side of your pencil, gradually lightening the pressure as you stroke.

**Blending**  To smooth out the transitions between strokes,  gently rub the lines with a blending tool or tissue.

**Shading with Texture**  For a mottled texture, use the side of the pencil tip to apply small uneven strokes.

Hatching

Crosshatching

Shading Darkly

Gradating

Blending

Shading with Texture

# CREATING FORM

The first step when creating an object is to establish a line drawing to delineate the flat area that the object takes up. This is known as the "shape" of the object.

Rectangle    Cylinder    Circle    Sphere    Triangle    Cone    Square    Cube

A shape can be further defined by showing how light hits the object to create highlights and shadows. First note from which direction the source of light is coming. In these examples, the light source is beaming from the upper right.

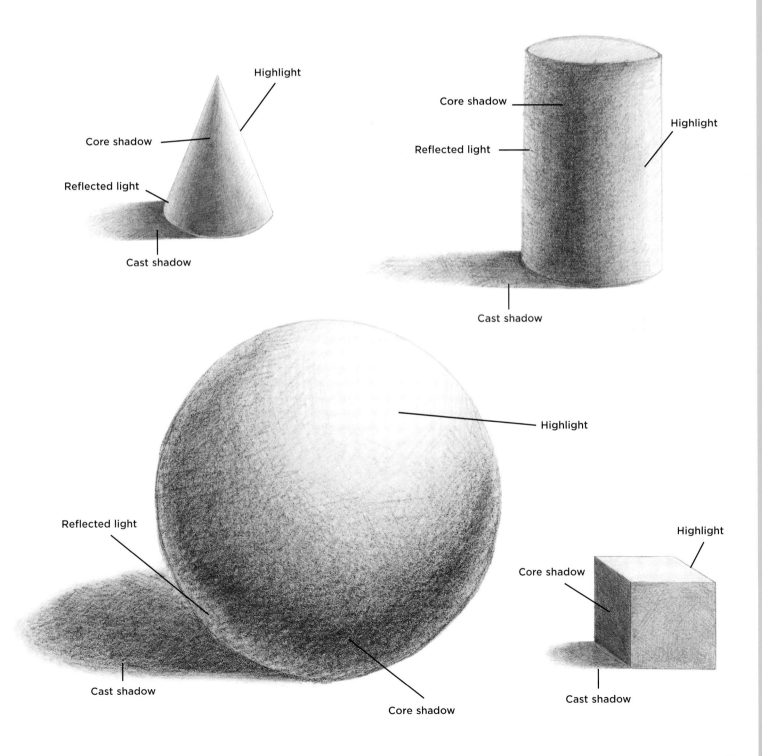

# PRACTICING LINES

When drawing lines, it is not necessary to always use a sharp point. In fact, sometimes a blunt point may create a more desirable effect. When using larger lead diameters, the effect of a blunt point is even more evident. Play around with your pencils to familiarize yourself with the different types of lines they can create. Make every kind of stroke you can think of, using both a sharp point and a blunt point. Practice the strokes below to help you loosen up.

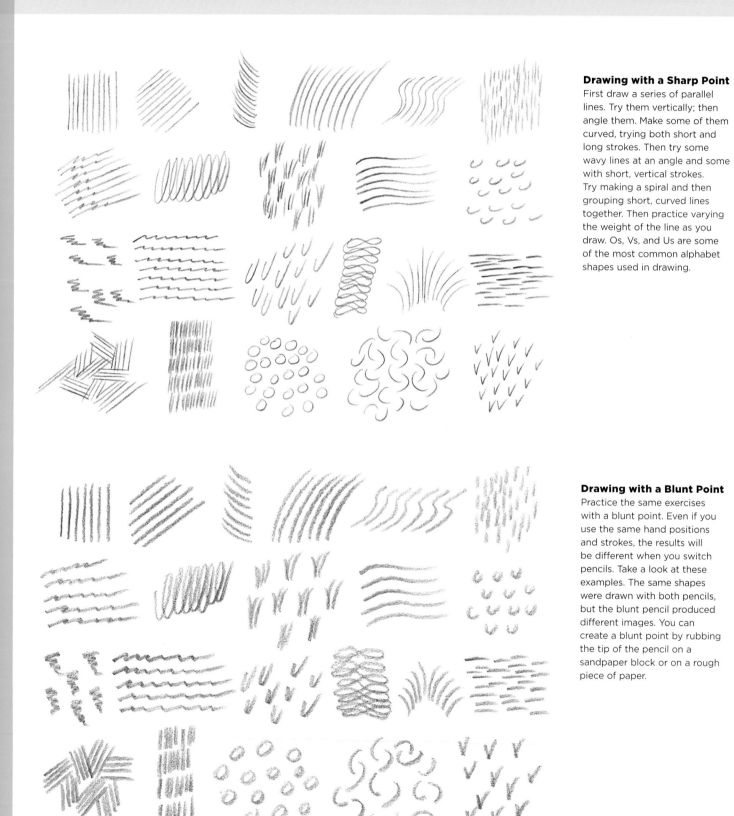

**Drawing with a Sharp Point**
First draw a series of parallel lines. Try them vertically; then angle them. Make some of them curved, trying both short and long strokes. Then try some wavy lines at an angle and some with short, vertical strokes. Try making a spiral and then grouping short, curved lines together. Then practice varying the weight of the line as you draw. Os, Vs, and Us are some of the most common alphabet shapes used in drawing.

**Drawing with a Blunt Point**
Practice the same exercises with a blunt point. Even if you use the same hand positions and strokes, the results will be different when you switch pencils. Take a look at these examples. The same shapes were drawn with both pencils, but the blunt pencil produced different images. You can create a blunt point by rubbing the tip of the pencil on a sandpaper block or on a rough piece of paper.

# "PAINTING" WITH PENCIL

When you use painterly strokes, your drawing will take on a new dimension. Think of your pencil as a brush and allow yourself to put more of your arm into the stroke. To create this effect, try using the underhand position, holding your pencil between your thumb and forefinger and using the side of the pencil. (See below.) If you rotate the pencil in your hand every few strokes, you will not have to sharpen it as frequently. The larger the lead, the wider the stroke will be. The softer the lead, the more painterly an effect you will have. These examples were all made on smooth paper with a 6B pencil, but you can experiment with rough papers for more broken effects.

**Starting Simply** First experiment with vertical, horizontal, and curved strokes. Keep the strokes close together and begin with heavy pressure. Then lighten the pressure with each stroke.

**Varying the Pressure** Randomly cover the area with tone, varying the pressure at different points. Continue to keep your strokes loose.

**Using Smaller Strokes** Make small circles for the first example. This is reminiscent of leathery animal skin. For the second example (at far right), use short, alternating strokes of heavy and light pressure to create a pattern that is similar to stone or brick.

**Loosening Up** Use long vertical strokes, varying the pressure for each stroke until you start to see long grass (at right). Then use somewhat looser movements that could be used for water (far right top). Next use a wavy movement, varying the pressure (far right bottom).

**The Writing Position** The writing position provides the most control in which to produce accurate, precise lines for rendering fine details and accents.

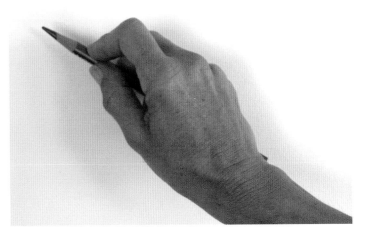

**The Underhand Position** Place your hand over the pencil and grasp it between the thumb and index finger. Allow your other fingers to rest alongside the pencil. This position is great for creating beautiful shading effects and long, sweeping lines.

# MORE PENCIL STROKES

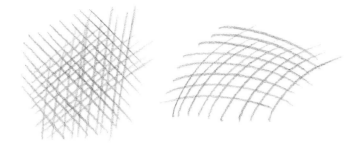

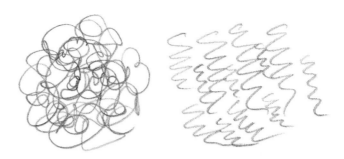

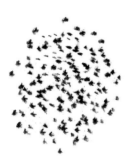 

**Using Crisscrossed Strokes** If you like a good deal of fine detail in your work, you'll find that crosshatching allows you a lot of control (see page 10). You can adjust the depth of your shading by changing the distance between your strokes.

**Sketching Circular Scribbles** If you work with round, loose strokes like these, you are probably very experimental with your art. These looping lines suggest a free-form style that is more concerned with evoking a mood than with capturing precise details.

**Drawing Small Dots** This technique is called "stippling"—many small dots are used to create a larger picture. Make the points different sizes to create various depths and shading effects. Stippling takes a great deal of precision and practice.

**Simulating Brushstrokes** You can create the illusion of brushstrokes by using short, sweeping lines. This captures the feeling of painting but allows you the same control you would get from crosshatching. These strokes are ideal for a more stylistic approach.

## Smudging

Smudging is an important technique for creating shading and gradients. Use a tortillon or chamois cloth to blend your strokes. Do not use your finger, because your hand, even if clean, has natural oils that can damage your art.

**Smudging on Rough Surfaces** Use a 6B pencil on vellum-finish Bristol board. Make your strokes with the side of the pencil and blend. In this example, the effect is very granular.

**Smudging on Smooth Surfaces** Use a 4B pencil on plate-finish Bristol board. Stroke with the side of the pencil, and then blend your strokes with a blending stump.

# WORKING WITH DIFFERENT TECHNIQUES

Below are several techniques that are important for creating more painterly effects in your drawing. Remember that B pencils have soft lead and H pencils have hard lead—you will need to use both for these exercises.

**Creating Washes** First shade an area with a water-soluble pencil (a pencil that produces washes similar to watercolor paint when manipulated with water). Then blend the shading with a wet brush. Make sure your brush isn't too wet, and use thicker paper, such as vellum board.

**Rubbing** Place paper over an object and rub the side of your pencil lead over the paper. The strokes of your pencil will pick up the pattern and replicate it on the paper. Try using a soft pencil on smooth paper, and choose an object with a strong textural pattern. This example uses a wire grid.

**Lifting Out** Blend a soft pencil on smooth paper, and then lift out the desired area of graphite with an eraser. You can create highlights and other interesting effects with this technique.

**Producing Indented Lines** Draw a pattern or design on the paper with a sharp, non-marking object, like a knitting needle or skewer, before drawing with a pencil. When you shade over the area with the side of your pencil, the graphite will not reach the indented areas, leaving white lines.

# LEARNING TO SEE

Many beginners draw without really looking carefully at their subject. Try drawing something you know well, such as your hand, without looking at it. Chances are your finished drawing won't look as realistic as you expected. That's because you drew what you think your hand looks like. Instead, you need to forget about all your preconceptions and learn to draw only what you really see in front of you (or in a photo). Two great exercises for training your eye to see are contour drawing and gesture drawing.

## CONTOUR DRAWING

In contour drawing, you pick a starting point on your subject and then draw only the contours—or outlines—of the shapes you see. Because you're not looking at your paper, you're training your hand to draw the lines exactly as your eye sees them. Try doing some contour drawings of your own; you'll be surprised at how well you're able to capture the subjects.

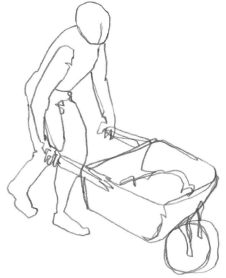

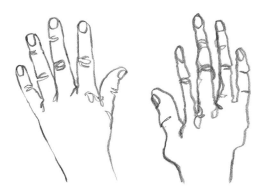

**"Blind" Drawing**  For the contour drawing on the left, the artist occasionally looked down at the paper. The drawing on the right is an example of a blind contour drawing, where the artist drew without looking at his paper even once. It's a little distorted, but it's clearly a hand. Blind contour drawing is one of the best ways of making sure you're truly drawing only what you see.

**Continuous Line Drawing**  When drawing this man pushing a wheelbarrow, try glancing only occasionally at your paper to check that you are on track, but concentrate on really looking at the subject and tracing the outlines you see. Instead of lifting your pencil between shapes, keep the line unbroken by freely looping back and crossing over your lines. Notice how this simple technique effectively captures the subject.

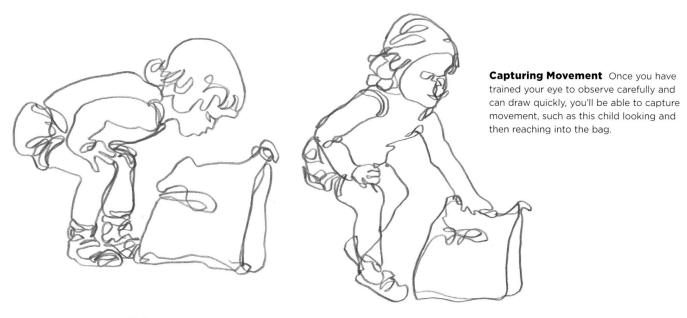

**Capturing Movement**  Once you have trained your eye to observe carefully and can draw quickly, you'll be able to capture movement, such as this child looking and then reaching into the bag.

## ARTIST'S TIP

To test your observation skills, study an object very closely for a few minutes, and then close your eyes and try drawing it from memory, letting your hand follow the mental image.

# GESTURE AND ACTION DRAWING

Another way to train your eye to see the essential elements of a subject—and train your hand to record them rapidly—is through gesture drawing. Instead of rendering the contours, gesture drawings establish the movement of a figure. First determine the main thrust of the movement, from the head, down the spine, and through the legs; this is the line of action, or action line. Then briefly sketch the general shapes of the figure around this line. These quick sketches are great for practicing drawing figures in action and sharpening your powers of observation.

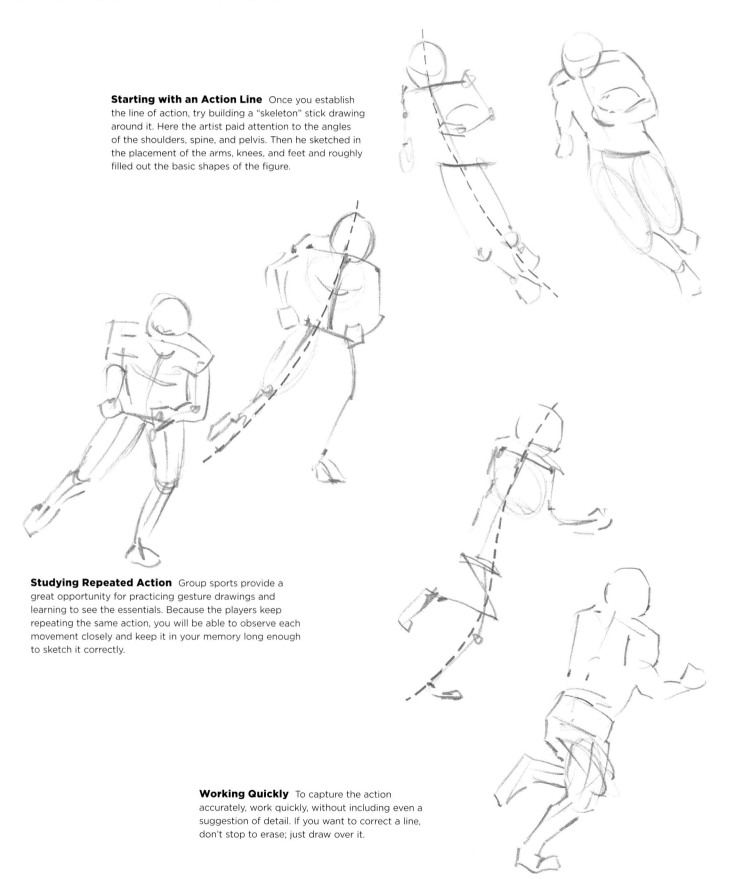

**Starting with an Action Line** Once you establish the line of action, try building a "skeleton" stick drawing around it. Here the artist paid attention to the angles of the shoulders, spine, and pelvis. Then he sketched in the placement of the arms, knees, and feet and roughly filled out the basic shapes of the figure.

**Studying Repeated Action** Group sports provide a great opportunity for practicing gesture drawings and learning to see the essentials. Because the players keep repeating the same action, you will be able to observe each movement closely and keep it in your memory long enough to sketch it correctly.

**Working Quickly** To capture the action accurately, work quickly, without including even a suggestion of detail. If you want to correct a line, don't stop to erase; just draw over it.

# PEOPLE IN PERSPECTIVE

Knowing the principles of perspective (the representation of objects on a two-dimensional surface that creates the illusion of three-dimensional depth and distance) allows you to draw more than one person in a scene realistically. In perspective, eye level is indicated by the horizon line. Imaginary lines receding into space meet on the horizon line at what are known as "vanishing points." Any figures drawn along these lines will be in proper perspective.

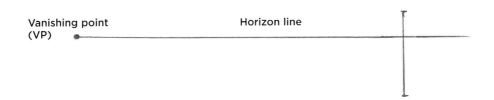

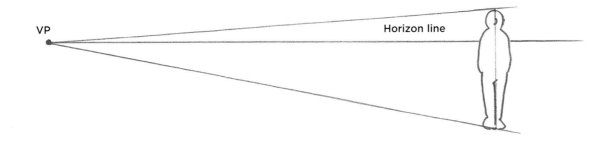

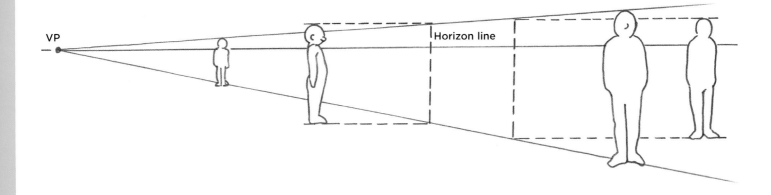

Note that objects appear smaller and less detailed as they recede into the distance.

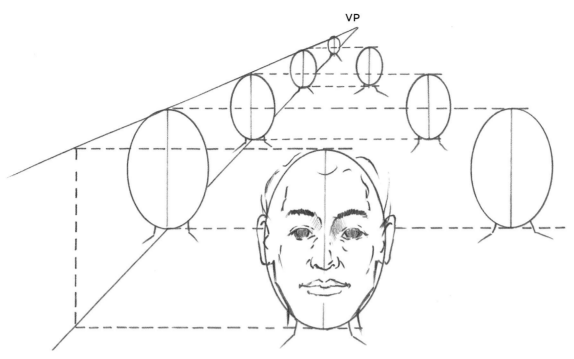

VP

Try drawing a frontal view of many heads as if they were in a theater. Start by establishing your vanishing point at eye level. Draw one large head representing the person closest to you, and use it as a reference for determining the sizes of the other figures in the drawing. The technique illustrated above can be applied when drawing entire figures, shown in the diagram below. Although all of these examples include just one vanishing point, a composition can even have two or three vanishing points.

If you're a beginner, you may want to begin with basic one-point perspective, shown on this page. As you progress, attempt to incorporate two- or three-point perspective.

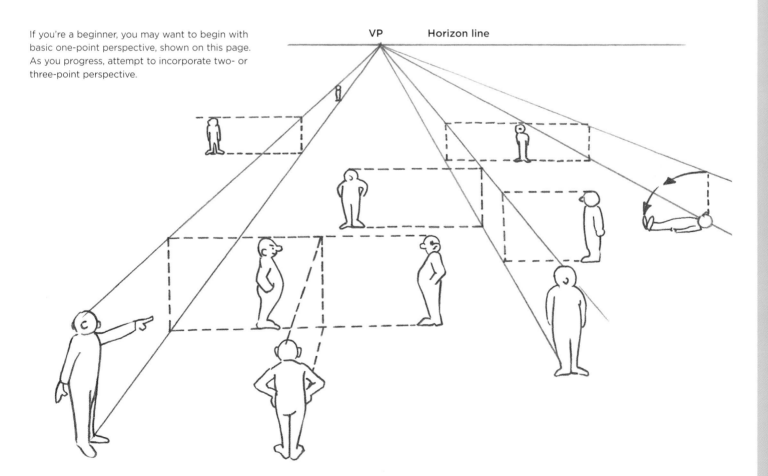

VP          Horizon line

# COMPOSITION

The positioning and size of a person on the picture plane (the physical area covered by the drawing) is of utmost importance to the composition. The open or "negative" space around the portrait subject generally should be larger than the area occupied by the subject, providing a sort of personal space surrounding them. Whether you are drawing only the face, a head-and-shoulders portrait, or a complete figure, thoughtful positioning will establish a pleasing composition with proper balance. Practice drawing thumbnail sketches of people to study the importance of size and positioning.

## PORTRAITURE BASICS

Correct placement on the picture plane is key to a good portrait, and the eyes of the subject are the key to placement. The eyes catch the viewer's attention first, so they should not be placed on either the horizontal or vertical centerline of the picture plane; preferably, the eyes should be placed above the centerline. Avoid drawing too near the sides, top, or bottom of the picture plane, as this gives an uneasy feeling of imbalance.

Too far right

Too low

Good placement

**Placement of a Portrait** These thumbnails show examples of balanced and off-balanced placement.

**Multiple Subjects** If you are drawing several similarly sized subjects, use the rules of perspective to determine relative size. Draw a vanishing point on a horizon line and a pair of perspective lines. Receding guidelines extended from the perspective lines will indicate the top of the head and chin of faces throughout the composition. The heads become smaller as they get farther from the viewer.

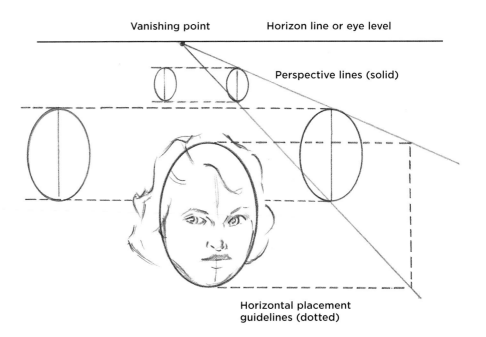

Vanishing point          Horizon line or eye level

Perspective lines (solid)

Horizontal placement guidelines (dotted)

## Adding Elements to Portraits

Many portraits are drawn without backgrounds to avoid distracting the viewer from the subject. If you do add background elements to portraits, be sure to control the size, shape, and arrangement of elements surrounding the figure. Additions should express the personality or interests of the subject.

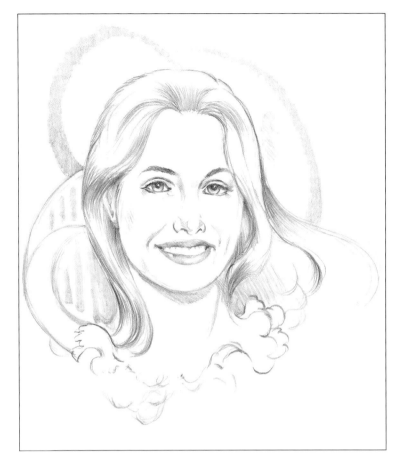

### Repetition of Shapes within the Portrait
The features of this woman are emphasized by the simple, abstract elements in the background. The flowing curves fill much of the negative space while accenting the woman's hair and features. Simplicity of form is important in this composition; the portrait highlights only her head and neck. Notice that her eyes meet the eyes of the viewer.

### Depicting the Subject's Interest
This portrait of a young man includes a background that shows his interest in rocketry. The straight lines in the background contrast the rounded shapes of the human form. Although the background detail is complex, it visually recedes and serves to balance the man's weight. The focus remains on the man, but we've generated visual interest by adding elements to the composition.

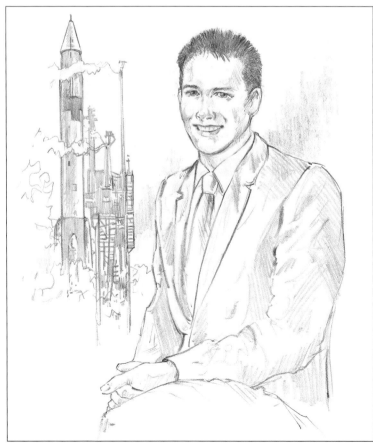

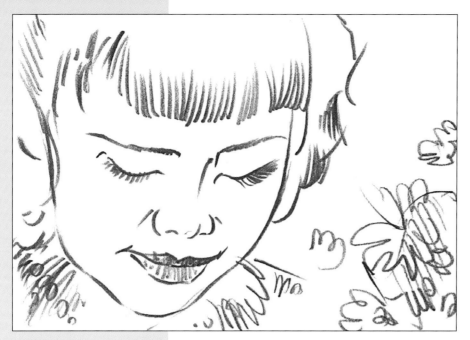

Intentionally drawing your subject larger than the image area, as in the example at left, can create a unique composition. Even if part of the image is cut off, this kind of close-up creates a dramatic mood.

Curved lines are good composition elements—they can evoke harmony and balance in your work. Try drawing some curved lines around the paper. The empty areas guide you in placing figures around your drawing.

Sharp angles can produce dramatic compositions. Draw a few straight lines in various angles, and make them intersect at certain points. Zigzagging lines also form sharp corners that give the composition an energetic feeling.

**Guiding the Eye** These compositions demonstrate how arm position, eyesight direction, and line intersection can guide the eye to a particular point of interest. Using these examples, try to design some of your own original compositions.

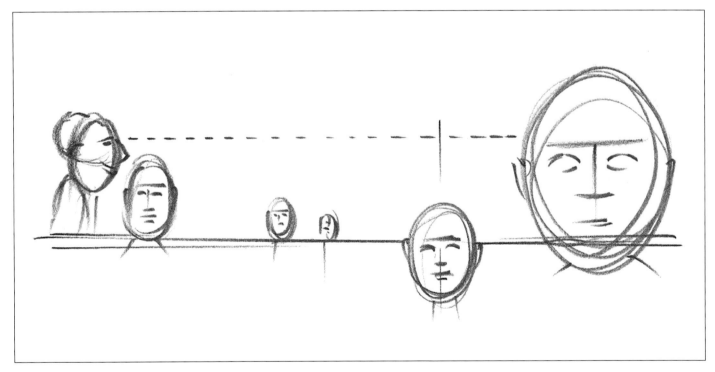

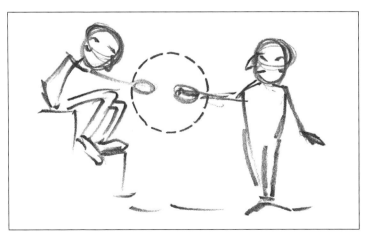

# FIGURES IN A COMPOSITION

Creating a composition that shows a complete person can be challenging. A standing figure is much taller than it is wide, so the figure should be positioned so that its action relates naturally to the eye level of the viewer and the horizon line. Remember that people appear smaller and less distinct when they are more distant. For comfortable placement of people in a composition, they should be on the same eye level as the viewer with the horizon line about waist high.

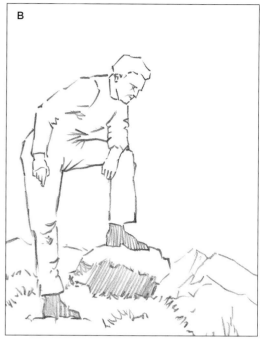

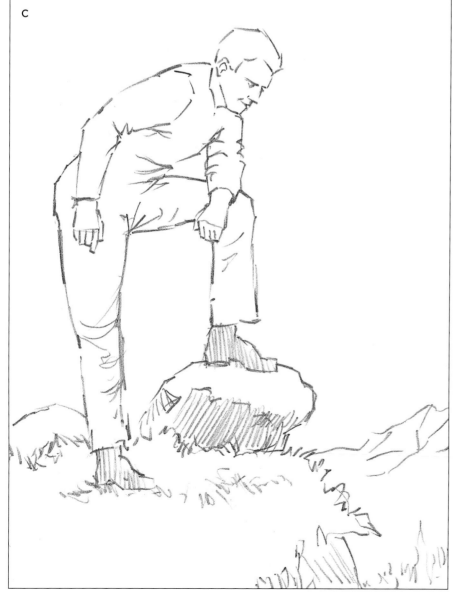

**Full Figure Placement** In thumbnail A, the subject is too perfectly centered in the picture plane. In thumbnail B, the figure is placed too far to the left. Thumbnail C is an example of effective placement of a human figure in a composition.

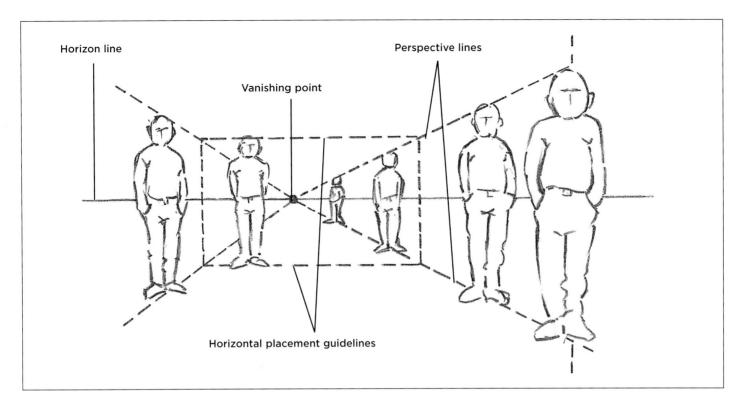

**Sizing Multiple Figures** For realistic compositions, we need to keep figures in proportion. All the figures here are in proportion; we use perspective to determine the height of each figure. Start by drawing a horizon line and placing a vanishing point on it. Then draw your main character (on the right here) to which all others will be proportional. Add light perspective lines from the top and bottom of the figure to the vanishing point to determine the height of other figures. If we want figures on the other side of the vanishing point, we draw horizontal placement guidelines from the perspective lines to determine his height, and then add perspective lines on that side.

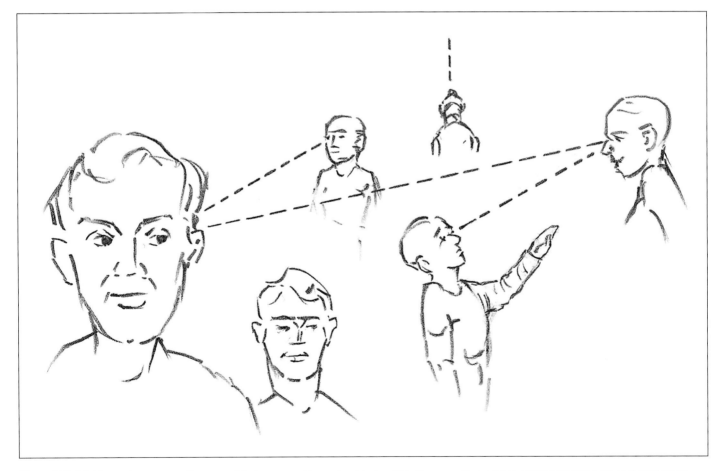

**Line of Sight** Figures in a composition can relate to one another or to objects within the scene through line of sight (shown here as dotted lines). You can show line of sight with the eyes, but also by using head position and even a pointing hand. These indications can guide the viewer to a particular point of interest in the composition. Though the man on the left is facing forward, his eyes are looking to our right. The viewer's eye follows the line of sight of those within the drawing and is guided around the picture plane as the people interact. The man at the top is looking straight up.

# PLACEMENT OF SINGLE AND GROUPED FIGURES

Artists often use the external shape and mass of figures to assist in placing elements within a composition—individual figures form various geometric shapes based on their pose, and several figures in close proximity form one mass. Establish a concept of what you want to show in your composition, and make thumbnail studies before attempting the final drawing. The following exercise is based on using the shape and mass of single and grouped figures to create a detailed, completed drawing.

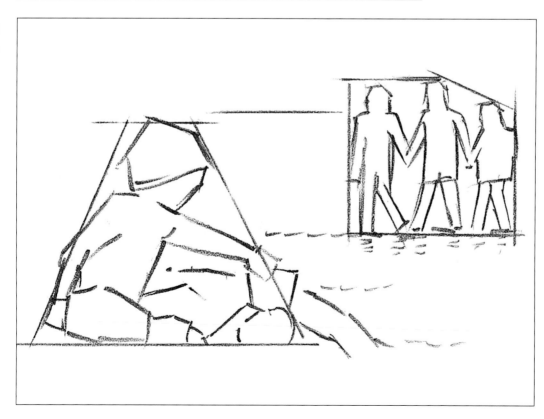

1

**Step One** Consider the overall setting—foreground, middle ground, and background—for a subject like these children at the beach. You can use elements from different photos and place them in one setting. Block in the basic shapes of your subjects; the boy in the foreground is a clipped triangular shape, and the group of children forms a rough rectangle. Determine balanced placement of the two masses of people.

**Step Two** Next, sketch in outlines of the figures. The little boy with the shovel and pail occupies an area close to the viewer. The three children occupy a slightly smaller mass in the middle ground at the water's edge. Even though there are three children in this area, they balance the little boy through size and placement at the opposite corner. The wave and water line unite the composition and lead the eye between the two masses.

2

3

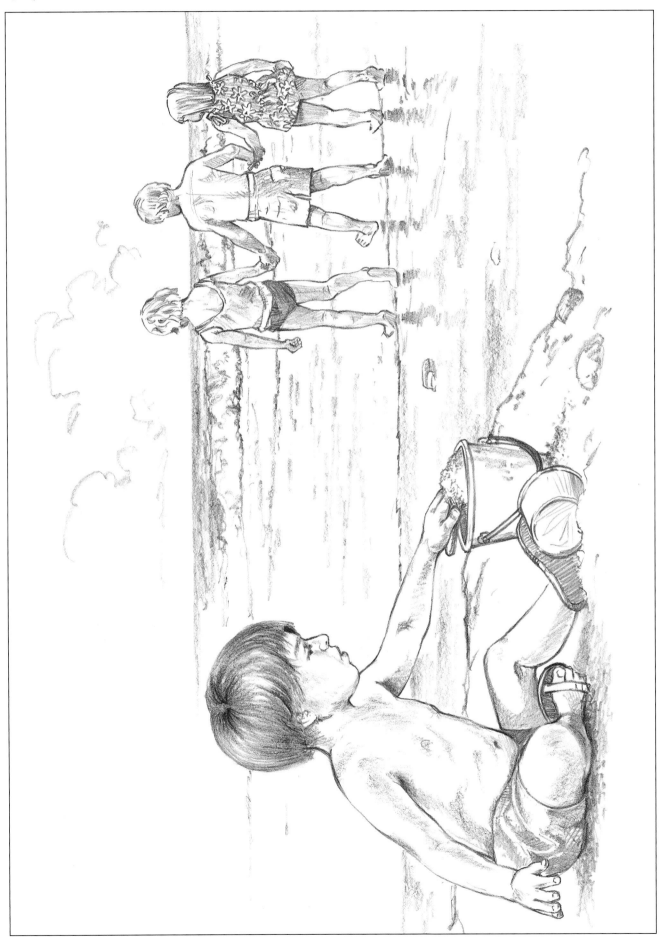

**Step Three** Place your figures so that they fit comfortably on the picture plane. Add detail and shading to elements that are important in the composition. Use an element in the foreground to help direct the viewer's eye to other areas, such as the outstretched arm of the boy. Placing the small rock between the middle- and foreground creates a visual stepping stone to the three children at right.

# BEGINNING PORTRAITURE

A good starting point for drawing people is the head and face. The shapes are fairly simple, and the proportions are easy to measure. You'll feel a great sense of satisfaction when you look at a portrait you've drawn and see a true likeness of your subject.

## DRAWING A CHILD'S PORTRAIT

Study the features carefully, and try to draw what you truly see, and not what you think an eye or a nose should look like. But don't be discouraged if you don't get a perfect likeness right off the bat. Just keep practicing!

**Starting with a Good Photo** When working from photographs, you may prefer candid, relaxed poses over formal portraits. Also try to get a close-up shot of the face so you can really study the features.

**Child Proportions** Draw guidelines to divide the head in half horizontally; then divide the lower half into fourths. Use the guidelines to place the eyes, nose, ears, and mouth, as shown.

1/2

1/4

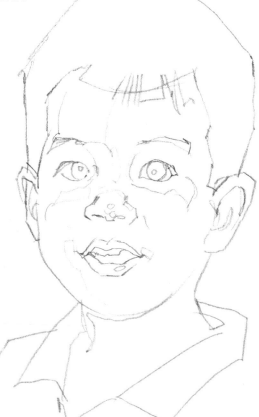

**Sketching the Guidelines** First pencil an oval for the shape of the head, and lightly draw a vertical centerline. Then add horizontal guidelines according to the chart at the top of the page, and sketch in the general outlines of the features. When you're happy with the overall sketch, carefully erase the guidelines.

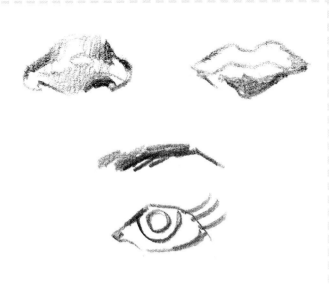

**Separating the Features** Before you attempt a full portrait, try drawing the features separately to get a feel for the shapes and forms. Look at faces in books and magazines, and draw as many different features as you can.

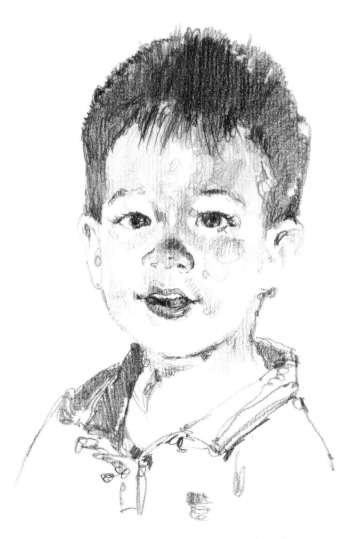

**Finishing the Portrait** With the side of your pencil, start laying in the middle values of the shadow areas, increasing the pressure slightly around the eye, nose, and collar. For the darkest shadows and hair, use the side of a 2B and overlap your strokes, adding a few fine hairs along the forehead with the sharp-pointed tip of your pencil.

## Common Proportion Flaws

There are quite a few things are wrong with the drawings below. Compare them with the photo, and see if you can spot the errors before reading the captions.

**Thin Neck** The boy has a slender neck, but not this slender. Refer to the photo to see where his neck appears to touch his face and ear.

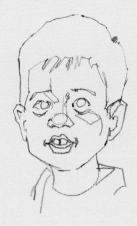

**Not Enough Forehead** Children have proportionately larger foreheads than adults do. By drawing the forehead too small, you will add years.

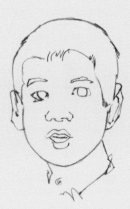

**Cheeks Too Round** Children do have round faces, but don't make them look like chipmunks. And be sure to make the ears round, not pointed.

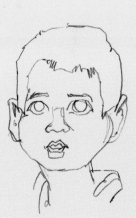

**Sticks for Eyelashes** Eyelashes should not stick straight out like spokes on a wheel. And draw the teeth as one shape; don't try to draw each tooth separately.

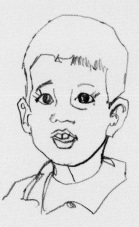

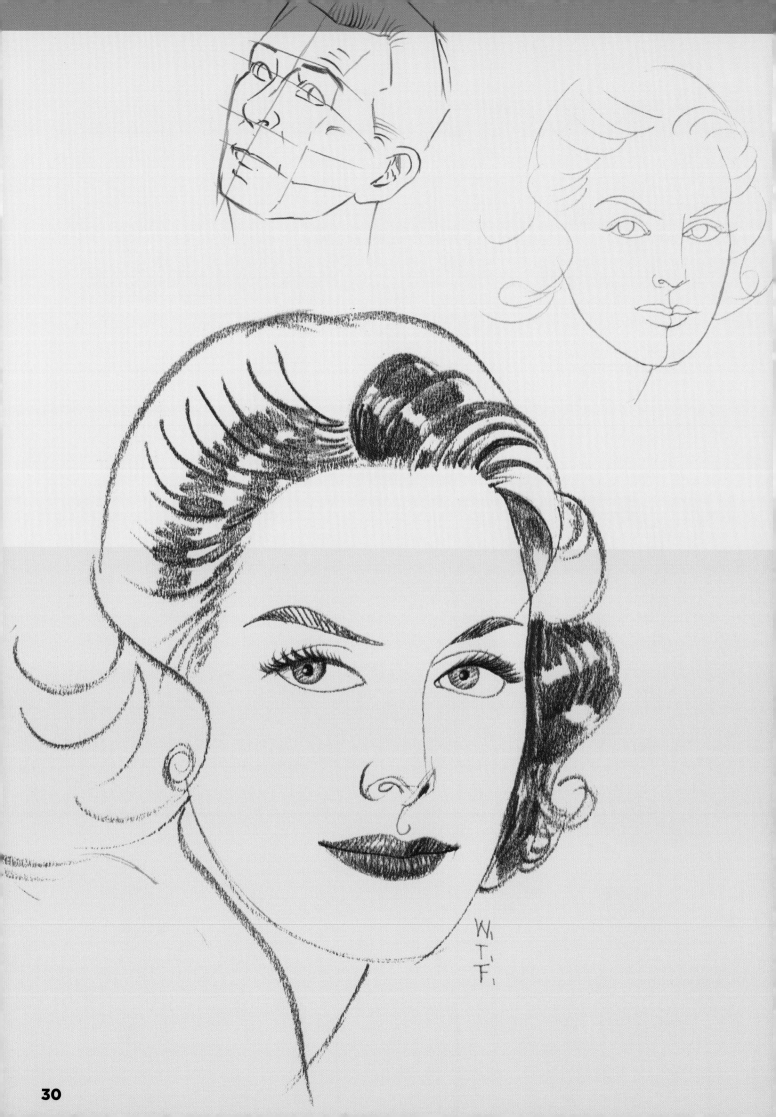

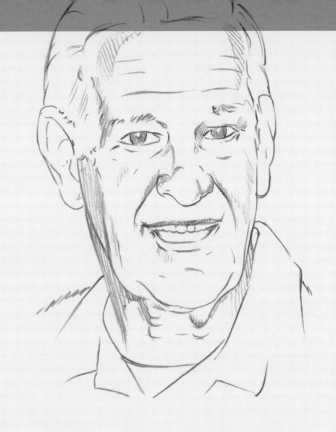

# BASIC HEADS & FACES

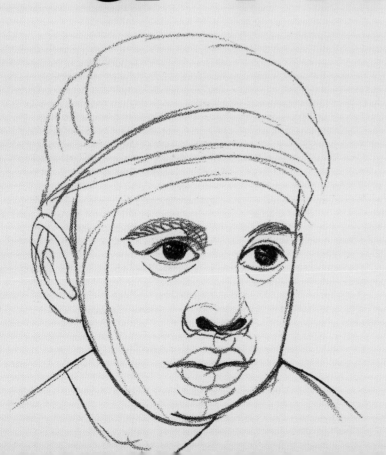

# BASIC LINE DRAWING

Drawing the human face is only a matter of proportion and properly placing the features. The lines and forms consist of simple curves and basic shapes. The easiest way to learn to draw people is to start with individual features such as the eyes and mouth. Eyes and lips are drawn around horizontal and vertical guidelines. Both guidelines are perpendicular in the frontal view, and the vertical line is slanted slightly in the profile view. Build on these guidelines with circles and simple curved lines.

## Eye

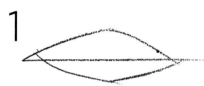

1

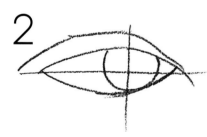

2

In this view, the iris is somewhat off-center, so place your guidelines just to the right of center.

3

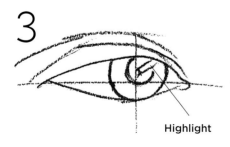

Highlight

## Eye Profile

1

Notice that a good portion of the eyeball is covered by the eyelid, no matter what the viewpoint.

2

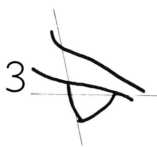

3

4

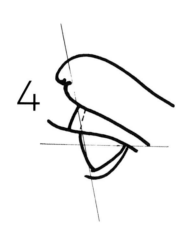

The dotted line indicates the shape of the eyeball beneath the eyelid. The curve of the eyelid follows the curve of the eyeball.

5

## Mouth Profile

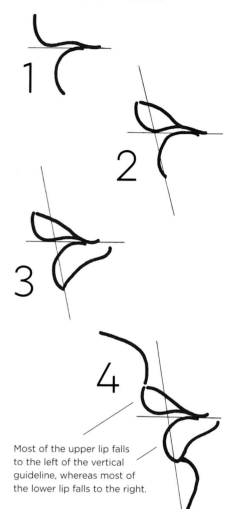

1

2

3

4

Most of the upper lip falls to the left of the vertical guideline, whereas most of the lower lip falls to the right.

## Mouth

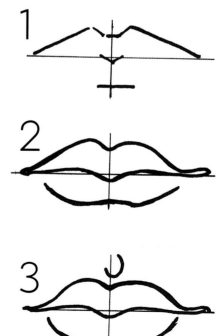

1

2

3

These profiles are built on two slanted guidelines: one for the line of the plane of the face, and one for the line of the nose. There are a variety of sizes and shapes of noses, eyes, and mouths; study your subject closely and make several practice sketches of the features. Then combine them into a simple profile.

For the full profile, start with a slanted guideline from the eyebrow to the chin. Then add horizontal guidelines to place the features. In adults, the bottom of the nose is approximately halfway between the eyebrow and the bottom of the chin. The bottom lip is about halfway between the nose and the chin. Note that these are just general rules of human proportion. The precise placement of features will vary slightly from individual to individual.

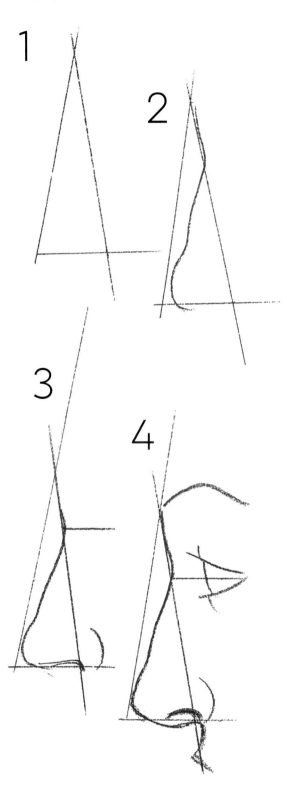

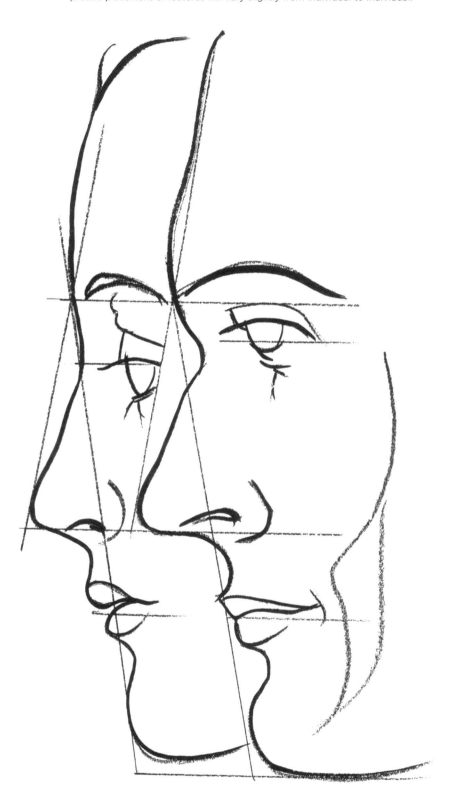

To draw the nose, block in a triangle and draw the basic outline of the nose within the triangle, as in steps 1 and 2. Refine the outline (step 3), and add a small curve to suggest the nostril in step 4.

Add the centerline for the eye at the top of the bridge of the nose. Next place the eye, eyebrow, and upper lip. Once you are satisfied with your sketches, try a complete profile.

# ESTABLISHING GUIDELINES

Step 1 illustrates the proportions of the face. In this close-up profile, the bottom of the nose is about halfway between the eyebrows and chin. The mouth is about halfway between the bottom of the nose and the chin.

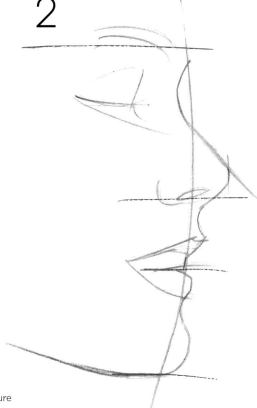

When drawing portraits, make sure you're comfortably seated and that the drawing board is at a good angle. Rotate the drawing often to prevent your hands from smudging areas you've already drawn.

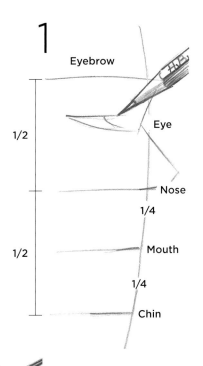

A tortillon is helpful for blending the contours of the face.

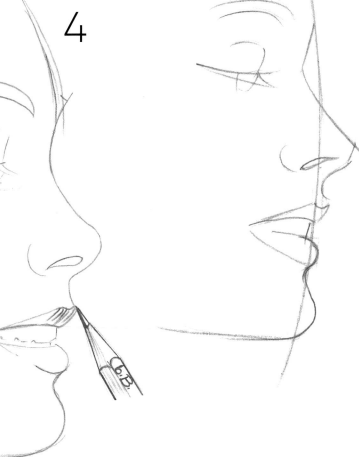

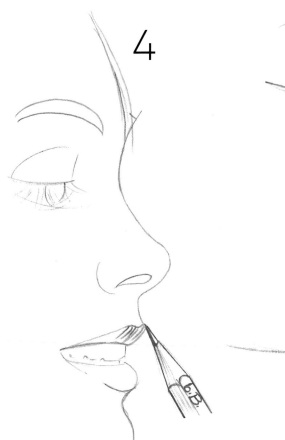

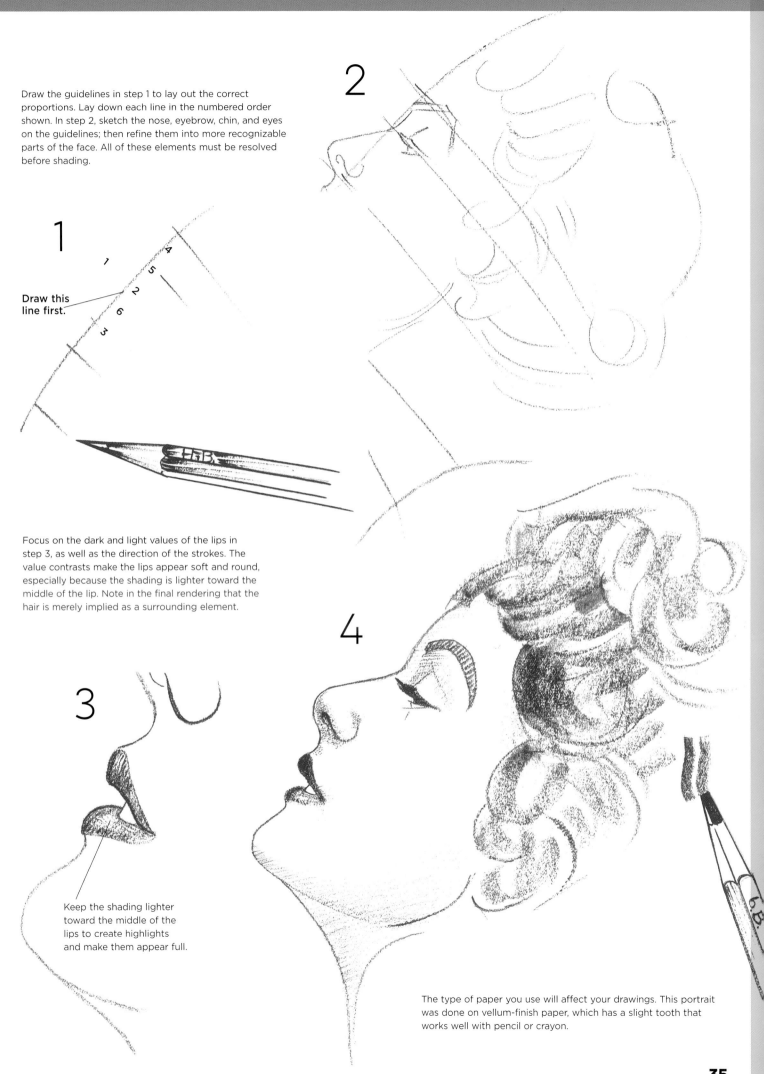

Draw the guidelines in step 1 to lay out the correct proportions. Lay down each line in the numbered order shown. In step 2, sketch the nose, eyebrow, chin, and eyes on the guidelines; then refine them into more recognizable parts of the face. All of these elements must be resolved before shading.

1

Draw this line first.

Focus on the dark and light values of the lips in step 3, as well as the direction of the strokes. The value contrasts make the lips appear soft and round, especially because the shading is lighter toward the middle of the lip. Note in the final rendering that the hair is merely implied as a surrounding element.

3

Keep the shading lighter toward the middle of the lips to create highlights and make them appear full.

2

4

The type of paper you use will affect your drawings. This portrait was done on vellum-finish paper, which has a slight tooth that works well with pencil or crayon.

# FRONT VIEW

For these front-view drawings, pay special attention to the position of the features. In a profile, for example, you don't have to worry about aligning the eyes with each other. Study your subject closely, because a small detail—such as the distance between the eyes—may determine whether your drawing achieves a strong likeness.

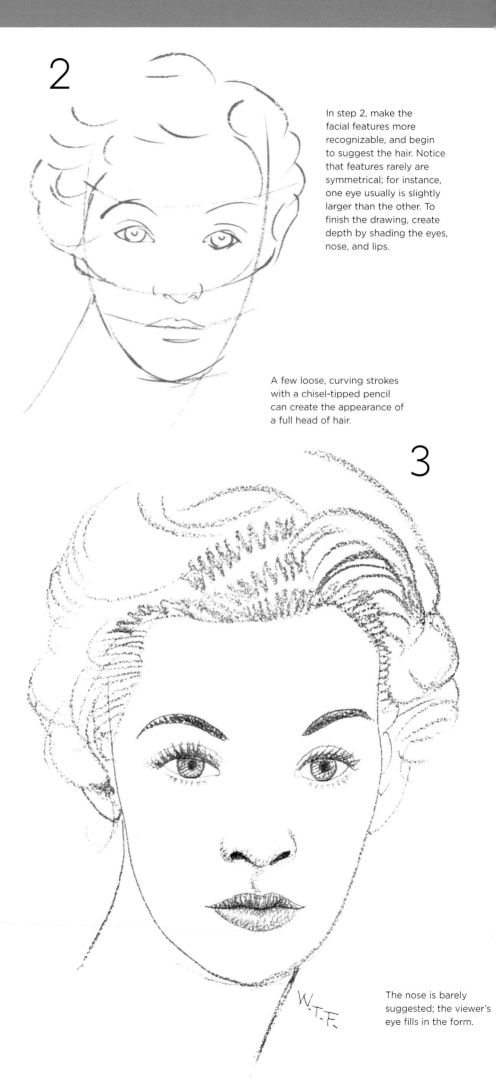

In step 2, make the facial features more recognizable, and begin to suggest the hair. Notice that features rarely are symmetrical; for instance, one eye usually is slightly larger than the other. To finish the drawing, create depth by shading the eyes, nose, and lips.

A few loose, curving strokes with a chisel-tipped pencil can create the appearance of a full head of hair.

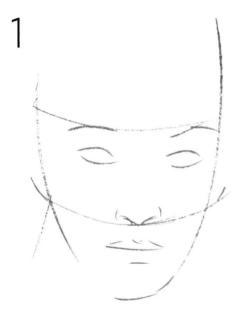

Step 1 shows minimal proportion guidelines. You will be able to start with fewer lines as you become more comfortable with your drawing and observation skills. Even the two lines shown are helpful for determining placement of the features.

The nose is barely suggested; the viewer's eye fills in the form.

2

In step 1, use an HB pencil to block in the proportions. Use the guidelines to place and develop the features in step 2. Notice the types of strokes used for the hair; they are loose and free. Quick renderings like this one are good for practice; do many of them!

1

3

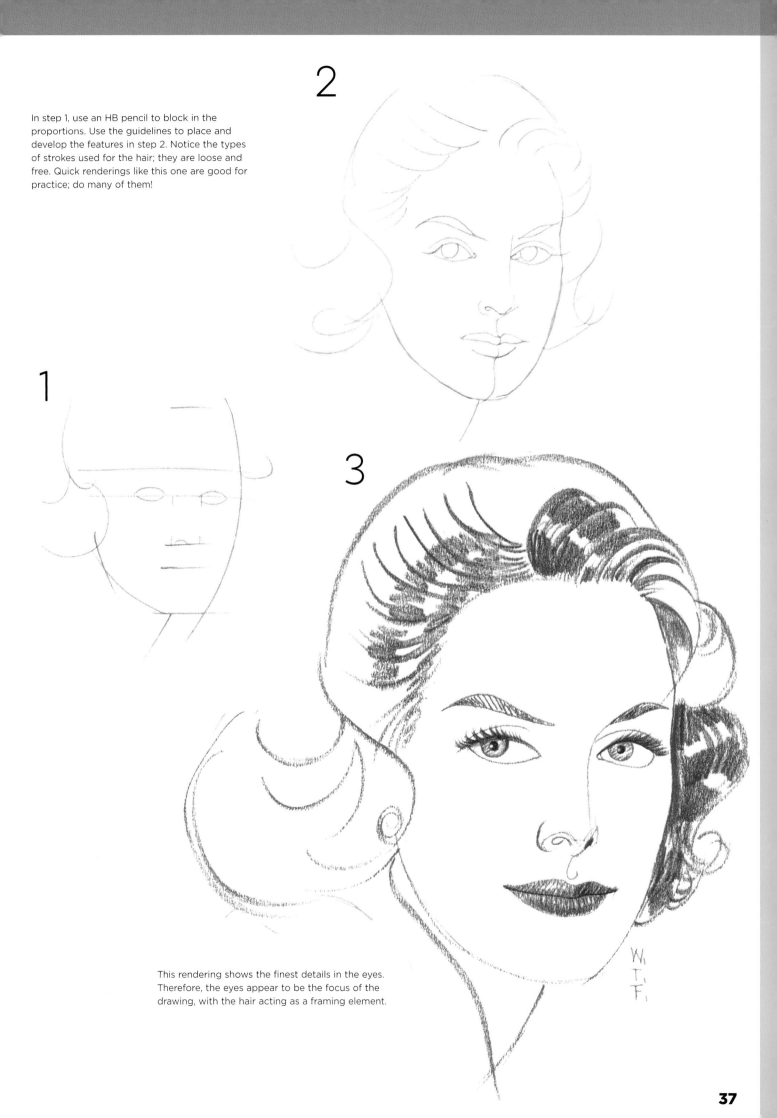

This rendering shows the finest details in the eyes. Therefore, the eyes appear to be the focus of the drawing, with the hair acting as a framing element.

# PROFILE

When shading the profile, it's important to recognize the different planes of the face. When you reach the shading stage, use a sharp 2B pencil to fill in darker areas such as wrinkles or creases. Use a paper stump to soften smoother features, such as cheeks.

1

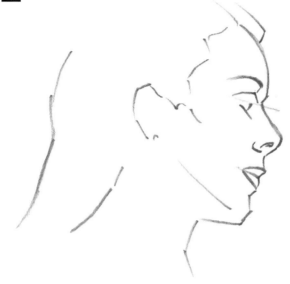

2

3

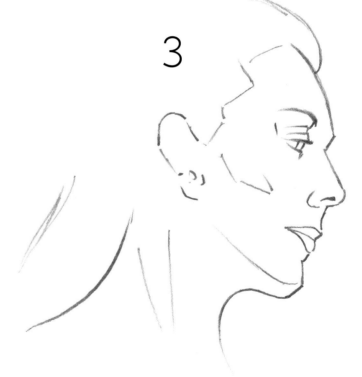

Planes of the Face

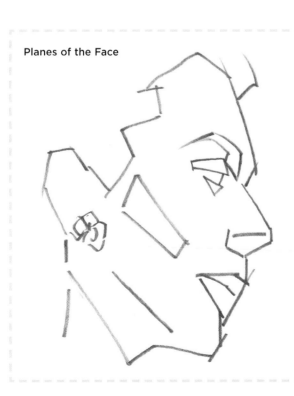

# 4

You can produce an effective drawing
with simple, delicate shading.

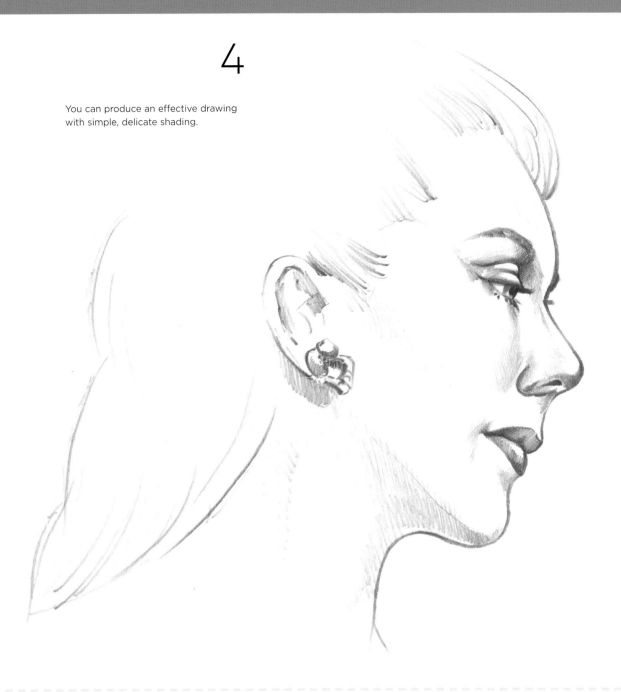

Although the nose is a prominent part of the profile, it should not dominate the entire drawing.
Take as much time drawing the other features as you would the nose.

## 1    2    3

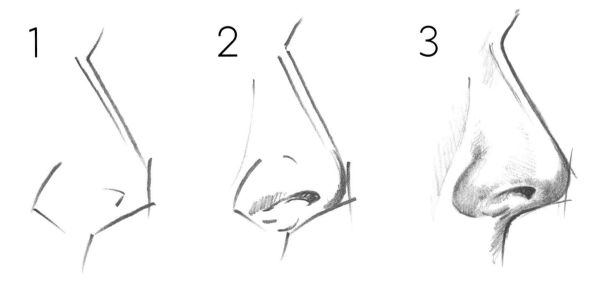

# THREE-QUARTER VIEW

Drawing a three-quarter view is slightly more difficult than the frontal view—but you can do it! Block in the basic shapes, and use guidelines to place the features. Note that because the face is angled, the features are all set off-center, with the nose at the three-quarter point. Curve the line for the bridge of the nose all the way out to the edge of the face, so it partially blocks her left eye.

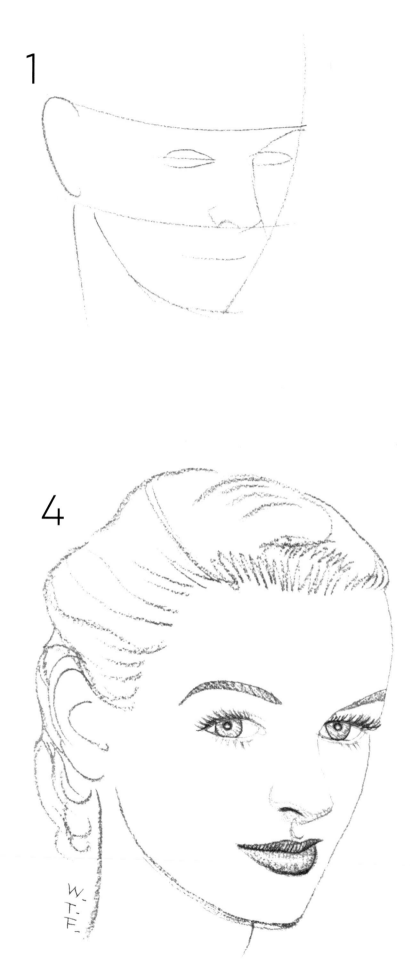

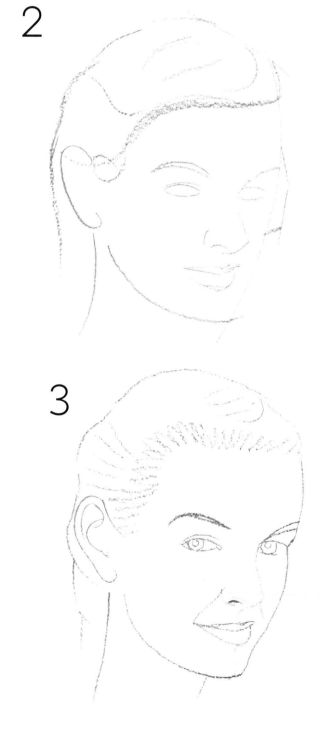

Browse through books and magazines for subjects to draw, or even look in the mirror and draw yourself. The more you practice and the more diverse your subjects, the better your drawings will become. Young or old, male or female, all portraits start with the same basic steps.

1

2

3

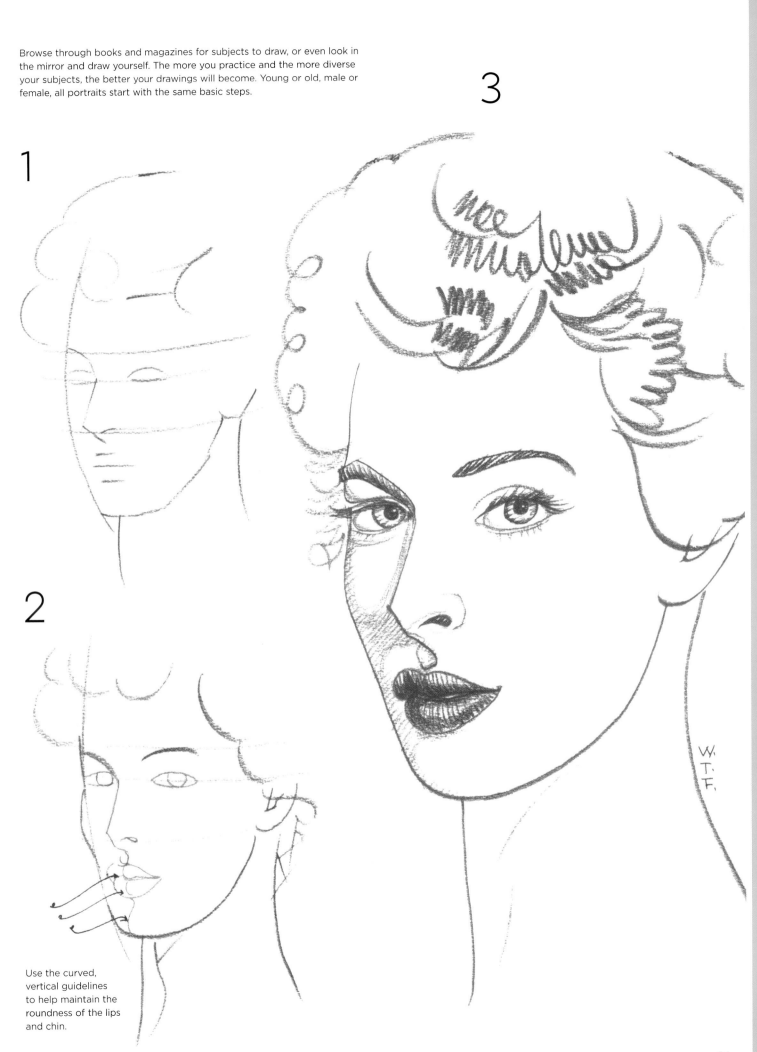

Use the curved, vertical guidelines to help maintain the roundness of the lips and chin.

# THREE-QUARTER VIEW

Although the three-quarter view may seem difficult, it can be drawn by following all of the techniques you've already learned. With an HB pencil, use the proper head proportions to lightly sketch the guidelines indicating where the main features will be located.

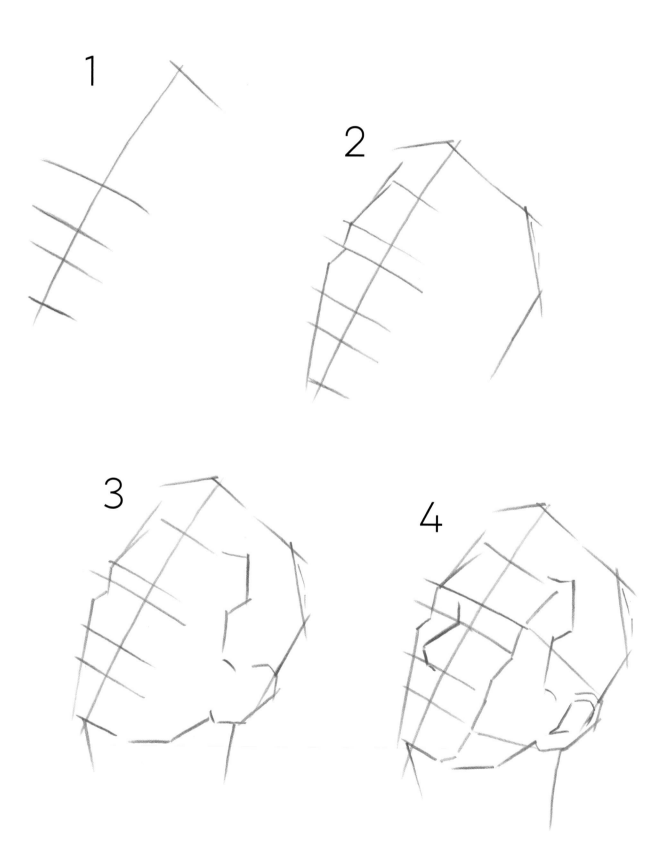

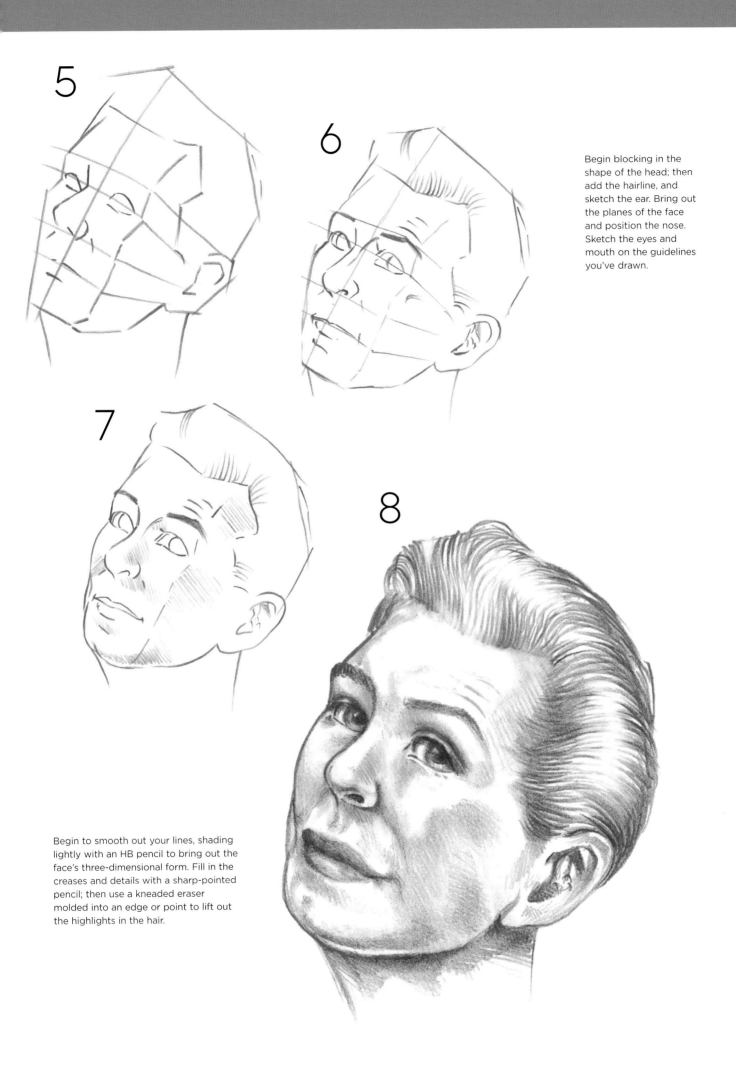

**5**

**6**

Begin blocking in the shape of the head; then add the hairline, and sketch the ear. Bring out the planes of the face and position the nose. Sketch the eyes and mouth on the guidelines you've drawn.

**7**

**8**

Begin to smooth out your lines, shading lightly with an HB pencil to bring out the face's three-dimensional form. Fill in the creases and details with a sharp-pointed pencil; then use a kneaded eraser molded into an edge or point to lift out the highlights in the hair.

# MATURE FACES

Older people generally reveal a lot of character in their faces. Be true to your subjects and try to bring out their essence and personality in your drawing.

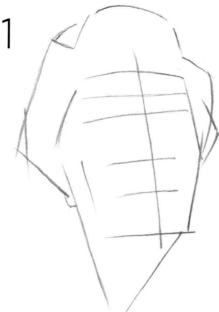

1

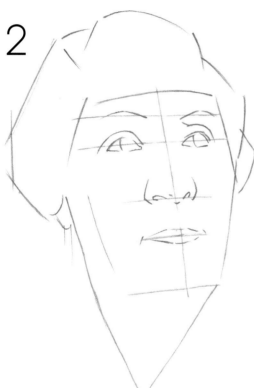

2

3

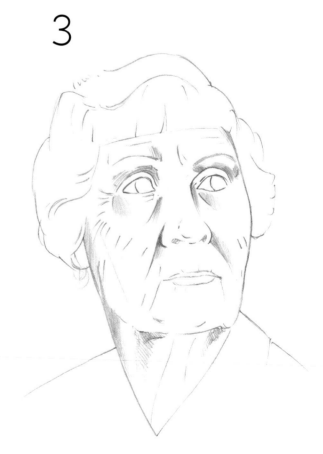

Once you've drawn the basic head shape, lightly indicate some gentle wrinkles. Some of the minor lines can be suggested through shading rather than drawing each one.

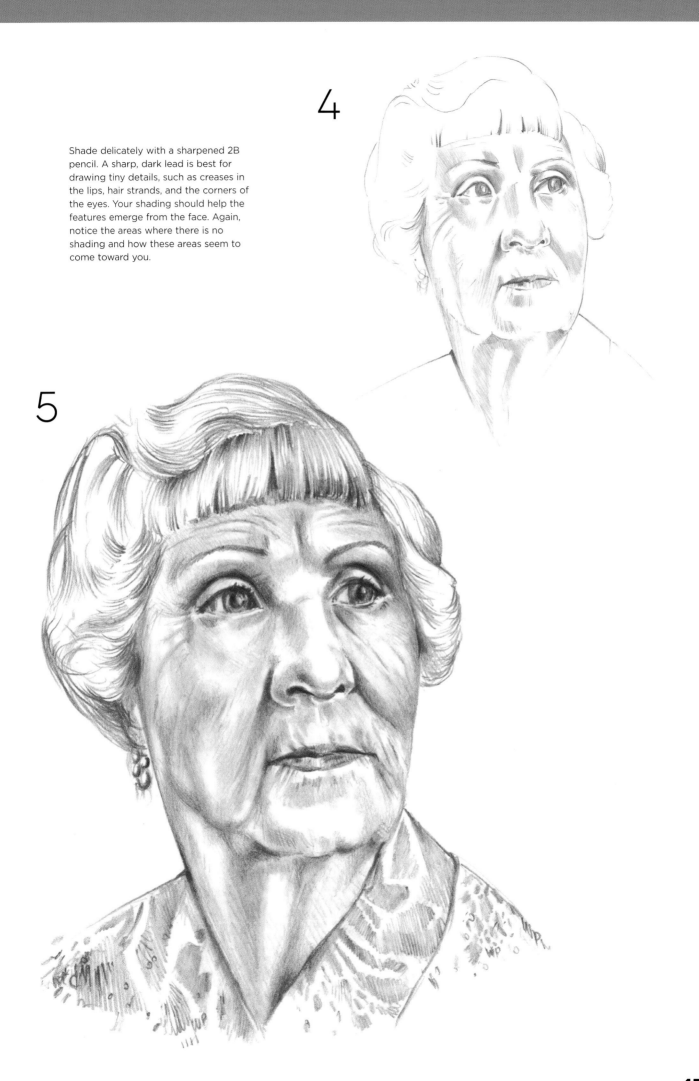

**4**

Shade delicately with a sharpened 2B pencil. A sharp, dark lead is best for drawing tiny details, such as creases in the lips, hair strands, and the corners of the eyes. Your shading should help the features emerge from the face. Again, notice the areas where there is no shading and how these areas seem to come toward you.

**5**

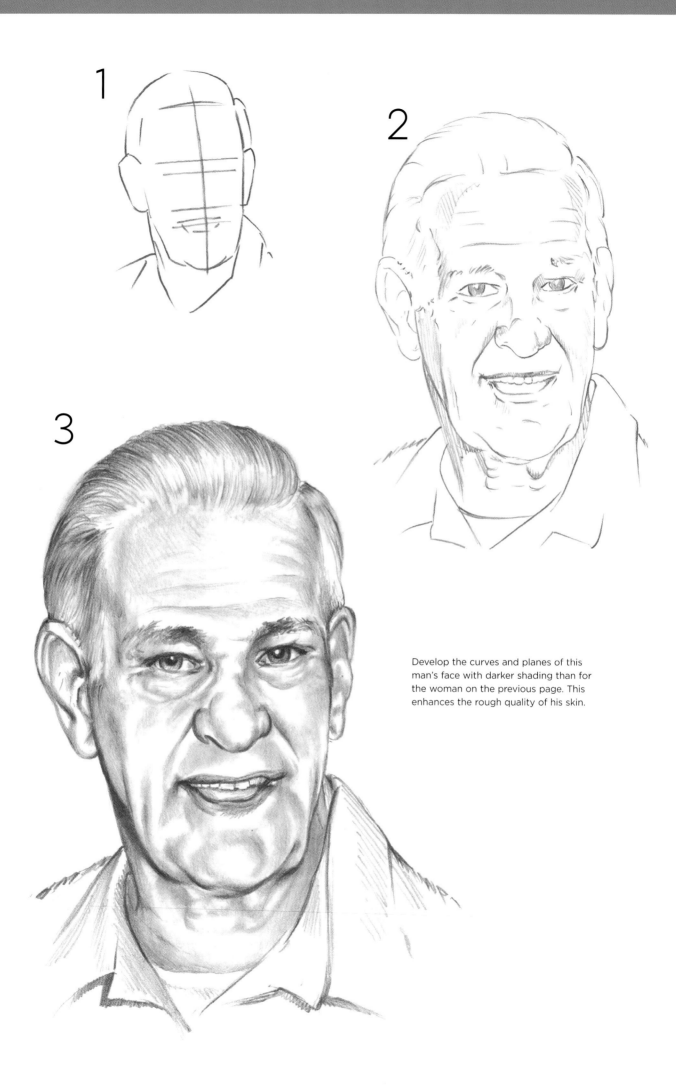

Develop the curves and planes of this
man's face with darker shading than for
the woman on the previous page. This
enhances the rough quality of his skin.

This man's face looks even more rugged and aged than the previous drawing. His cheekbones also are more defined, and he has a wider chin. It's helpful to envision the skull inside his head to accurately shade the outer features.

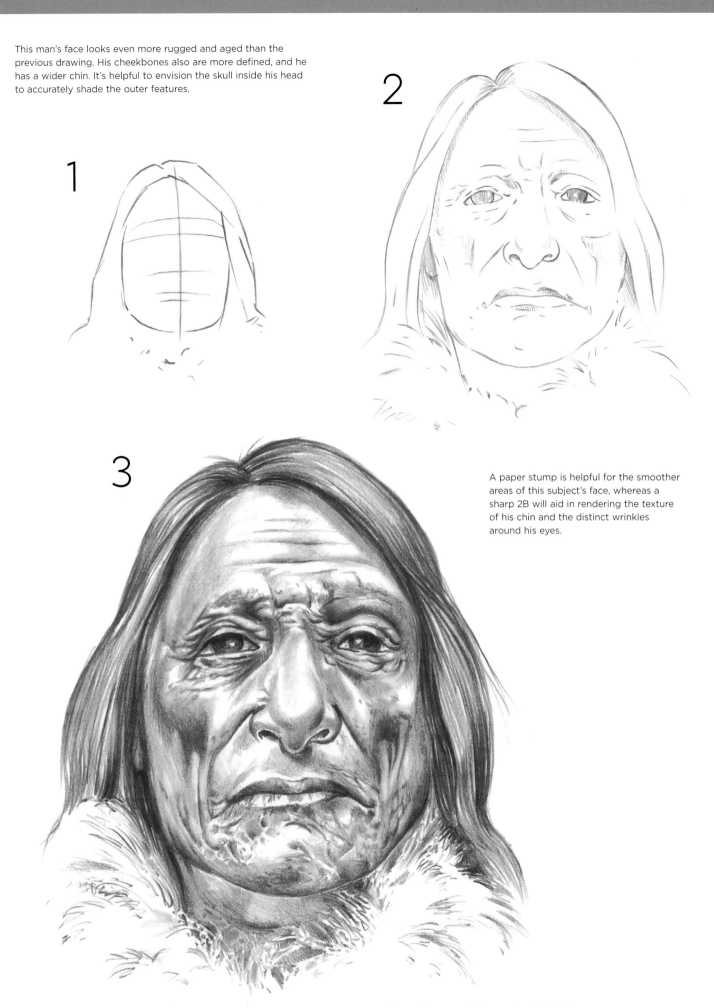

A paper stump is helpful for the smoother areas of this subject's face, whereas a sharp 2B will aid in rendering the texture of his chin and the distinct wrinkles around his eyes.

**Drawn from a photograph of Big Star.**
© American Museum of Natural History, New York.

# YOUNG FACES

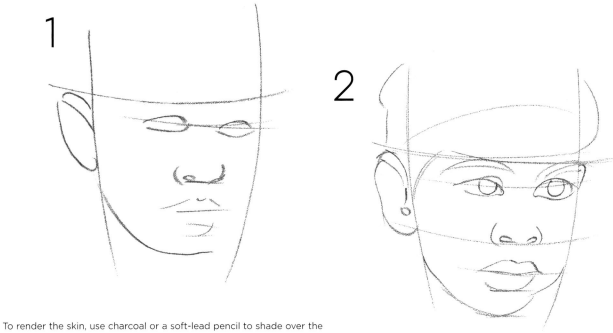

To render the skin, use charcoal or a soft-lead pencil to shade over the face with even, parallel strokes. Leave areas of white for highlights, especially on the tip of the nose and the center of the lower lip.

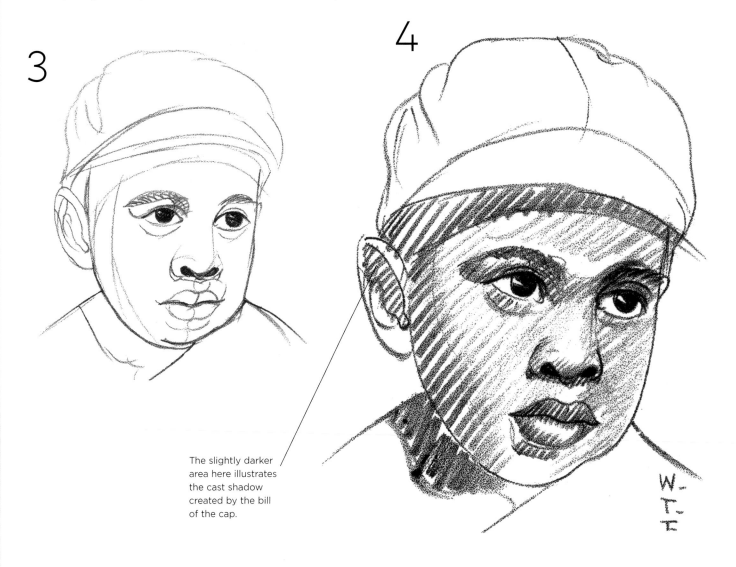

The slightly darker area here illustrates the cast shadow created by the bill of the cap.

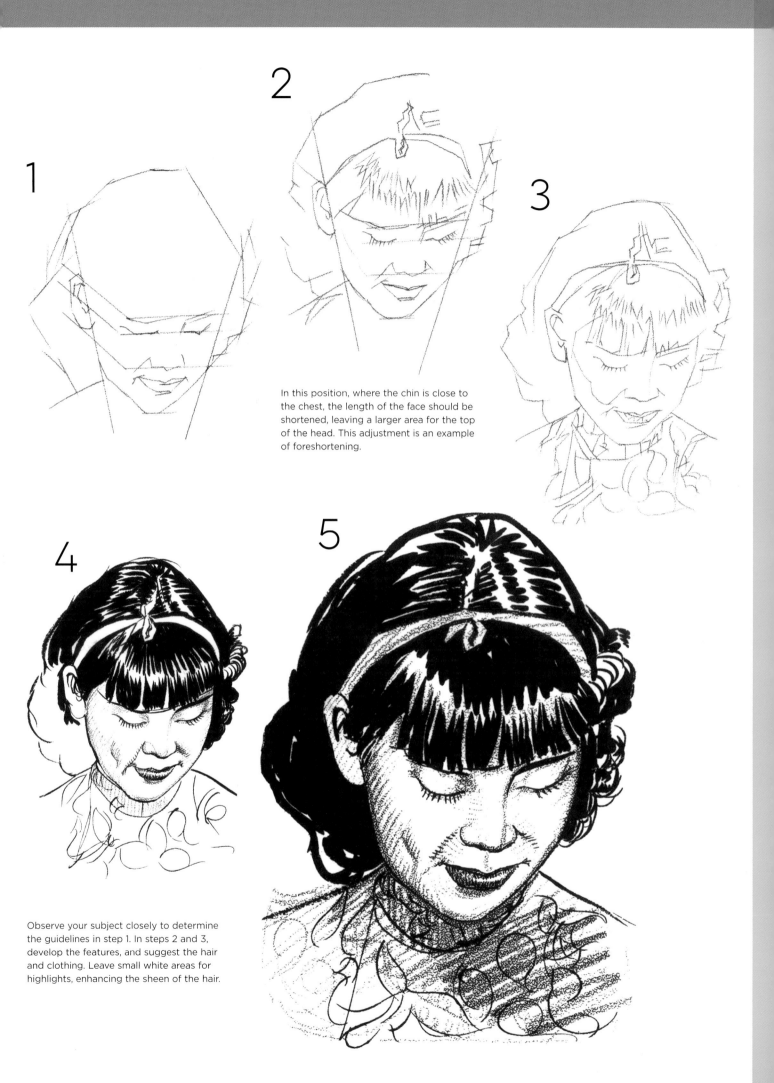

**1**

**2**

In this position, where the chin is close to the chest, the length of the face should be shortened, leaving a larger area for the top of the head. This adjustment is an example of foreshortening.

**3**

**4**

**5**

Observe your subject closely to determine the guidelines in step 1. In steps 2 and 3, develop the features, and suggest the hair and clothing. Leave small white areas for highlights, enhancing the sheen of the hair.

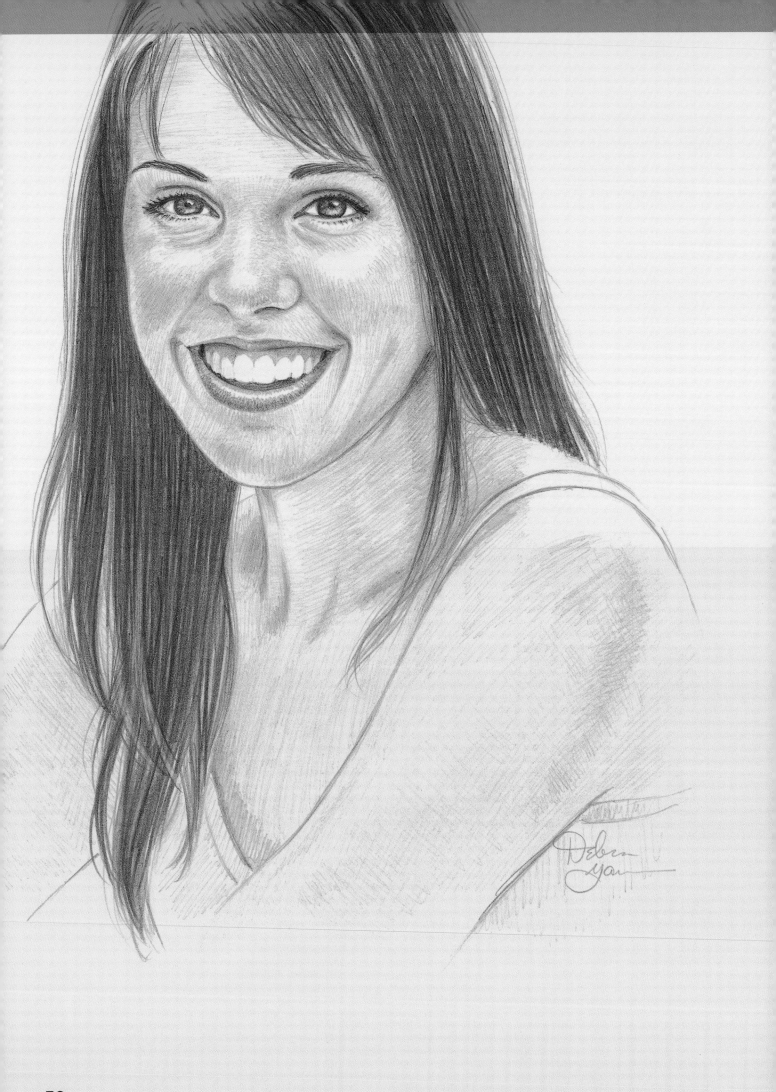

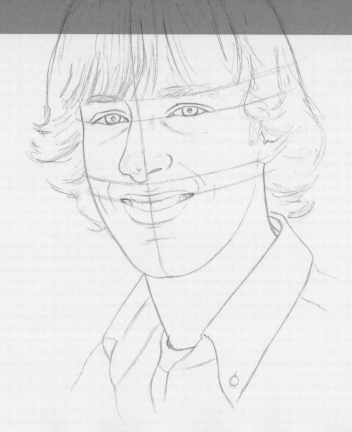

# REALISTIC PORTRAITS

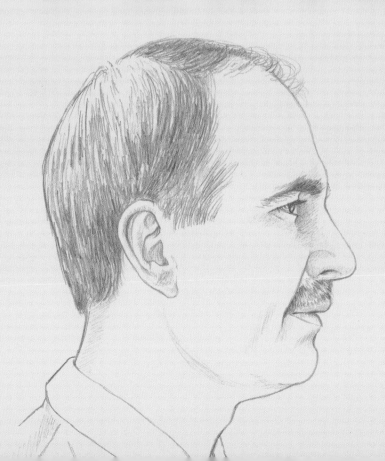

# ADULT FACIAL PROPORTIONS

Understanding the basic rules of human proportions (meaning the comparative sizes and placement of parts to one another) is imperative for accurately drawing the human face. Understanding proper proportions will help you determine the correct size and placement of each facial feature, as well as how to modify them to fit the unique, individual characteristics of your subject.

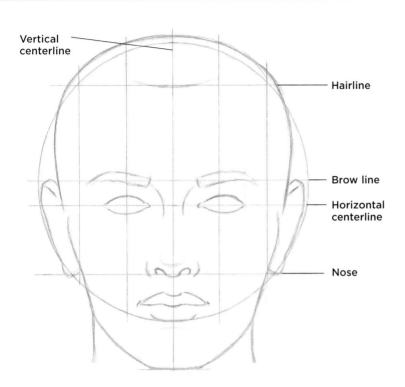

Vertical centerline

Hairline

Brow line

Horizontal centerline

Nose

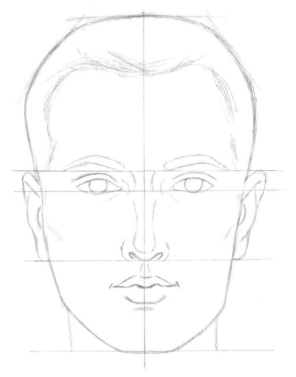

**Establishing Guidelines** Visualize the head as a ball that has been flattened on the sides. The ball is divided in half horizontally and vertically, and the face is divided horizontally into three equal parts: the hairline, the brow line, and the line for the nose. Use these guidelines to determine the correct placement and spacing of adult facial features.

**Placing the Features** The eyes lie between the horizontal centerline and the brow line. The bottom of the nose is halfway between the brow line and the bottom of the chin. The bottom lip is halfway between bottom of the nose and the chin, and the ears extend from the brow line to the bottom of the nose.

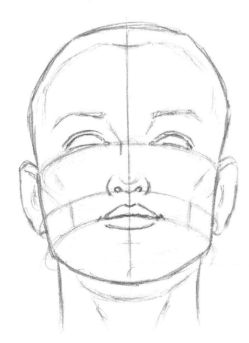

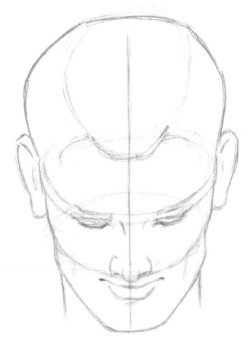

**Looking Up** When the head is tilted back, the horizontal guidelines curve with the shape of the face. Note the way the features change when the head tilts back: The ears appear a little lower on the head, and more of the whites of the eyes are visible.

**Looking Down** When the head is tilted forward, the eyes appear closed, and much more of the top of the head is visible. The ears appear higher, almost lining up with the hairline and following the curve of the horizontal guideline.

# Exploring Other Views

Beginning artists often study profile views first, as this angle tends to simplify the drawing process. For example, in a profile view, you don't have to worry about aligning symmetrical features. But the rules of proportion still apply when drawing profile views, as well as the more complex three-quarter views.

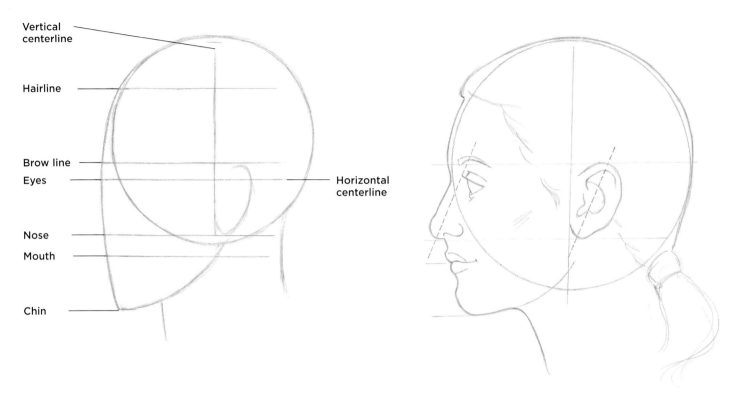

**Simplifying the Profile** To draw an adult head in profile, start by blocking in the cranial mass with a large circle. Add two curved lines that meet at a point to establish the face and chin. Place the ear just behind the vertical centerline.

**Placing the Features** Use the large cranial circle as a guideline for placing the features. The nose, lips, and chin fall outside the circle, whereas the eyes and ear remain inside. The slanted, broken lines indicate the parallel slant of the nose and ear.

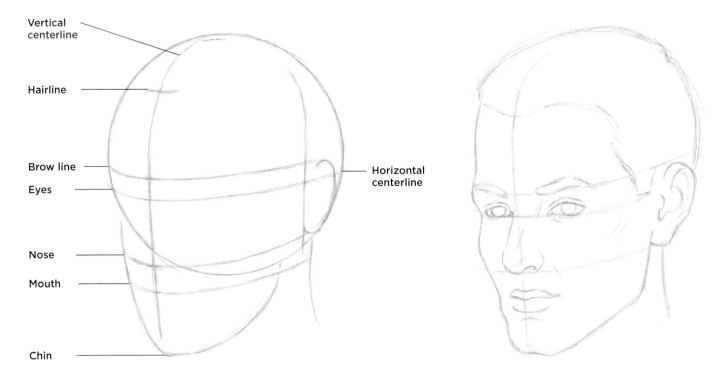

**Drawing a Three-Quarter View** In a three-quarter view, the vertical centerline shifts into view. More of the left side of the subject's head is visible, but you still see only the left ear. As the head turns, the guidelines also curve, following the shape of the head.

**Distorting the Features** When the head turns, the eye closest to the viewer (in this case the left eye) appears larger than the other eye. This is a technique called "foreshortening," in which elements of a drawing are distorted to create the illusion of three-dimensional space; objects closer to the viewer appear larger than objects that are farther away.

# THE PLANES OF THE FACE

Once you understand the basic structure of the head, you can simplify the complex shapes of the skull into geometric planes. These planes are the foundation for shading, as they act as a guide to help you properly place highlights and shadows.

## The Effects of Light

**Lighting the Planes from Above**   When light comes from above, the more prominent planes of the face—such as the bridge of the nose and the cheekbones—are highlighted. The eyes, which recede slightly, are shadowed by the brow; the sides of the nose, bottom of the chin, and underside of the neck also are in shadow.

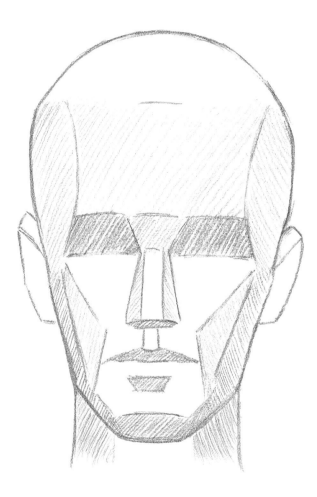

**Lighting the Planes from the Side**
Features are shaded differently when light hits the side of the face: The eyes are still in shadow, but the side of the face and neck are now highlighted. The shading on the head becomes darker as it recedes toward the neck; the sides of the cheeks appear "sunken"; and the ear casts a shadow on the back of the head.

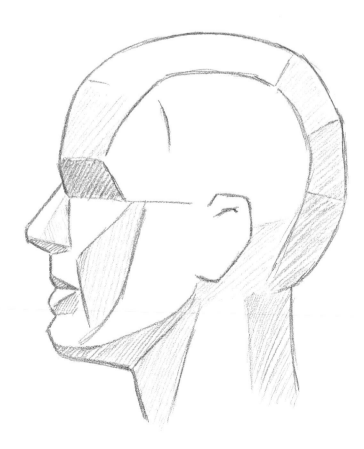

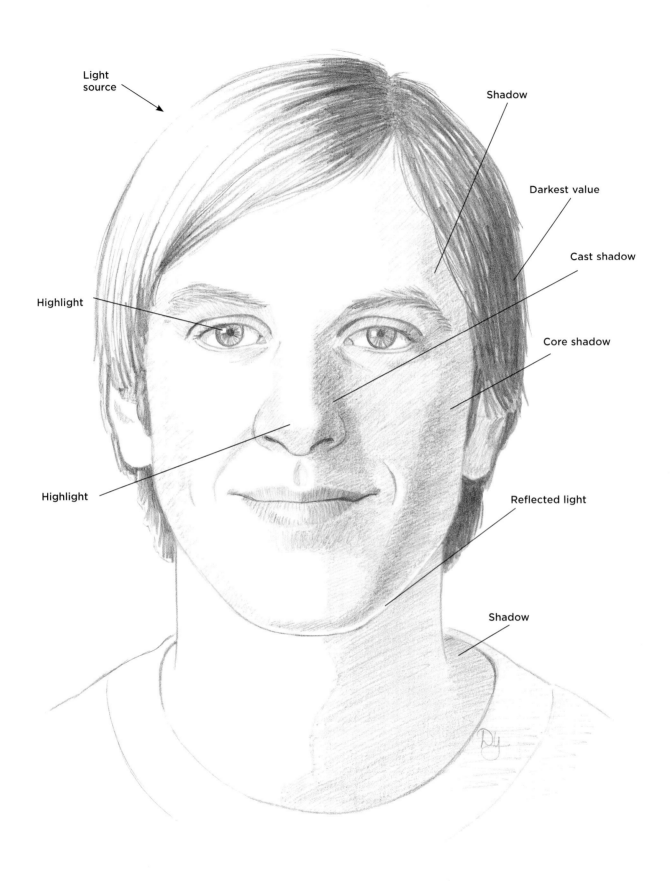

Light source

Shadow

Darkest value

Cast shadow

Core shadow

Highlight

Highlight

Reflected light

Shadow

**Shading the Planes of the Face** Many types and values of shadows contribute to the piecing together of all the planes of the face. Core shadows—or the main value of the shadows—are a result of both the underlying structure and the light source. Protruding objects, such as the nose, produce cast shadows, like the dark area on the left of this subject's nose. Highlights are most visible when directly in the light's path; here the light source is coming from above left, so the lightest planes of the face are the top of the head and the forehead. The darkest areas are directly opposite the light source, here the left side of the subject's face and neck. Even in shadow, however, there are areas of the planes that receive spots of reflected light, such as those shown here on the chin and under the eye.

# ADULT FACIAL FEATURES

If you're a beginner, it's a good idea to practice drawing all the facial features separately, working out any problems before attempting a complete portrait. Facial features work together to convey everything from mood and emotion to age. Pay attention to the areas around the features, as well; wrinkles, moles, and other similar characteristics help make your subject distinct.

## Eyes

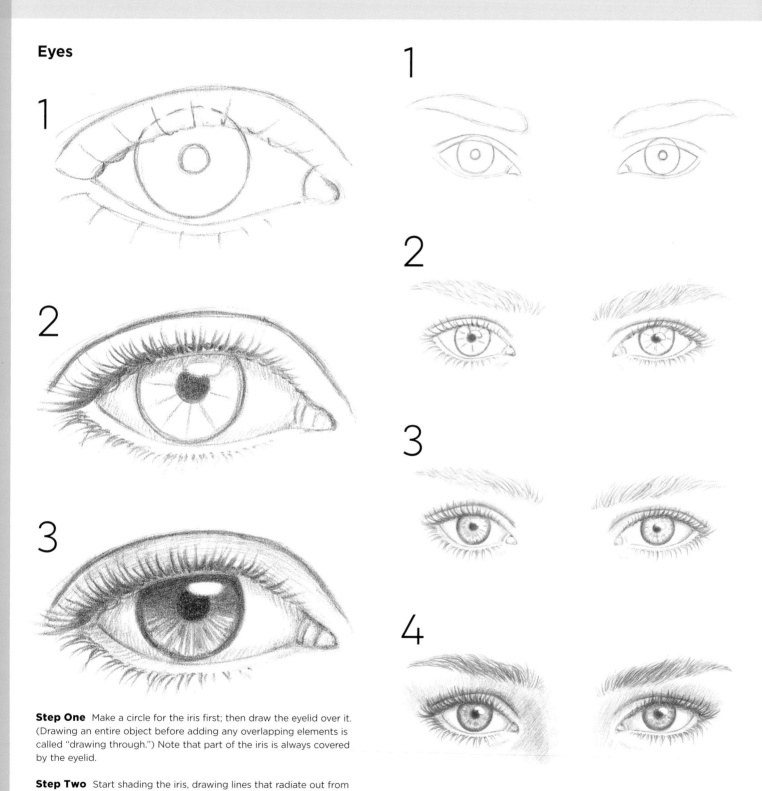

**Step One**  Make a circle for the iris first; then draw the eyelid over it. (Drawing an entire object before adding any overlapping elements is called "drawing through.") Note that part of the iris is always covered by the eyelid.

**Step Two**  Start shading the iris, drawing lines that radiate out from the pupil. Then add the eyelashes and the shadow being cast on the eyeball from the upper lid and eyelashes, working around the highlight on the iris.

**Step Three**  Continue shading the iris, stroking outward from the pupil. Then shade the eyelid and the white of the eye to add three-dimensional form.

**Rendering a Pair of Eyes**  After becoming comfortable with drawing the eye itself, start developing the features around the eye, including the eyebrows and the nose. Be sure to space adult eyes about one eye-width apart from each other. And keep in mind that eyes are always glossy—the highlights help indicate this. It's best to shade around the highlights, but if you accidentally shade over the area, you can pull out the highlight with a kneaded eraser.

1

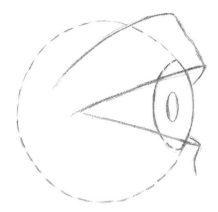

2

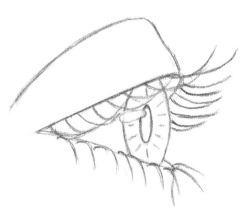

3

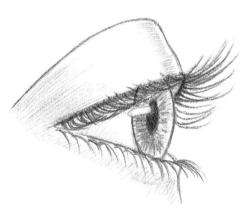

## Varying Qualities

There are several characteristics that influence the final impression that a pair of eyes give: The shape of the eye, position of the eyebrows, length and thickness of the eyelashes, and number of creases and wrinkles can denote everything from age and gender to mood. Study the examples below to see how these different elements work together.

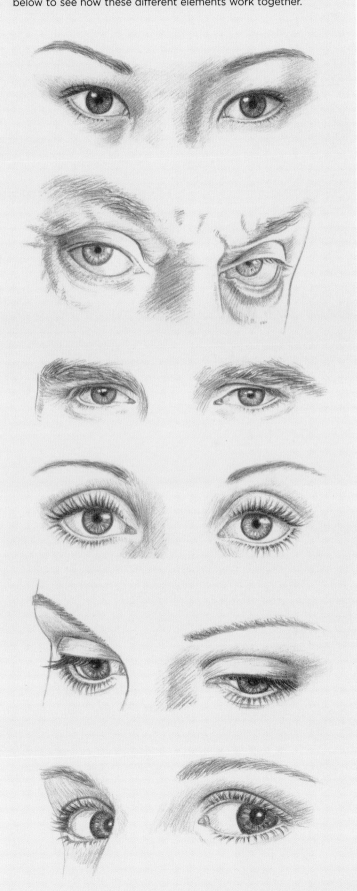

**Step One** Draw through a circle for the eye first; then draw the eyelid around it, as shown. In a profile view, the iris and pupil are ellipses; the top and bottom of the iris are covered by the upper and lower eyelids.

**Step Two** To draw eyelashes in profile, start at the outside corner of the eye and make quick, curved lines, always stroking in the direction of growth. The longest lashes are at the center of the eye.

**Step Three** When shading the eyelid, make light lines that follow the curve of the eyelid. As with the frontal view, the shading in the iris radiates out from the pupil.

# Noses

**Rendering Noses**  To draw a nose, first block in the four planes—two for the bridge and two for the sides (see "Combining Features" below right). Study the way each plane is lit before adding the dark and light values. The nostrils should be shaded lightly; if they're too dark, they'll draw attention away from the rest of the face. Generally men's nostrils are more angular, whereas women's are more gently curved.

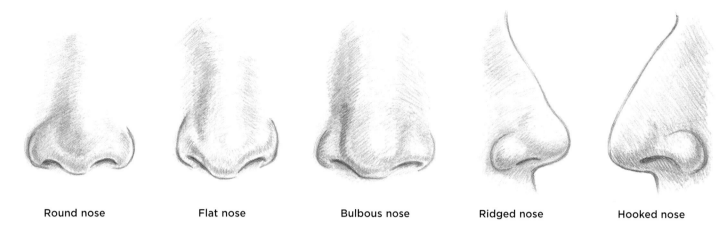

Round nose    Flat nose    Bulbous nose    Ridged nose    Hooked nose

# Ears

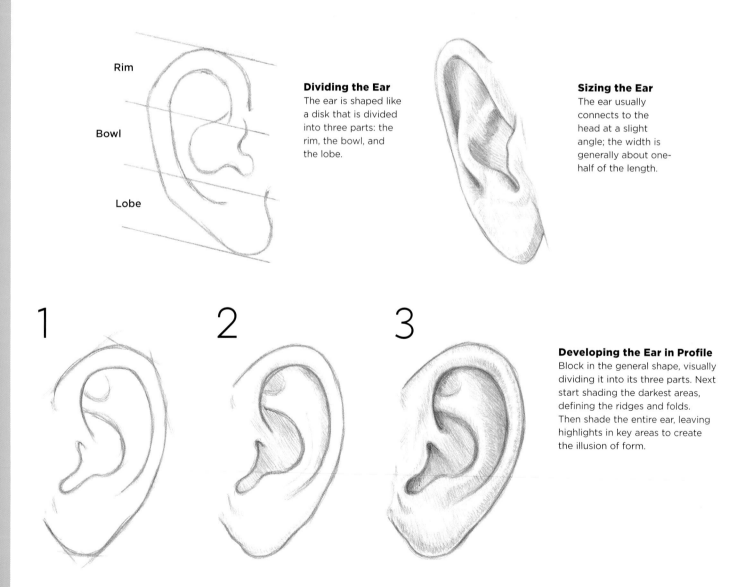

Rim

Bowl

Lobe

**Dividing the Ear**
The ear is shaped like a disk that is divided into three parts: the rim, the bowl, and the lobe.

**Sizing the Ear**
The ear usually connects to the head at a slight angle; the width is generally about one-half of the length.

1    2    3

**Developing the Ear in Profile**
Block in the general shape, visually dividing it into its three parts. Next start shading the darkest areas, defining the ridges and folds. Then shade the entire ear, leaving highlights in key areas to create the illusion of form.

# Lips

**1**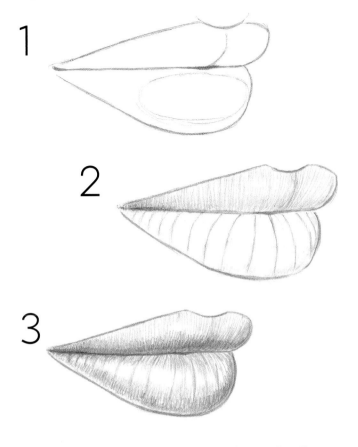

**2**

**3**

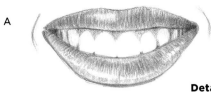A

B

## Detailing the Lips
Determine how much detail you'd like to add. You can add smile lines and dimples (A, B, and D), clearly defined teeth (A) or parts of the teeth (E and F), or closed lips (B, C, and D).

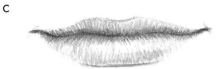C

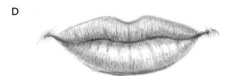D

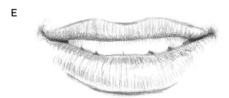E

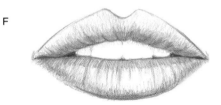F

**Step One** When drawing lips, first sketch the basic outline. The top lip slightly protrudes over the bottom lip; the bottom lip is also usually fuller than the top lip.

**Step Two** Begin shading in the direction of the planes of the lips. The shading on the top lip curves upward, and the shading on the bottom lip curves downward.

**Step Three** Continue shading, making the darkest value at the line where the lips meet. Pull out some highlights to give the lips shine and form. Highlights also enhance the lips' fullness, so it's often best to include larger highlights on the fuller bottom lip.

## Combining Features

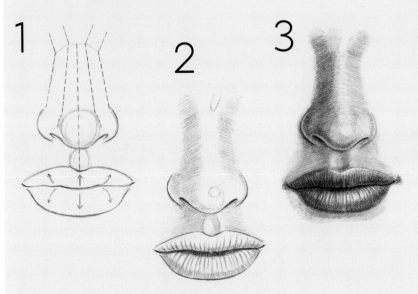

**1** **2** **3**

**Step One** Simplify the nose by dividing it into four planes—plus a circle on the tip to indicate its roundness. Draw the outline of the lips. Add a small circle to connect the base of the nose with the top of the lip. The arrows on the lips indicate the direction of shading.

**Step Two** Lightly shade the sides of the nose, as well as the nostrils and the area between the nose and lips. Begin shading the lips in the direction indicated by the arrows in step 1. Then shade the dark area between the top and bottom lips. This helps separate the lips and gives them form.

**Step Three** Continue shading to create the forms of the nose and mouth. Where appropriate, retain lighter areas for highlights and to show reflected light. For example, use a kneaded eraser to pull out highlights on the top lip, on the tip of the nose, and on the bridge of the nose.

# DRAWING FROM A SNAPSHOT

In this photo, try to capture the features that are unique to the model: the slightly crooked mouth, smile lines, and wide-set eyes. Note also that you can barely see her nostrils. It's details like these that will make the drawing look like this individual and no one else.

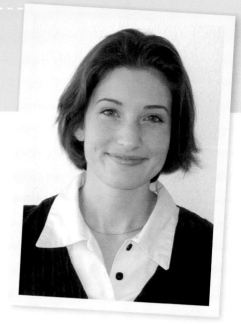

1

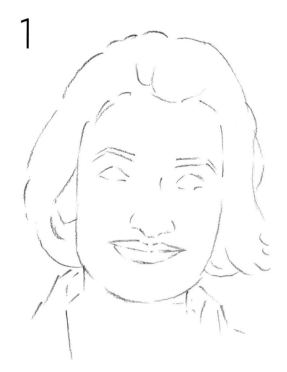

2

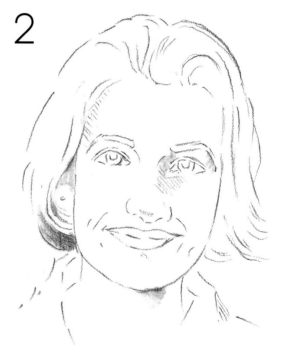

3

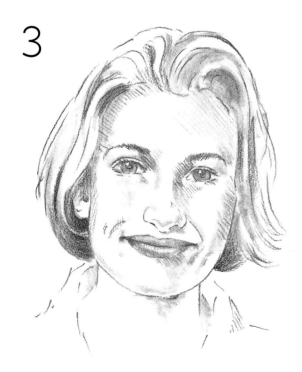

**Step One** With a sharp HB charcoal pencil, lightly sketch the general shapes of the head, hair, and collar. Lightly place her features.

**Step Two** Begin refining the features, adding the pupil and iris in each eye, plus dimples and smile lines. Begin to add a few shadows.

**Step Three** Continue to develop the forms with shading, using the side of an HB charcoal pencil and following the direction of the facial planes. Use a kneaded eraser to lift out the eye highlights and a soft willow charcoal stick for the dark masses of hair.

**Step Four** Continue building up the shading with the charcoal pencil and willow stick. For gradual blends and soft gradations of value, gently rub the area with your finger. (Don't use a brush or cloth to remove the excess charcoal dust; it will smear the drawing.) When finished, gently tap the back side to release any loose dust. Finally, spray it lightly with fixative to protect it from further smudging.

4

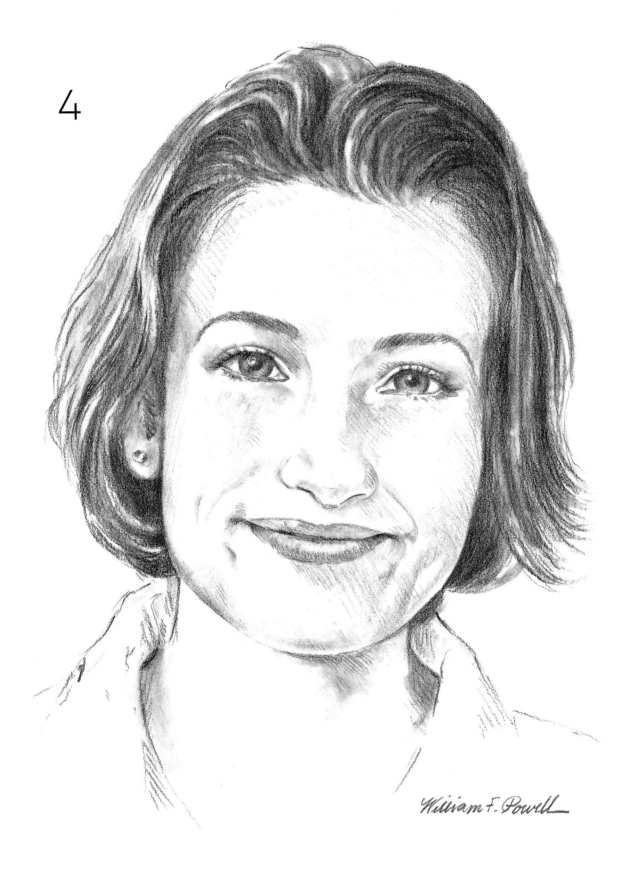

*William F. Powell*

# DRAWING WHAT YOU SEE

Use your understanding of the basics of proportion to block in the head and place the features. Study your subject carefully to see how his or her facial proportions differ from the "average"; capturing these subtle differences will help you achieve a better likeness to your subject.

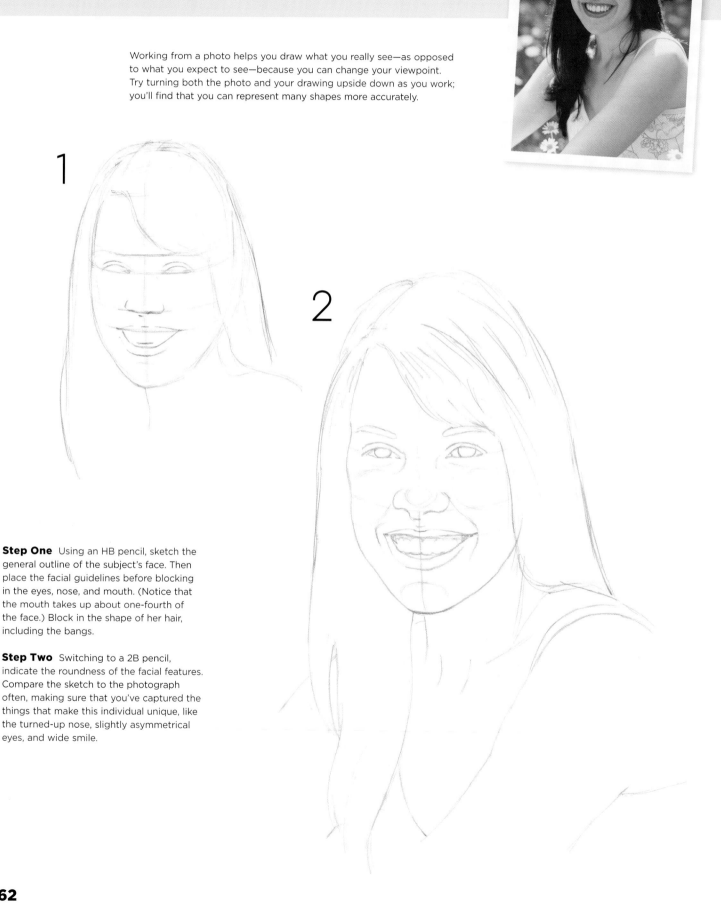

Working from a photo helps you draw what you really see—as opposed to what you expect to see—because you can change your viewpoint. Try turning both the photo and your drawing upside down as you work; you'll find that you can represent many shapes more accurately.

1

2

**Step One** Using an HB pencil, sketch the general outline of the subject's face. Then place the facial guidelines before blocking in the eyes, nose, and mouth. (Notice that the mouth takes up about one-fourth of the face.) Block in the shape of her hair, including the bangs.

**Step Two** Switching to a 2B pencil, indicate the roundness of the facial features. Compare the sketch to the photograph often, making sure that you've captured the things that make this individual unique, like the turned-up nose, slightly asymmetrical eyes, and wide smile.

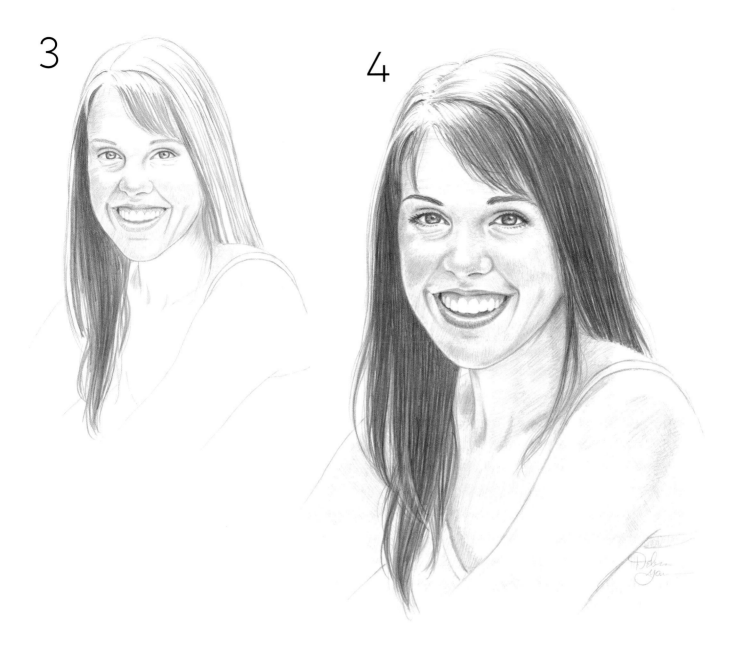

**Step Three** Erase the guidelines and then begin shading, following the form of the face with the 2B pencil and softly blending to create the smoothness of the skin. Next create the teeth, lightly indicating the separations with incomplete lines. Switch to a 3B pencil to lay in more dark streaks of hair.

**Step Four** To render the smooth, shiny hair, use a 4B to lay in darker values. Vary the length of the strokes, pulling some strokes into the areas at the top of her head that have been left white for highlights; this produces a gradual transition from light to dark. Refine the eyes and mouth by adding darker layers of shading.

## Focusing on Features

This drawing shows the same young lady with a different hair style, expression, and pose. Although she's in costume, she is still recognizable as the same subject.

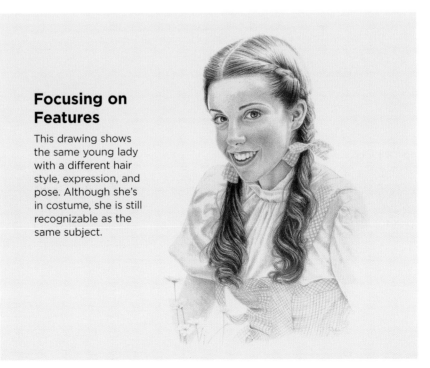

# CAPTURING PERSONALITY

When drawing a portrait, try to go beyond likeness and capture something truly unique about the individual's personality. Your goal is to decide on an expression that best represents the sitter without replicating the candid quality of photographic snapshots.

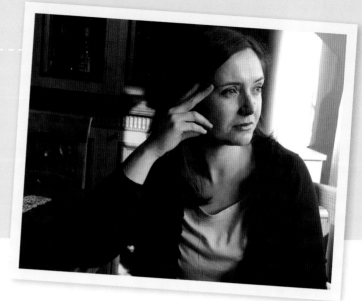

**Step One** Study the head's angle and draw the guidelines, followed by the egg-shaped head. Determine the arm's angle and size in relation to the head, using an elongated oval shape to place it. Add shapes for the hand, and mark the first finger joints. Block in the shirt and facial features.

Keep the fingers simple, and focus on the angles.

Use small lines to indicate the widths of the mouth and nose.

**Step Two** Check the proportions, measurements, and angles before placing the facial features. Break the hand shapes into smaller finger shapes. Then mark the shadowline and edge of the sleeve on the arm.

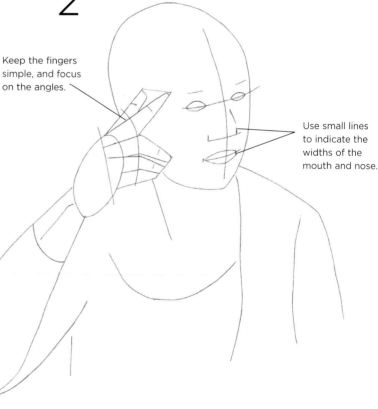

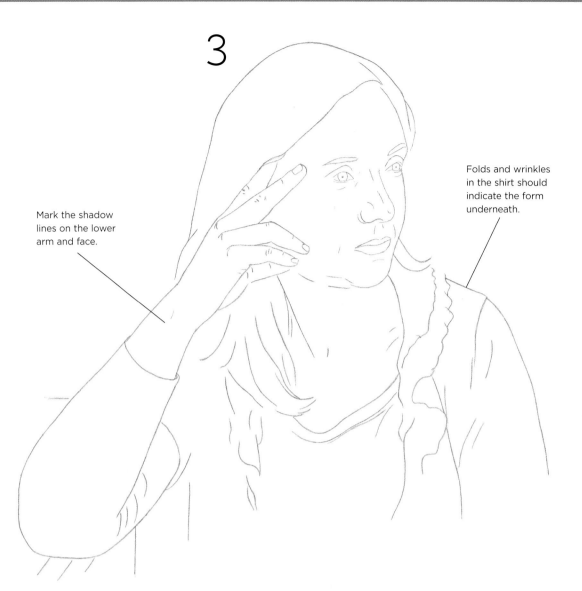

3

Mark the shadow lines on the lower arm and face.

Folds and wrinkles in the shirt should indicate the form underneath.

**Step Three** Recheck the proportions and angles before tracing the outline onto heavyweight tracing paper. Mark the hairline, and detail the facial features. Refine the jawline, chin, and mouth. Next add the small shapes of the fingers, knuckles, and fingernails.

## Drawing Hands

Hands are extremely complex, especially considering the many ways they can move and the different shapes that result. Practice drawing your own hands, other people's hands, and hands from magazines to familiarize yourself with them.

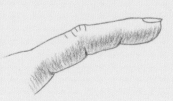
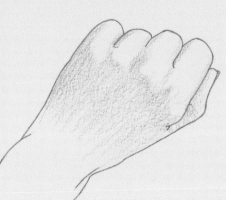
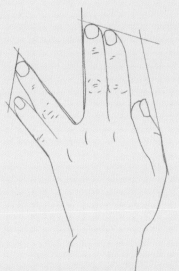

If the hand is in complete shadow or complete sunlight, light and shadow can't help describe the form. Look for pleasing shadow patterns.

Look for graceful positions that show the length of the fingers. It's difficult to make a drawing of a fist look realistic, as the fingers often appear cut off.

*Enveloping*—or blocking—trains the eye to see large shapes first. In this drawing, the pinky and ring fingers are grouped as one shape, and the middle and index fingers and thumb as another.

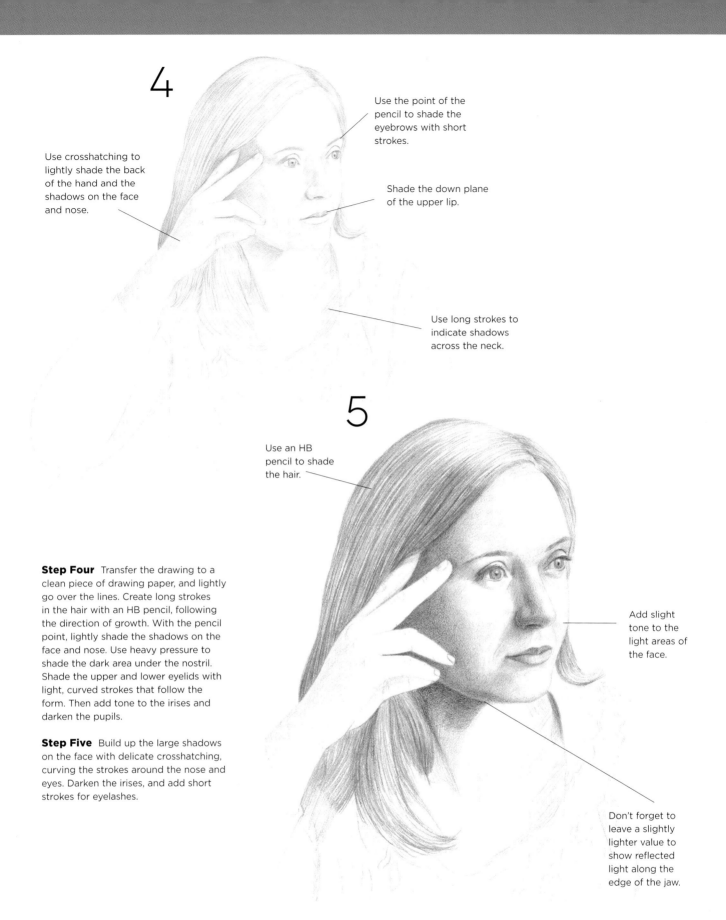

4

Use the point of the pencil to shade the eyebrows with short strokes.

Use crosshatching to lightly shade the back of the hand and the shadows on the face and nose.

Shade the down plane of the upper lip.

Use long strokes to indicate shadows across the neck.

5

Use an HB pencil to shade the hair.

Add slight tone to the light areas of the face.

Don't forget to leave a slightly lighter value to show reflected light along the edge of the jaw.

**Step Four** Transfer the drawing to a clean piece of drawing paper, and lightly go over the lines. Create long strokes in the hair with an HB pencil, following the direction of growth. With the pencil point, lightly shade the shadows on the face and nose. Use heavy pressure to shade the dark area under the nostril. Shade the upper and lower eyelids with light, curved strokes that follow the form. Then add tone to the irises and darken the pupils.

**Step Five** Build up the large shadows on the face with delicate crosshatching, curving the strokes around the nose and eyes. Darken the irises, and add short strokes for eyelashes.

# ARTIST'S TIP

When rendering the back of the hand, wrist, and lower arm, check and recheck proportions, as the transition from arm to hand is subtle.

**ARTIST'S TIP**

Don't go overboard on the sweater details. You don't want it to become the focus of the drawing.

6

**Step Six** Use more crosshatching strokes on the back of the hand. Finish shading the fingers, leaving the knuckles almost white in value. Then switch to a 2B pencil to create the texture of the sweater. Use the side of the pencil to shade the arm, following its contour. Then use the point of the pencil to add subtle detail to the sweater.

Use a soft lead to reveal the subtle texture of the paper.

The shift in the edge of the shadow shape suggests the wrist bone.

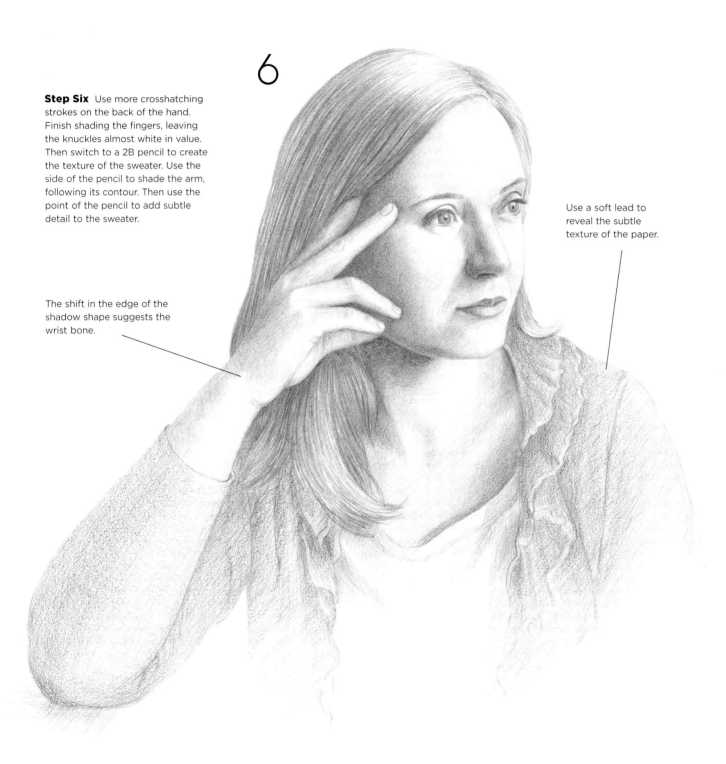

# WORKING WITH LIGHTING

Lighting can influence the mood or atmosphere of your drawing—intense lighting creates drama, whereas soft lighting produces a more tranquil feeling. Lighting also can affect shadows, creating stronger contrasts between light and dark values. Remember that the lightest highlights will be in the direct path of your light source, and the darkest shadows will be opposite the light source.

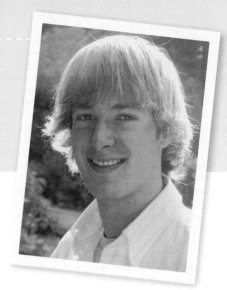

**1**

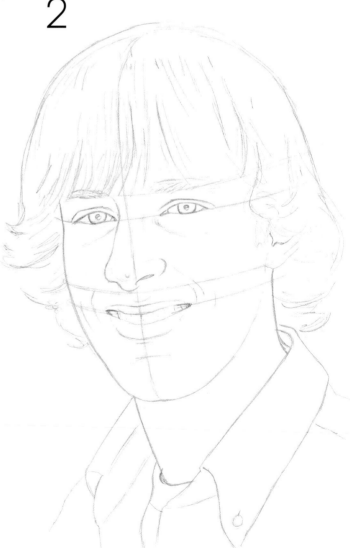

**Using Backlighting**  In the photo above, the light source is coming from behind the subject—the face is in shadow, but the hair is highlighted. When drawing a backlit subject, try leaving some areas of paper white around the edges of the head. This keeps the hair from looking stiff and unrealistic, and it also separates the hair from the background.

**2**

**Step One**  Sketch the basic shape of the head, neck, and hair with an HB pencil. The subject's head is turned in a three-quarter view, so curve the guidelines around the face accordingly. Lightly sketch the facial features, indicating the roundness of the nose and the chin.

**Step Two**  Switching to a 2B pencil, define the features and fill in the eyebrows. Sketch a few creases near the mouth and around the eyes; then add the collar, button, and neckband to the shirt.

3

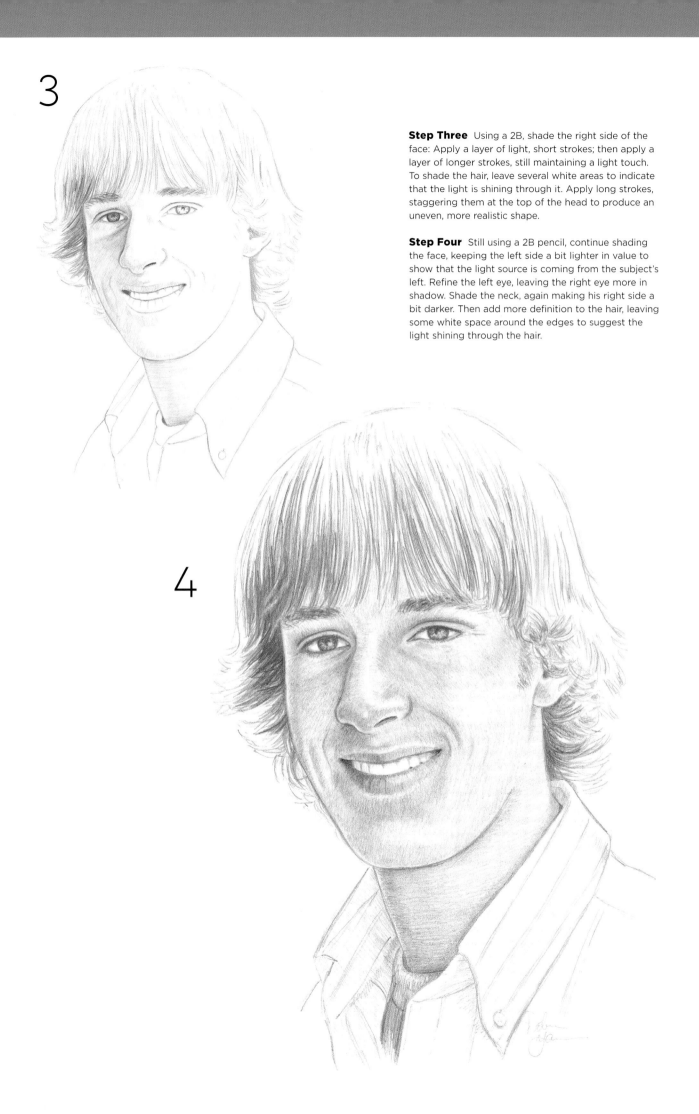

**Step Three**  Using a 2B, shade the right side of the face: Apply a layer of light, short strokes; then apply a layer of longer strokes, still maintaining a light touch. To shade the hair, leave several white areas to indicate that the light is shining through it. Apply long strokes, staggering them at the top of the head to produce an uneven, more realistic shape.

**Step Four**  Still using a 2B pencil, continue shading the face, keeping the left side a bit lighter in value to show that the light source is coming from the subject's left. Refine the left eye, leaving the right eye more in shadow. Shade the neck, again making his right side a bit darker. Then add more definition to the hair, leaving some white space around the edges to suggest the light shining through the hair.

4

# INCLUDING A BACKGROUND

An effective background will draw the viewer's eye to your subject and play a role in setting a mood. A background should always complement a drawing. Generally a light, neutral setting will enhance a subject with dark hair or skin, and a dark background will set off a subject with light hair or skin.

**Simplifying a Background** When working from a photo reference that features an unflattering background, you easily can change it. Simplify a background by removing any extraneous elements or altering the overall values.

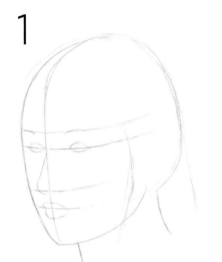

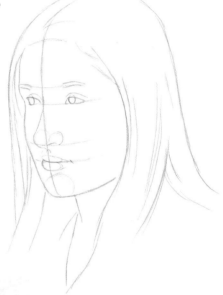

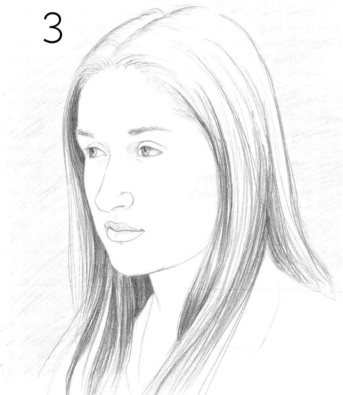

**Step One** With an HB pencil, sketch in the basic head shape and the guidelines. Then block in the position of the eyes, brows, nose, and mouth. (Notice that the center guideline is to the far left of the face because of the way the head is turned.) Next indicate the neck and the hair.

**Step Two** Switching to a 2B pencil, begin refining the shape of the eyes, brows, nose, and mouth. Block in the hair with long, sweeping strokes, curving around the face and drawing in the direction the hair grows. Add a neckline to the shirt.

**Step Three** Shade the irises with a 2B pencil. Then begin shading the background using diagonal hatching strokes. Once the background is laid in, use a 3B to build up the dark values of the hair. Note: It's best to create the background before developing the hair so your hand doesn't smear the strands of hair.

4

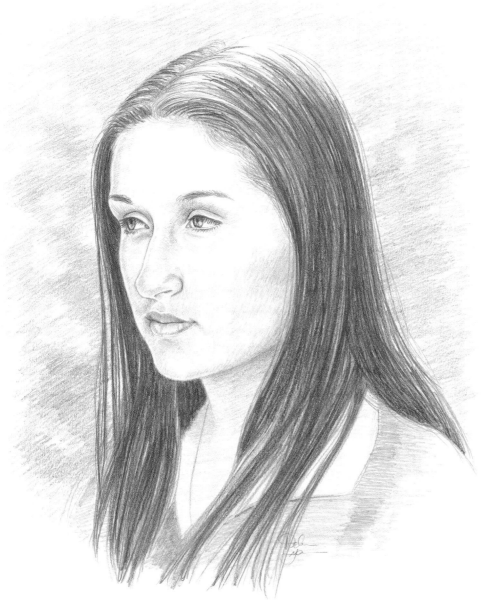

**Step Four** Finish shading the face, neck, and shirt with a 2B; switch to a 3B to add more dark streaks to the hair. Apply another layer of strokes to the background, carefully working around the hair and leaving a few gaps between the strokes to create texture and interest. Use a kneaded eraser to smooth out the transitions.

## Creating Drama

A darker background can add intensity or drama to your portrait. Here the subject is in profile, so the lightest values of her face stand out against the dark values of the background. To ensure that her dark hair does not become "lost," create a gradation from dark to light, leaving the lightest areas of the background at the top and along the edge of the hair for separation.

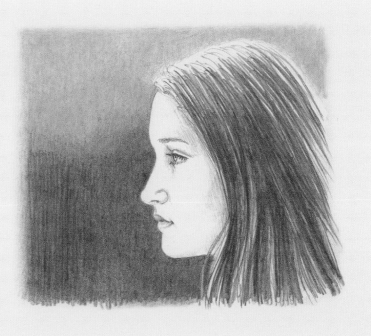

# PORTRAIT IN PROFILE

A profile view can be very dramatic. Seeing only one side of the face can bring out a subject's distinctive features, such as a protruding brow, an upturned nose, or a strong chin. Because parts of the face appear more prominent in profile, be careful not to allow any one feature to dominate the entire drawing. Take your time working out the proportions before drawing the complete portrait.

1

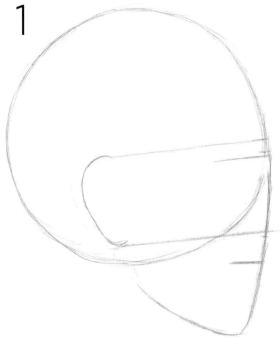

When drawing a subject in profile, be careful with proportions, as your facial guidelines will differ slightly. In a profile view, you see more of the back of the head than you do of the face, so be sure to draw the shape of the skull accordingly.

2

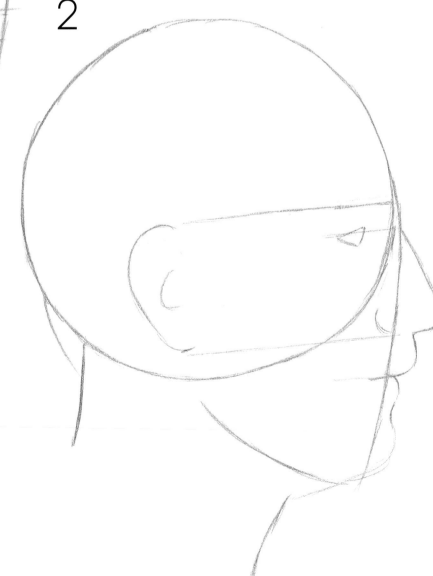

**Step One**  After lightly drawing a circle for the cranial mass, use an HB pencil to block in the general shapes of the face, chin, and jawline. Add guidelines for the eyes, nose, mouth, and ear.

**Step Two**  Following the guidelines, rough in the shapes of the features, including the slightly protruding upper lip. Sketch a small part of the eye, indicating little of the iris.

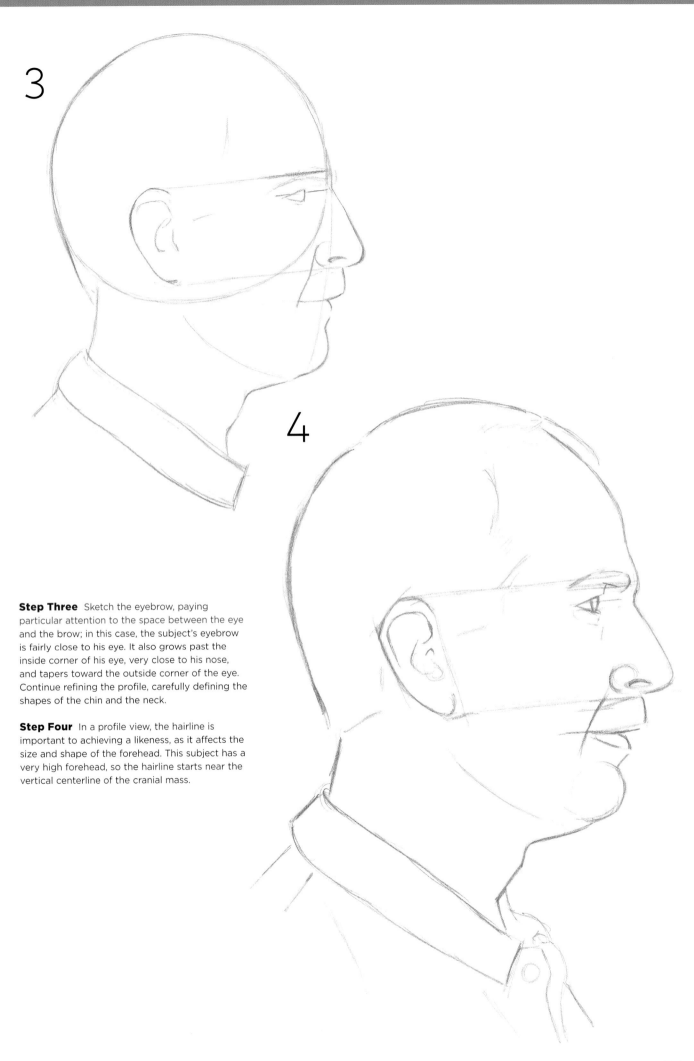

3

4

**Step Three** Sketch the eyebrow, paying particular attention to the space between the eye and the brow; in this case, the subject's eyebrow is fairly close to his eye. It also grows past the inside corner of his eye, very close to his nose, and tapers toward the outside corner of the eye. Continue refining the profile, carefully defining the shapes of the chin and the neck.

**Step Four** In a profile view, the hairline is important to achieving a likeness, as it affects the size and shape of the forehead. This subject has a very high forehead, so the hairline starts near the vertical centerline of the cranial mass.

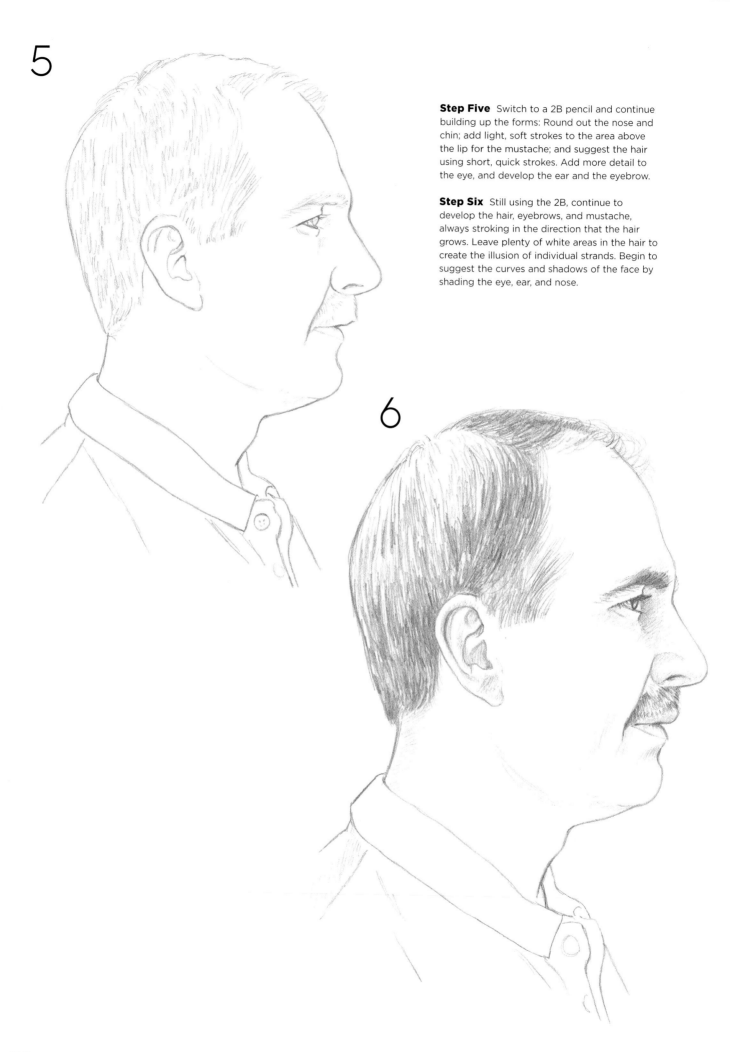

5

**Step Five** Switch to a 2B pencil and continue building up the forms: Round out the nose and chin; add light, soft strokes to the area above the lip for the mustache; and suggest the hair using short, quick strokes. Add more detail to the eye, and develop the ear and the eyebrow.

**Step Six** Still using the 2B, continue to develop the hair, eyebrows, and mustache, always stroking in the direction that the hair grows. Leave plenty of white areas in the hair to create the illusion of individual strands. Begin to suggest the curves and shadows of the face by shading the eye, ear, and nose.

6

7

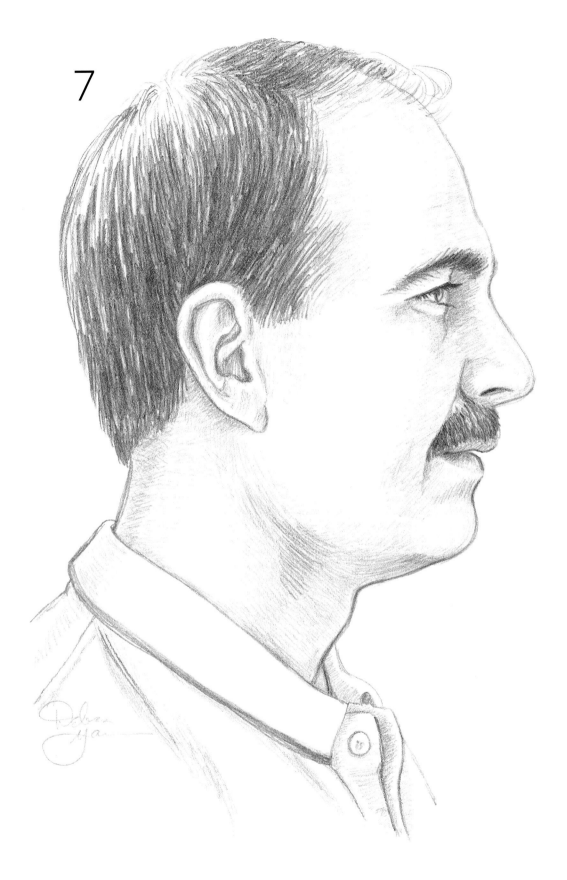

**Step Seven** Continue shading the lips, pulling out a white highlight on the bottom lip with a kneaded eraser. Shade more of the ear and add even darker values to the hair, leaving highlights on the crown of the head, as it is in the direct path of the light source. Shade the forehead, the nose, and the chin, but leave the majority of the cheek and the middle part of the forehead free of shading. This helps indicate that the light source is coming from above, angled toward the visible side of the face.

# DEVELOPING HAIR

Because hair is often one of an individual's most distinguishing features, knowing how to render different types and textures is essential. When drawing hair, don't try to draw every strand; just create the overall impression and allow the viewer's eye and imagination to fill in the rest.

1

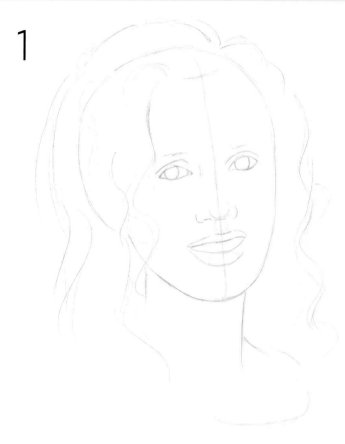

2

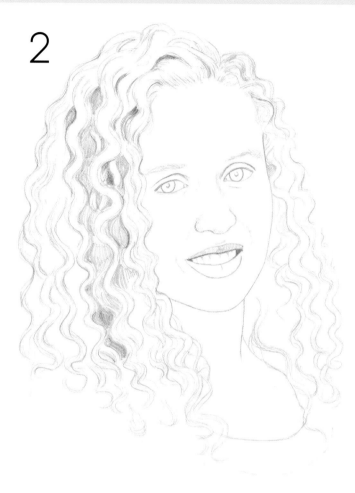

**Step One** Use an HB pencil to sketch the shape of the head and place the features. Then use loose strokes to block in the general outline of the hair. Starting at the part on the left side of the head, lightly draw the hair in the direction of growth on either side of the part. At this stage, merely indicate the shape of the hair; don't worry about the individual ringlets yet.

**Step Two** Switching to a 2B pencil, refine the eyes, eyebrows, nose, and mouth. Then define the neckline with curved lines. Returning to the hair, lightly sketch in sections of ringlets, working from top to bottom. Start adding dark values underneath and behind certain sections of hair, creating contrast and depth. (See "Creating Ringlets" below.)

## Creating Ringlets

Sketch the shapes of the ringlets using curved, S-shaped lines. Make sure that the ringlets are not too similar in shape; some are thick and some are thin.

To give the ringlets form, leave the top of the ringlets (the hair closest to the head) lighter and add a bit more shading as you move down the strands, indicating that the light is coming from above.

To create the darkest values underneath the hair, place the strokes closer together.

Add even darker values, making sure that transitions in value are smooth and that there are no abrupt changes in direction.

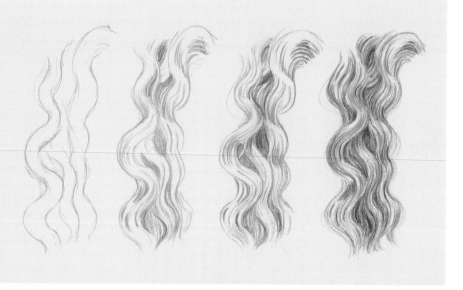

**3**

**Step Three** Shade the face, neck, and chest using linear strokes that reach across the width of the body. Define the eyes, lips, and teeth; then add her shoulder and sleeve. Continue working in darker values within the ringlets, leaving some areas of hair white to suggest blond highlights. Draw some loose strands along the edges of the hair, leaving the lightest values at the top of the subject's head.

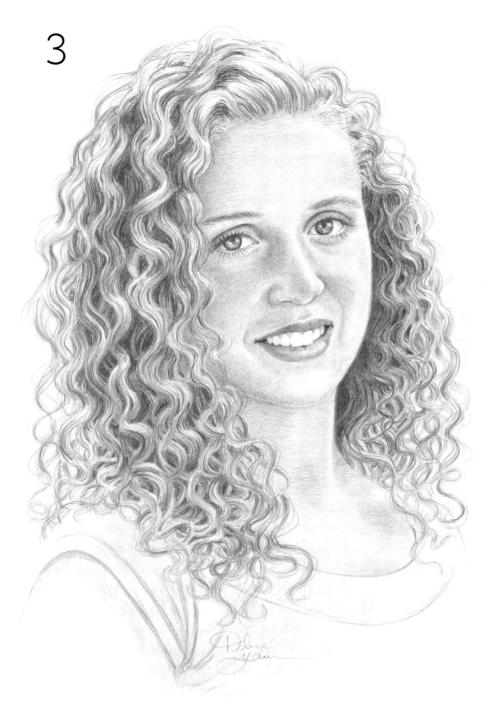

## Rendering Braids

Sketch the outline of each braid. Taper the ends a bit, adding a line across the bottom of each to indicate the ties that hold the braids together.

Start shading each section, indicating the overlapping hair in each braid. Add some wispy hair "escaping" from the braids to add realism.

Continue shading the braids using heavier strokes and add even more loose strands of hair. Use a kneaded eraser to pull out highlights at the bottom of each braid, emphasizing the ties. Then pull out some highlights in the braids themselves.

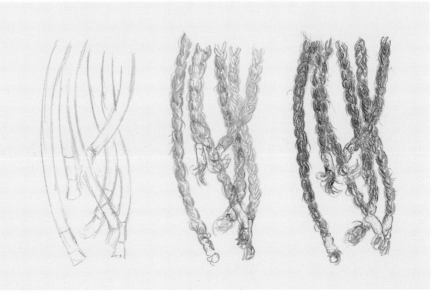

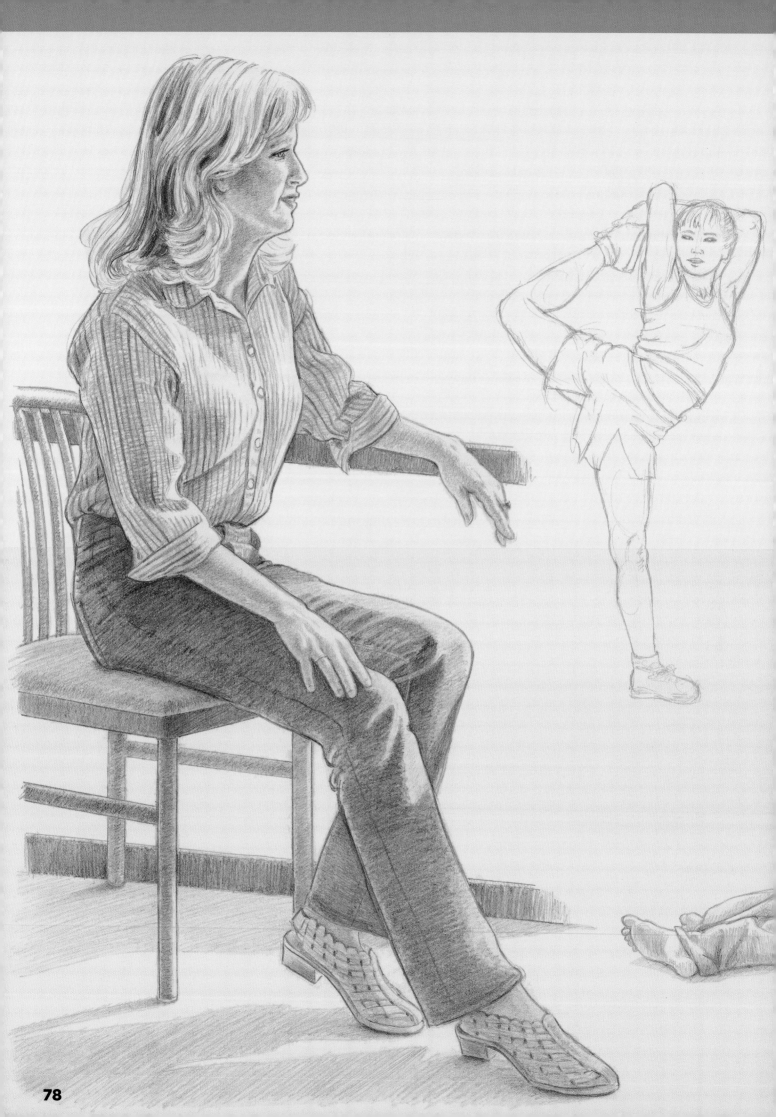

# DRAWING THE BODY

# SHOWING MOVEMENT

All the parts of the body combine to show movement of the figure. Our jointed skeleton and muscles allow us to bend and stretch into many different positions. To create drawings with realistic poses, it helps to study how a body looks and changes when stretched or flexed, as well as when sitting or standing. Begin by drawing the *line of action* (a line to indicate the curve and movement of the body) first, and then build the forms of the figure around it.

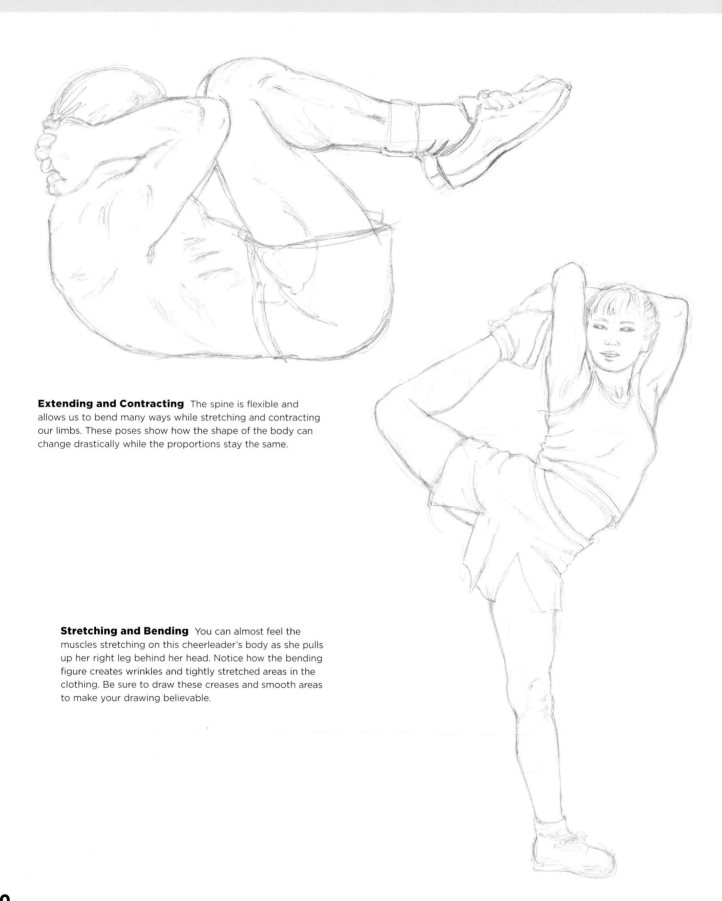

**Extending and Contracting** The spine is flexible and allows us to bend many ways while stretching and contracting our limbs. These poses show how the shape of the body can change drastically while the proportions stay the same.

**Stretching and Bending** You can almost feel the muscles stretching on this cheerleader's body as she pulls up her right leg behind her head. Notice how the bending figure creates wrinkles and tightly stretched areas in the clothing. Be sure to draw these creases and smooth areas to make your drawing believable.

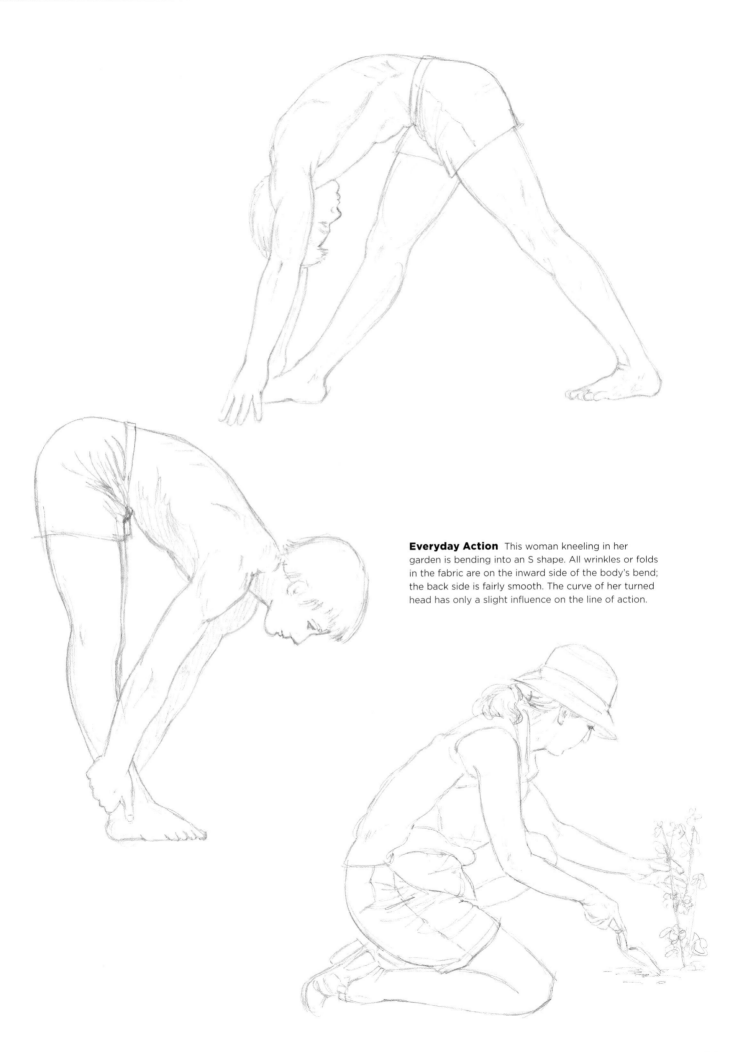

**Everyday Action**  This woman kneeling in her garden is bending into an S shape. All wrinkles or folds in the fabric are on the inward side of the body's bend; the back side is fairly smooth. The curve of her turned head has only a slight influence on the line of action.

# FORESHORTENING

To achieve realistic depth in your drawings, it's important to understand foreshortening. Foreshortening refers to the visual effect (or optical illusion) that an object is shorter than it actually is because it is angled toward the viewer—and that objects closer to the viewer appear proportionately larger than objects farther away. For example, an arm held out toward the viewer will look shorter (and the hand will look larger) than an arm held straight down by the subject's side. When using foreshortening in a drawing, be sure to draw the object the way you really see it—not the way you think it should look. Foreshortening helps create a three-dimensional effect and often provides dramatic emphasis.

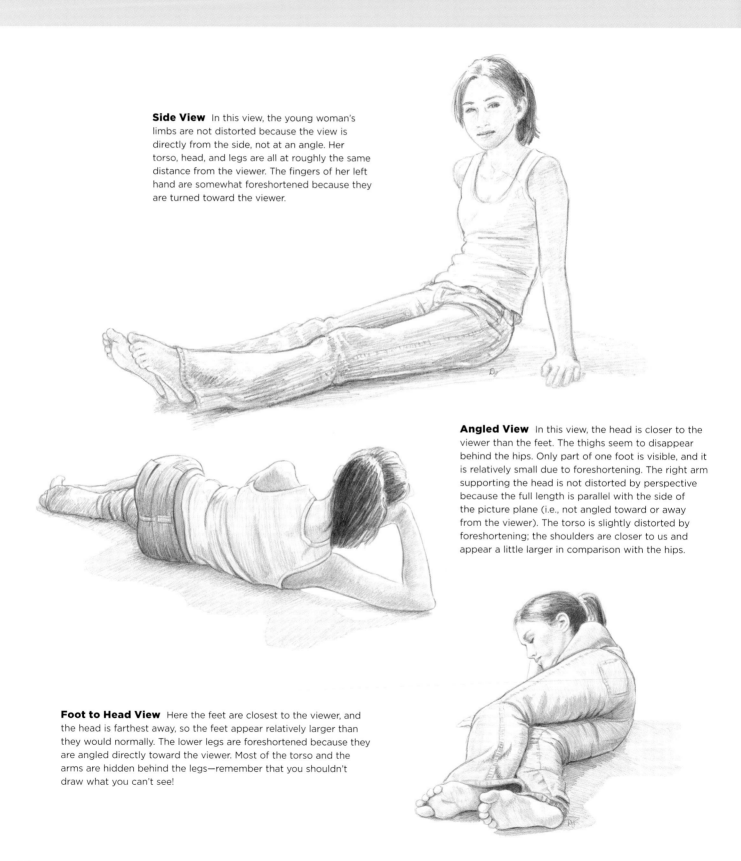

**Side View** In this view, the young woman's limbs are not distorted because the view is directly from the side, not at an angle. Her torso, head, and legs are all at roughly the same distance from the viewer. The fingers of her left hand are somewhat foreshortened because they are turned toward the viewer.

**Angled View** In this view, the head is closer to the viewer than the feet. The thighs seem to disappear behind the hips. Only part of one foot is visible, and it is relatively small due to foreshortening. The right arm supporting the head is not distorted by perspective because the full length is parallel with the side of the picture plane (i.e., not angled toward or away from the viewer). The torso is slightly distorted by foreshortening; the shoulders are closer to us and appear a little larger in comparison with the hips.

**Foot to Head View** Here the feet are closest to the viewer, and the head is farthest away, so the feet appear relatively larger than they would normally. The lower legs are foreshortened because they are angled directly toward the viewer. Most of the torso and the arms are hidden behind the legs—remember that you shouldn't draw what you can't see!

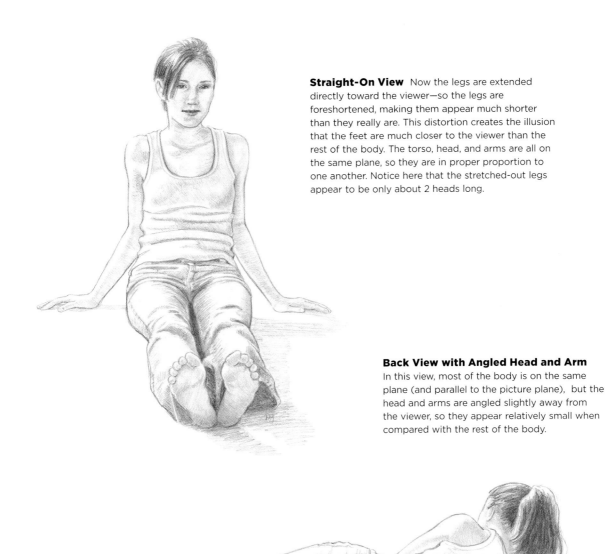

**Straight-On View** Now the legs are extended directly toward the viewer—so the legs are foreshortened, making them appear much shorter than they really are. This distortion creates the illusion that the feet are much closer to the viewer than the rest of the body. The torso, head, and arms are all on the same plane, so they are in proper proportion to one another. Notice here that the stretched-out legs appear to be only about 2 heads long.

**Back View with Angled Head and Arm** In this view, most of the body is on the same plane (and parallel to the picture plane), but the head and arms are angled slightly away from the viewer, so they appear relatively small when compared with the rest of the body.

## Focus on Fingers

When foreshortening occurs, you must forget everything you know about proportion and draw what you see instead of what you expect to see. Even something as simple as a fingertip can take on a drastically different appearance.

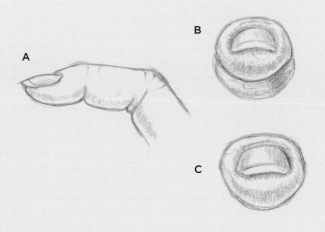

A

B

C

**Fingers** When viewing a finger from the side (A), the tip of the finger is much smaller than the knuckle. When viewed straight on (B), the tip and the knuckle appear equal in size. When the lines of the rounded fingertip and nail are shortened, both appear quite square (C). Foreshortening from this angle causes the length of the fingernail to appear quite short as well.

# HANDS

Hands are complex and involve many moveable elements, which can be a challenge to draw. Some positions of the hand are more difficult to draw than others. You may want to try posing a hand—yours or a model's—in many different positions and drawing them for practice. When sizing a hand to a figure, remember that a hand is about the same length as the face, from chin to hairline. If a hand is posed in a way that does not allow you to see all the fingers, don't be tempted to draw what you can't see or it will look unnatural.

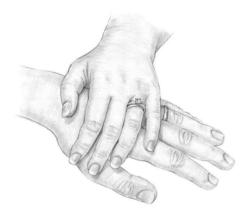

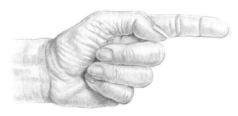

**Extended Versus Folded Fingers**
The skin at the base of the thumb shows more modeling or folds than the other fingers. This view is lit from above, so the highlights are on the tops of the fingers, and the shadows are beneath.

**Differences in Male and Female Hands**
Here the hands of a young couple clearly show how male and female hands are drawn differently. The strong lighting is from above, creating bright highlights on the back of the woman's hand.

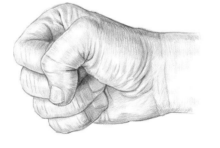

**Showing an Open Palm** An open-palm rendering could be at rest, showing us something, or reaching for something. With lighting from above, the highlights are on the tops of the fingers and palm, with the back of the hand in shadow.

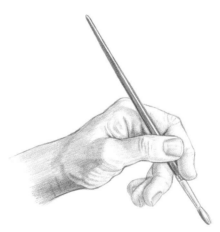

**Making a Fist** This fist could be holding something tightly or using a tool. The lighting is soft and evenly distributed from a source that is to the viewer's left.

**Holding a Pen or Brush** This hand holds a paintbrush, but the same pose could hold a pen or pencil. The strong light source from the right highlights the fingers and leaves the back of the hand and wrist shadowed.

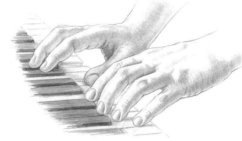

**Playing an Instrument** In this view, several of the fingers are not visible. This position could also depict reaching for something. The light here is from above, highlighting the backs of the hands.

## Hand Anatomy Bones and Muscles

Studying the bones and muscles of the hand can help you understand the form and movement of the hand. That, in turn, can help you render more successful drawings. Notice the joints of the fingers, their relationship to the other fingers, and how the bones and muscles extend from the base of the hand.

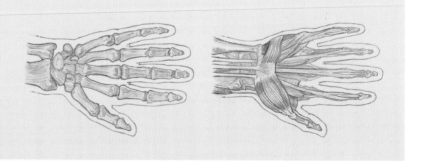

# FEET

Toes are less flexible than fingers, so feet are not as complicated to draw as hands. However, because feet have a unique structure, it is still helpful to study the bones, muscles, and tendons to help you render accurate drawings. Practice drawing feet in various views, as shown here, to build your skills.

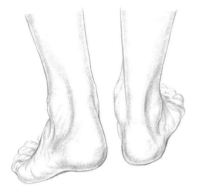

**Back View of Feet** When viewed from behind, the heel and leg bone catch the light and become one large area. Very little of the front of the feet are visible from this angle.

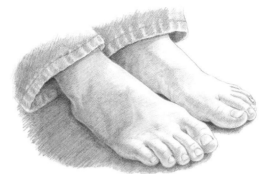

**Young Female Feet** The feet of this young girl are smooth on top because she is sitting with her feet extended in front of her. The strong lighting from above gives the tops of the feet bright highlights and casts dark shadows.

**Adult Male Feet** This man is lifting his right foot at an angle to take a step; it looks smaller than the other foot because it is farther away from the viewer. Notice how the raised foot catches the light, but the foot on the floor shows more intricate shading of light and dark areas.

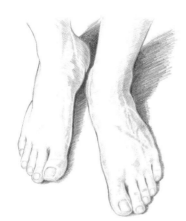

**Crossed Feet** From our viewpoint in front of this man's crossed feet, we see the entire bottom of his right foot. The left leg is crossed over the right and the foot is pointed at us, so there is severe foreshortening.

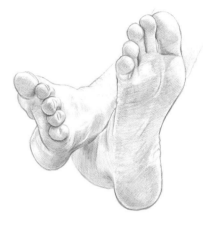

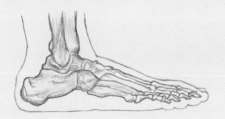

**Feet in Profile** In this view of a woman walking, her right foot is a complete side view with only the big toe showing. Her left foot is bending at the toes and pointed slightly toward us, so we can see all the toes on that foot. Notice the difference between the shape of the foot when flat as opposed to when it is bent.

## Foot Anatomy

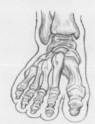

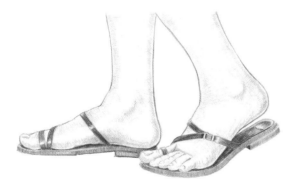

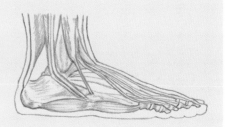

**Skeletal Structure** In this frontal view, we see that the main bones of the feet are heavier than those of the hands. The toe joints are close together, as compared with the widely separated finger joints.

**Heel and Arch Formation** Both the attachment of the leg bones at the ankle and the heavy bone that forms the heel and arch are visible in this side view of the skeletal structure of the foot.

**Muscles** The relationship between the foot and leg are easy to see in this side view of the musculature of the foot. You can follow most of the foot muscles up the leg, from which most foot movement comes.

# LIGHTING A SUBJECT

Lighting can have a dramatic effect on a figure's appearance, eliciting an emotional response and setting the mood of the drawing. Subtle lighting often is associated with tranquility and can make a subject appear soft and smooth. On the other hand, strong lighting makes it easier to see the contrasts between light and dark, which can add drama and make the subject appear more precisely formed. Longer shadows can mute the mood of a portrait, producing an air of pensiveness. Here strong shadows on the subject's face make her subtle smile seem reflective rather than content.

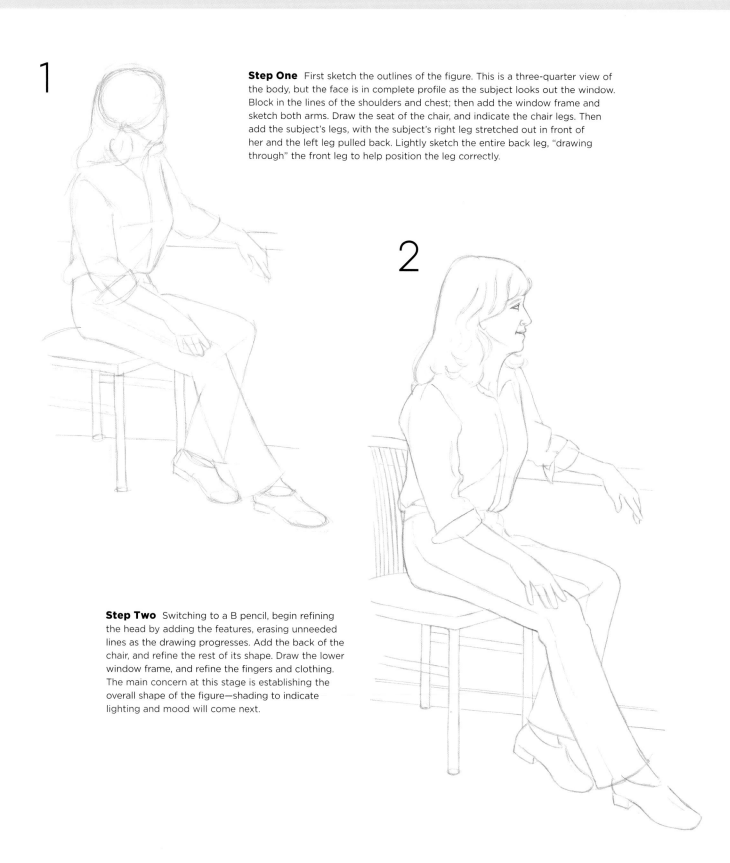

**Step One**  First sketch the outlines of the figure. This is a three-quarter view of the body, but the face is in complete profile as the subject looks out the window. Block in the lines of the shoulders and chest; then add the window frame and sketch both arms. Draw the seat of the chair, and indicate the chair legs. Then add the subject's legs, with the subject's right leg stretched out in front of her and the left leg pulled back. Lightly sketch the entire back leg, "drawing through" the front leg to help position the leg correctly.

**Step Two**  Switching to a B pencil, begin refining the head by adding the features, erasing unneeded lines as the drawing progresses. Add the back of the chair, and refine the rest of its shape. Draw the lower window frame, and refine the fingers and clothing. The main concern at this stage is establishing the overall shape of the figure—shading to indicate lighting and mood will come next.

3

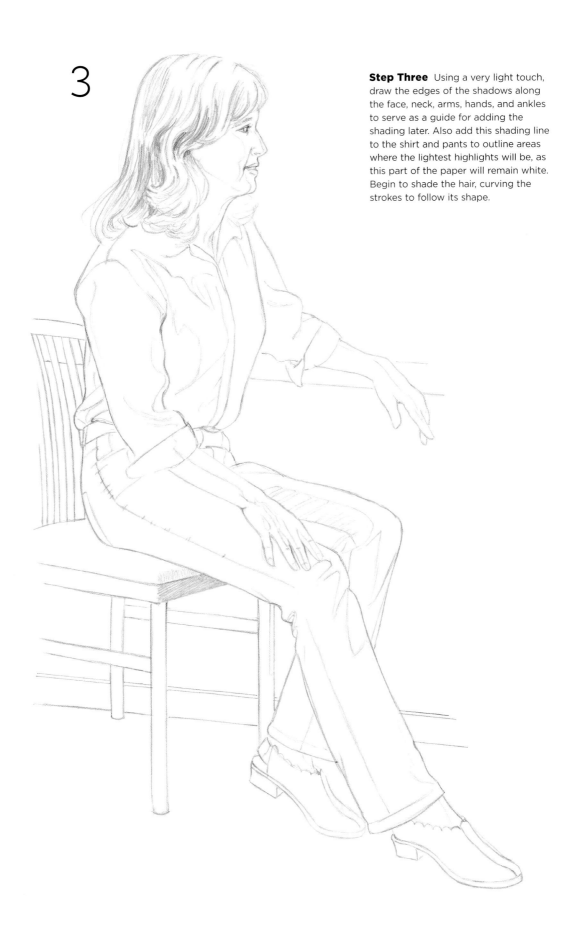

**Step Three** Using a very light touch, draw the edges of the shadows along the face, neck, arms, hands, and ankles to serve as a guide for adding the shading later. Also add this shading line to the shirt and pants to outline areas where the lightest highlights will be, as this part of the paper will remain white. Begin to shade the hair, curving the strokes to follow its shape.

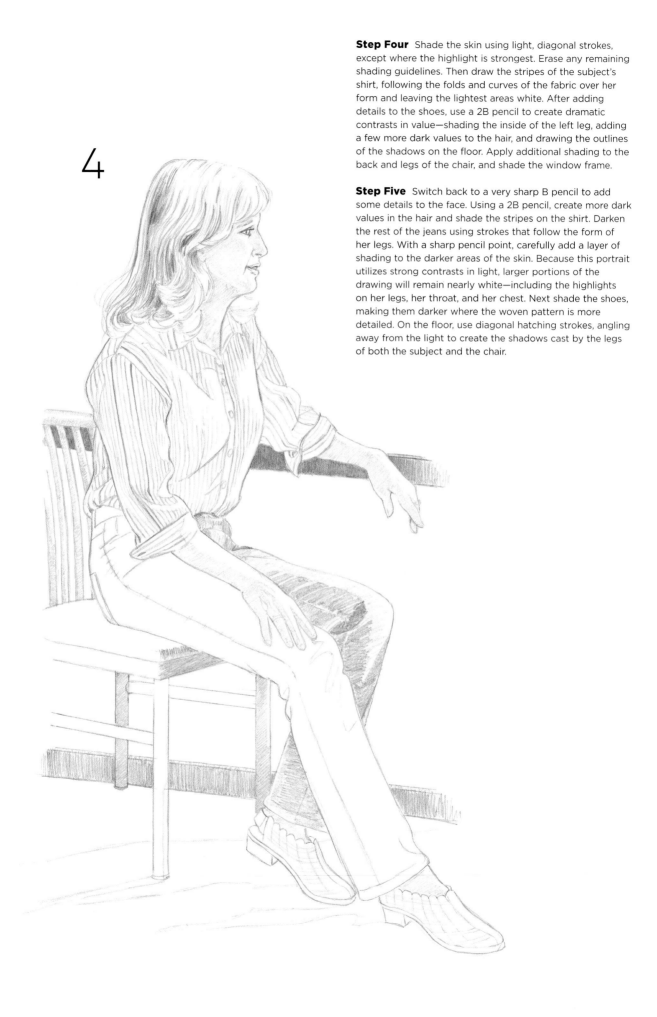

**Step Four** Shade the skin using light, diagonal strokes, except where the highlight is strongest. Erase any remaining shading guidelines. Then draw the stripes of the subject's shirt, following the folds and curves of the fabric over her form and leaving the lightest areas white. After adding details to the shoes, use a 2B pencil to create dramatic contrasts in value—shading the inside of the left leg, adding a few more dark values to the hair, and drawing the outlines of the shadows on the floor. Apply additional shading to the back and legs of the chair, and shade the window frame.

**Step Five** Switch back to a very sharp B pencil to add some details to the face. Using a 2B pencil, create more dark values in the hair and shade the stripes on the shirt. Darken the rest of the jeans using strokes that follow the form of her legs. With a sharp pencil point, carefully add a layer of shading to the darker areas of the skin. Because this portrait utilizes strong contrasts in light, larger portions of the drawing will remain nearly white—including the highlights on her legs, her throat, and her chest. Next shade the shoes, making them darker where the woven pattern is more detailed. On the floor, use diagonal hatching strokes, angling away from the light to create the shadows cast by the legs of both the subject and the chair.

5

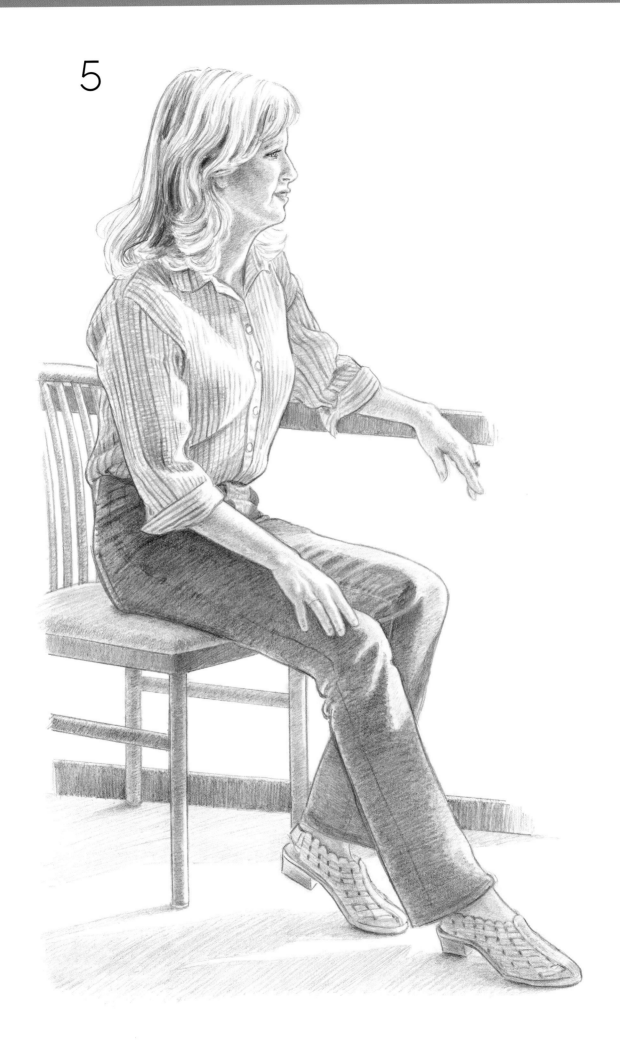

# LIFE DRAWING

Drawing from life (also called "life drawing") helps you avoid overworking your drawing because you're instead focused on quickly recording the gesture and specific details of your model before he or she moves, resulting in a spontaneous, uncomplicated finished drawing. Allow short breaks for your models (also providing you time to rest), and don't require them to smile, as this can tire out their facial muscles. Because you're working at a faster pace, drawing from life will help you learn freedom and flexibility—both of which will benefit your drawings regardless of the type of reference.

**Step One**  Using an HB pencil, lightly block in the basic shapes of the figure and the rocking chair, paying particular attention to the vertical lines and balance to make sure the figure doesn't look as if he's going to tip over in the chair. Notice that the model's back curves forward while the back of the chair angles backward, and his head aligns vertically with the back of the chair leg. Foreshorten the right leg and make the right foot larger than the left because the right leg is angled toward the viewer.

**Step Two**  Begin to refine the shapes, indicating the clothing and shoes. Then block in the mustache and beard, and place guidelines for the facial features.

**Step Three**  With a B pencil, draw in the facial features and refine the shapes of the head, including the ear, hair, and hat. Then hone the rest of the body, drawing the folds and details of the fabric and adding the fingers on the left hand. Next further develop the chair, using a ruler to create straight lines. Continue by shading the hat, the sock, the far rocker, and the model's back.

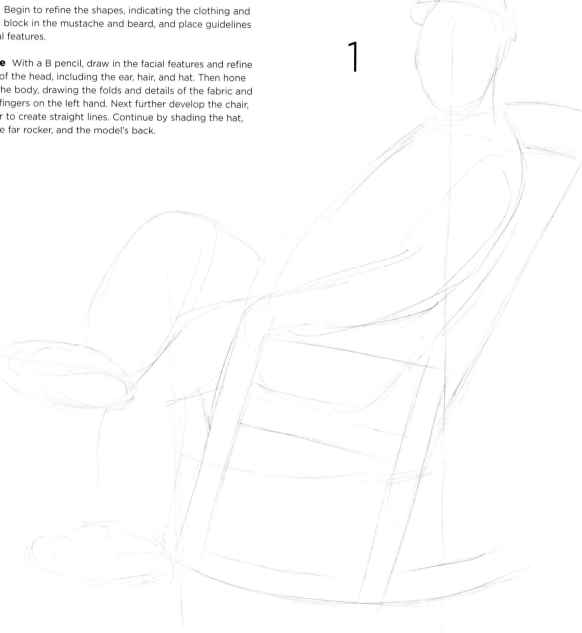

1

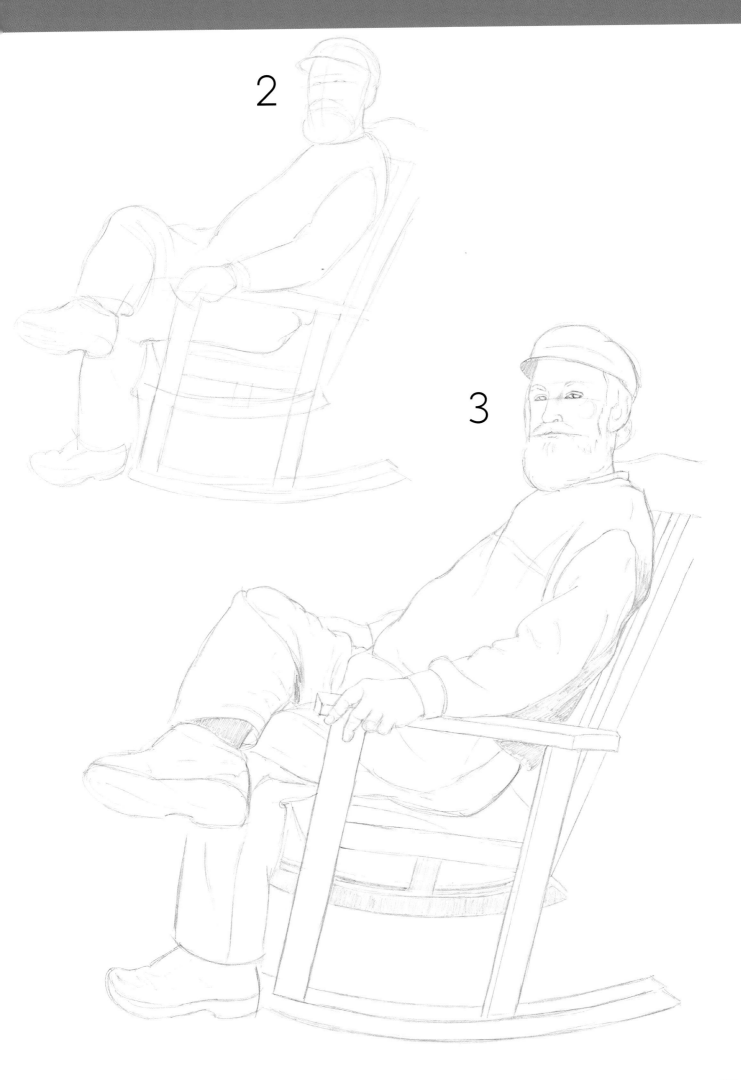

2

3

**Step Four** Using a 2B pencil, begin shading the hat, leaving the top edge and a line on the brim white. Add some detailing to the hair and beard with short strokes, following the direction of growth. Shade the clothing, leaving the areas white along the side where the light hits. Watch the shapes of the wrinkles and how they affect the lights and shadows. Also shade some of the rocker, and lightly sketch in the shapes of the cast shadows.

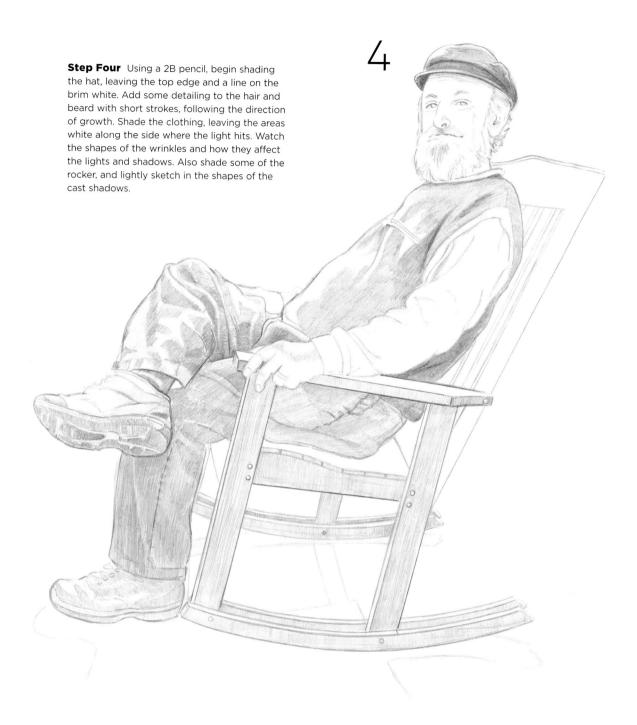

## Face Detail

To create the beard, apply very dark tone to areas of the beard, showing the gaps between groups of hair. Also leave some areas of the paper completely white to reflect the areas of the beard that are in the direct path of sunlight. When detailing the face, shade very lightly to indicate wrinkles and creases. The wrinkles should appear soft, so avoid using hard lines. To create the twinkle in the eyes, pull out a highlight in each pupil with a kneaded eraser.

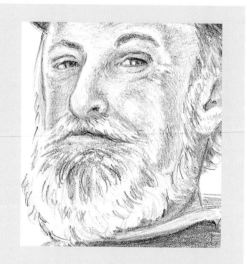

5

**Step Five**  Lightly shade the face, varying your strokes to follow the different planes. Add further details and shading to the eyes, nose, mouth, ear, hair, and facial hair. Shade the clothing and chair, always keeping in mind where the light is coming from and adjusting the lights and shadows as needed to enhance the illusion of depth. Use a 4B pencil for the darkest areas and leave the lightest areas pure white. Soften any hard edges with an eraser, a tortillon, or a tissue.

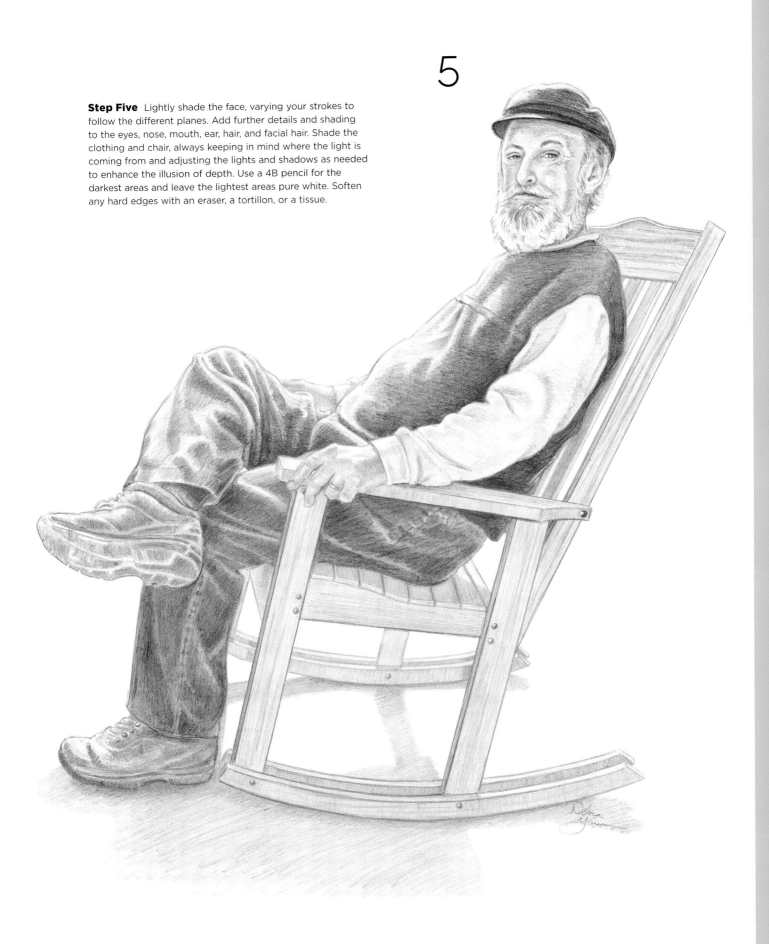

# OCCASION PORTRAIT

Special occasion photos, such as a bridal portrait, provide great references for drawing people. When drawing a bride, focus on capturing the key elements that symbolize the event, such as the veil, bouquet, and gown. The details of these objects are always unique to the particular subject, making it easy to achieve a likeness. Pay special attention to the way the gown and veil drape, the small details on the gown, the way the veil fits on the bride's head, and how her hair is styled. Finally, be sure to capture the glowing expression on her face!

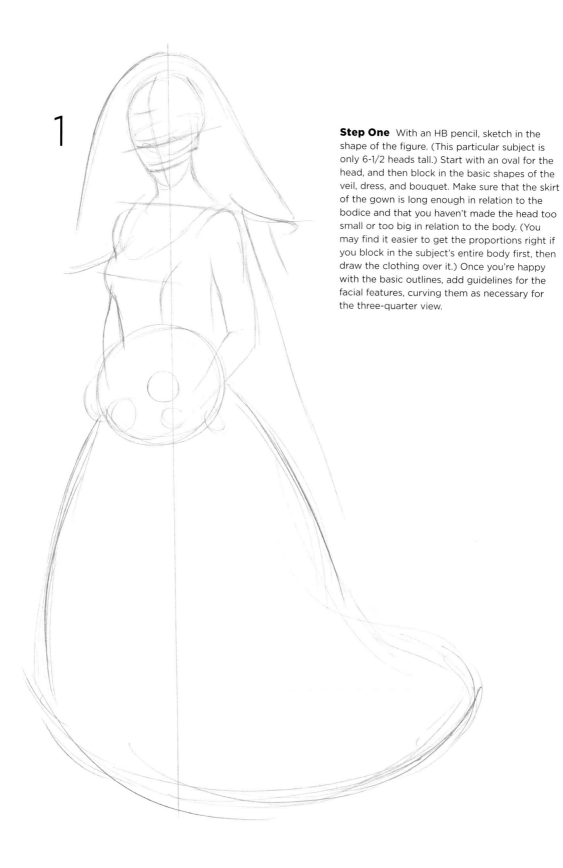

**Step One** With an HB pencil, sketch in the shape of the figure. (This particular subject is only 6-1/2 heads tall.) Start with an oval for the head, and then block in the basic shapes of the veil, dress, and bouquet. Make sure that the skirt of the gown is long enough in relation to the bodice and that you haven't made the head too small or too big in relation to the body. (You may find it easier to get the proportions right if you block in the subject's entire body first, then draw the clothing over it.) Once you're happy with the basic outlines, add guidelines for the facial features, curving them as necessary for the three-quarter view.

2

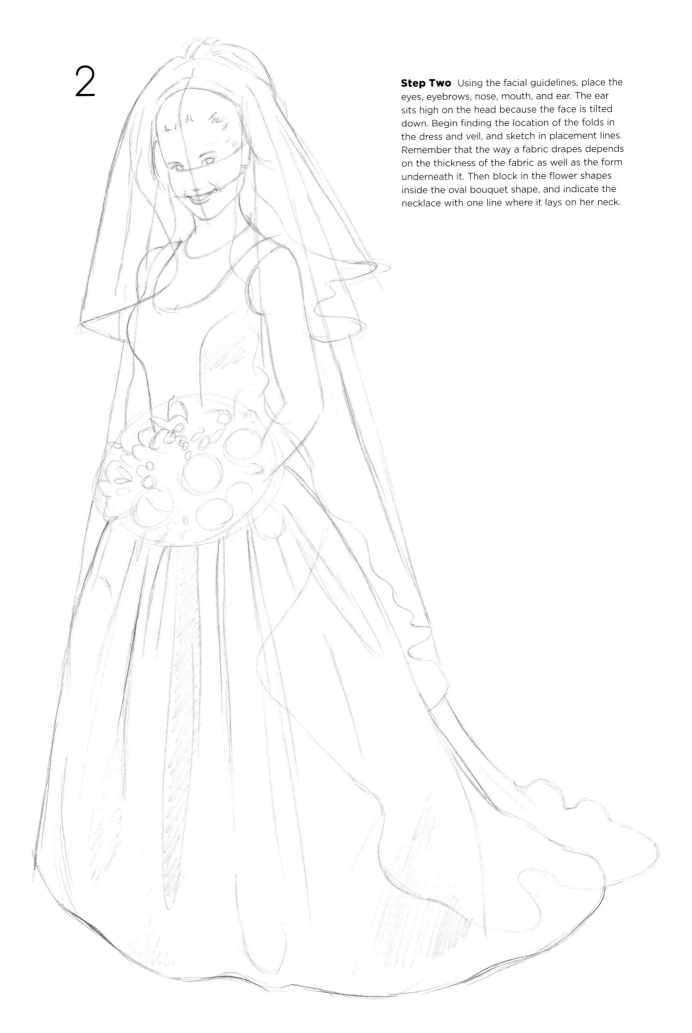

**Step Two** Using the facial guidelines, place the eyes, eyebrows, nose, mouth, and ear. The ear sits high on the head because the face is tilted down. Begin finding the location of the folds in the dress and veil, and sketch in placement lines. Remember that the way a fabric drapes depends on the thickness of the fabric as well as the form underneath it. Then block in the flower shapes inside the oval bouquet shape, and indicate the necklace with one line where it lays on her neck.

3

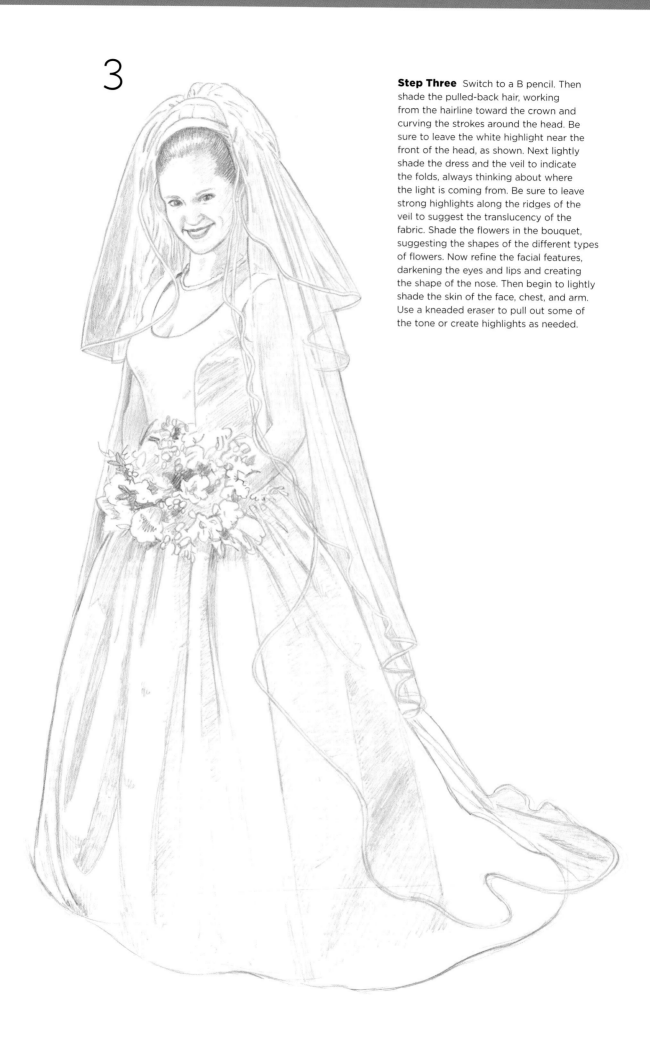

**Step Three** Switch to a B pencil. Then shade the pulled-back hair, working from the hairline toward the crown and curving the strokes around the head. Be sure to leave the white highlight near the front of the head, as shown. Next lightly shade the dress and the veil to indicate the folds, always thinking about where the light is coming from. Be sure to leave strong highlights along the ridges of the veil to suggest the translucency of the fabric. Shade the flowers in the bouquet, suggesting the shapes of the different types of flowers. Now refine the facial features, darkening the eyes and lips and creating the shape of the nose. Then begin to lightly shade the skin of the face, chest, and arm. Use a kneaded eraser to pull out some of the tone or create highlights as needed.

4

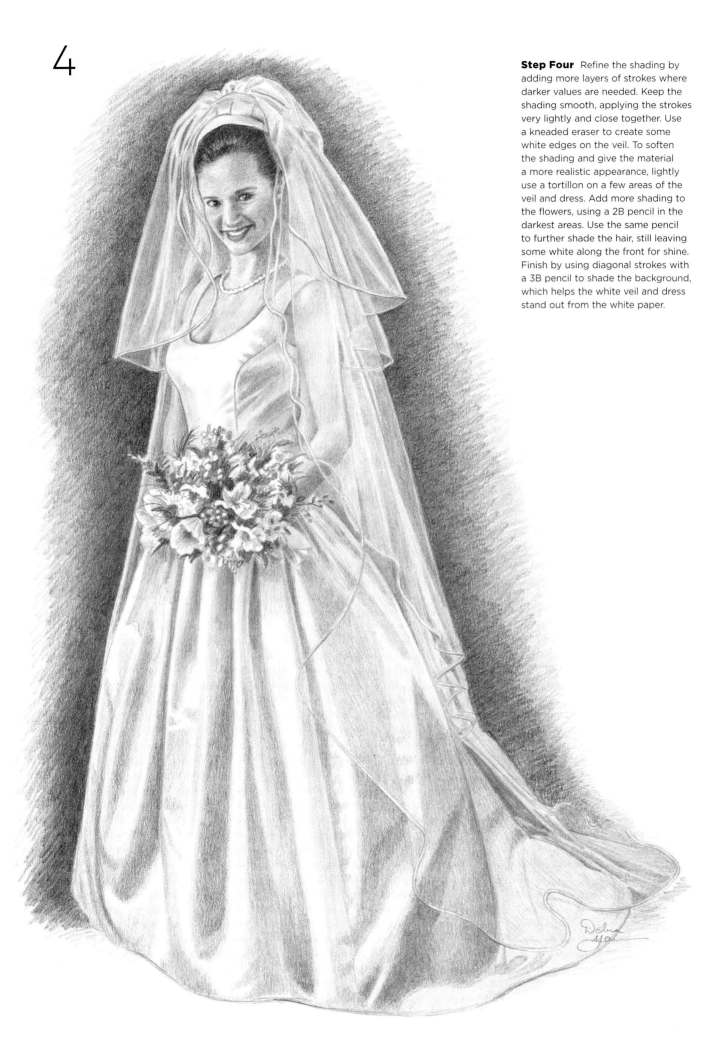

**Step Four** Refine the shading by adding more layers of strokes where darker values are needed. Keep the shading smooth, applying the strokes very lightly and close together. Use a kneaded eraser to create some white edges on the veil. To soften the shading and give the material a more realistic appearance, lightly use a tortillon on a few areas of the veil and dress. Add more shading to the flowers, using a 2B pencil in the darkest areas. Use the same pencil to further shade the hair, still leaving some white along the front for shine. Finish by using diagonal strokes with a 3B pencil to shade the background, which helps the white veil and dress stand out from the white paper.

# DRAWING CHILDREN

# CHILDREN'S FACIAL PROPORTIONS

Children's proportions are different than those of adults. Young children have rounder faces with larger eyes that are spaced farther apart. Their features also are positioned a little lower on the face; for example, the eyebrows begin on the centerline, where the eyes would be on a teenager or an adult. As a child ages, the shape of the face elongates, altering the proportions.

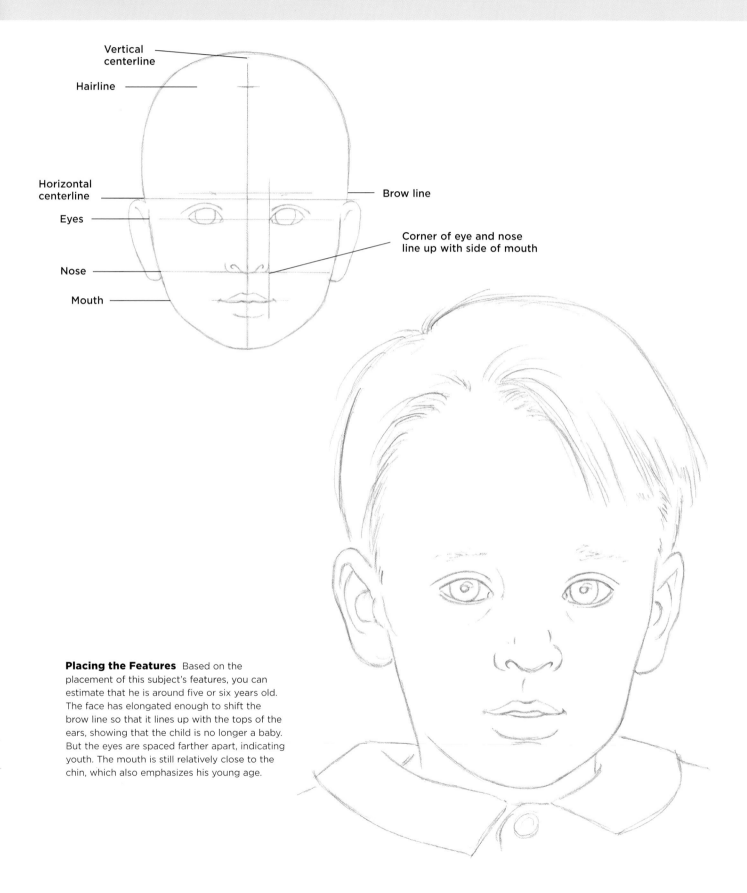

Vertical centerline

Hairline

Horizontal centerline

Eyes

Nose

Mouth

Brow line

Corner of eye and nose line up with side of mouth

**Placing the Features** Based on the placement of this subject's features, you can estimate that he is around five or six years old. The face has elongated enough to shift the brow line so that it lines up with the tops of the ears, showing that the child is no longer a baby. But the eyes are spaced farther apart, indicating youth. The mouth is still relatively close to the chin, which also emphasizes his young age.

# CHANGING OVER TIME

The placement of the features changes as the face becomes longer and thinner with age. Use horizontal guidelines to divide the area from the horizontal centerline to the chin into equal sections; these lines can then be used to determine where to the place the facial features.

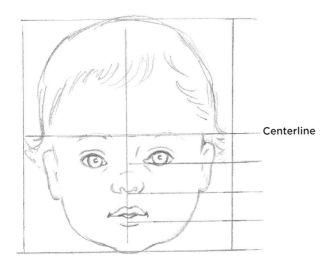

Centerline

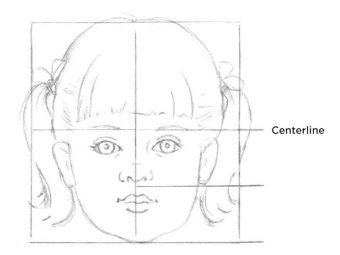

Centerline

**Drawing an Infant** A baby's head fits into a square shape, as shown here. Babies have larger foreheads than adults do, so their eyebrows (not their eyes) fall on the horizontal centerline. Their eyes are large in relation to the rest of their features because the eyes are already fully developed at birth.

**Drawing a Toddler** As a child grows, the forehead shortens a bit and the chin elongates, so the bottoms of the eyebrows now meet the horizontal centerline. The eyes are still more than one eye-width apart, but they are bit closer together than an infant's eyes are.

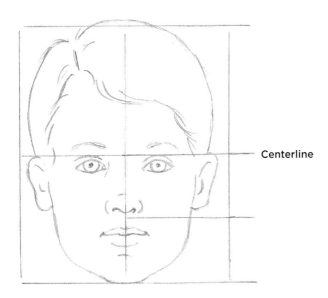

Centerline

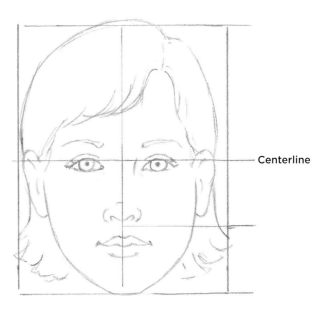

Centerline

**Drawing a Child** As a child nears seven or eight years of age, the face has lengthened and fits into more of a rectangular shape. The eyebrows are now well above the horizontal centerline and the eyes are a little closer to the centerline. The ears line up with the bottom of the nose.

**Drawing a Teenager** By age 13, the face is even longer and has lost most of its round shape; now it's more oval. The eyes are nearly at the centerline, as on an adult's face, but a teen's face and eyes are still slightly more rounded and full. The tops of the ears are about even with the eyebrows.

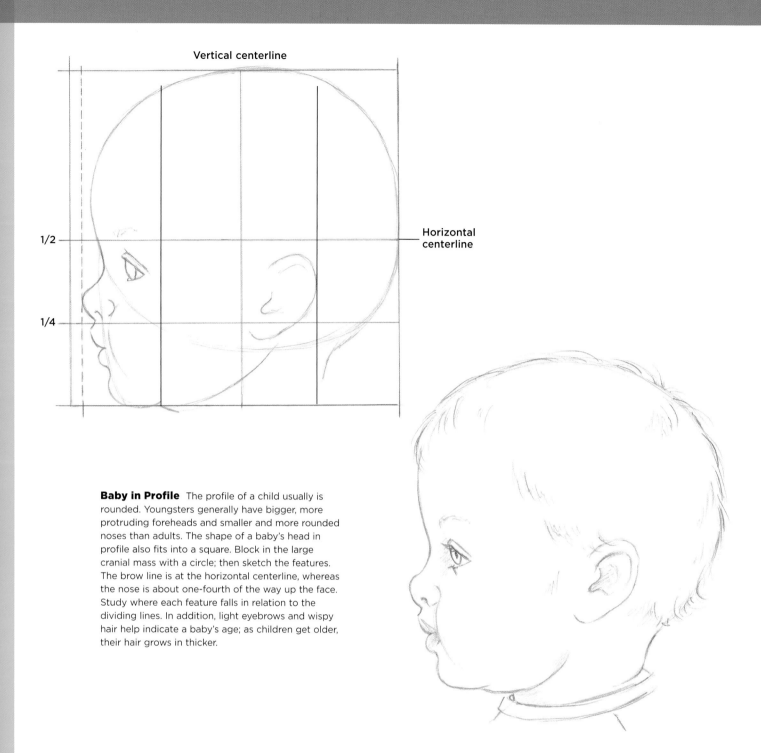

Vertical centerline

Horizontal centerline

1/2

1/4

**Baby in Profile** The profile of a child usually is rounded. Youngsters generally have bigger, more protruding foreheads and smaller and more rounded noses than adults. The shape of a baby's head in profile also fits into a square. Block in the large cranial mass with a circle; then sketch the features. The brow line is at the horizontal centerline, whereas the nose is about one-fourth of the way up the face. Study where each feature falls in relation to the dividing lines. In addition, light eyebrows and wispy hair help indicate a baby's age; as children get older, their hair grows in thicker.

## Modifying the Profile

As children age, their profiles change quite a bit.  The head elongates at each stage: The top of the baby's eyebrow lines up with the bottom of the toddler's eyebrow, the midway-point between the young boy's eyebrow and eyelid, and the top of the teenage girl's eyelid.

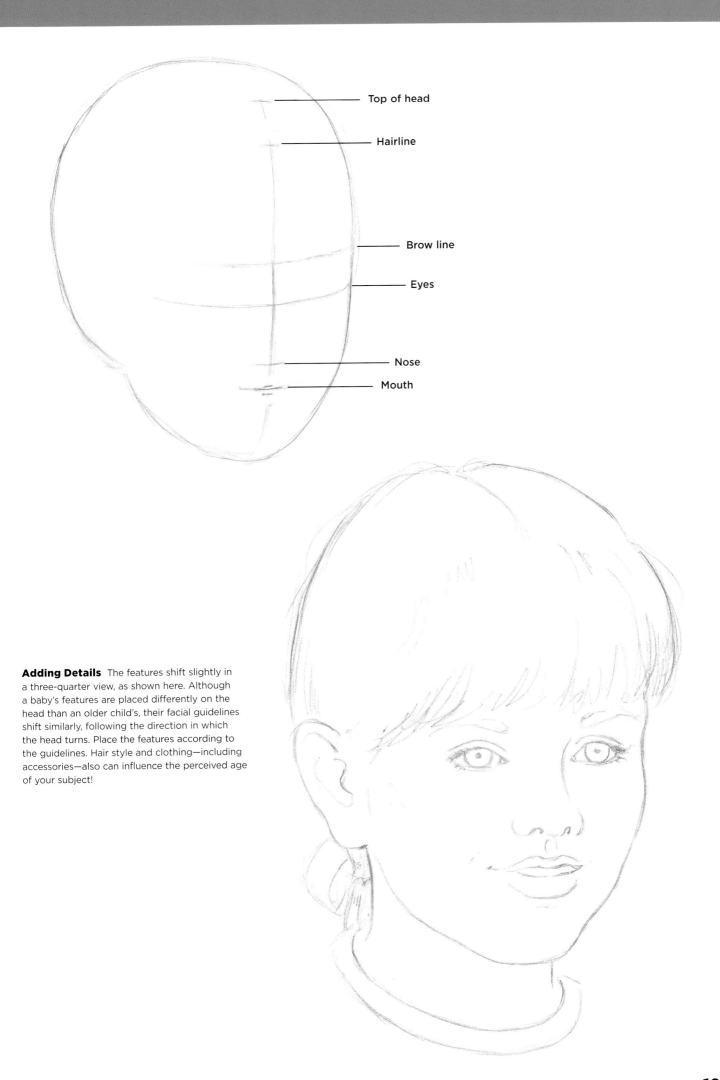

Top of head

Hairline

Brow line

Eyes

Nose

Mouth

**Adding Details** The features shift slightly in a three-quarter view, as shown here. Although a baby's features are placed differently on the head than an older child's, their facial guidelines shift similarly, following the direction in which the head turns. Place the features according to the guidelines. Hair style and clothing—including accessories—also can influence the perceived age of your subject!

# PORTRAYING CHILDREN'S FEATURES

Children are fascinating drawing subjects, but they can be a challenge to draw accurately. It's important to get the right proportions for the particular age and to correctly render their features. Their eyes tend to be bigger and more rounded than those of adults, their nostrils are barely visible, and their hair is usually fine and wispy.

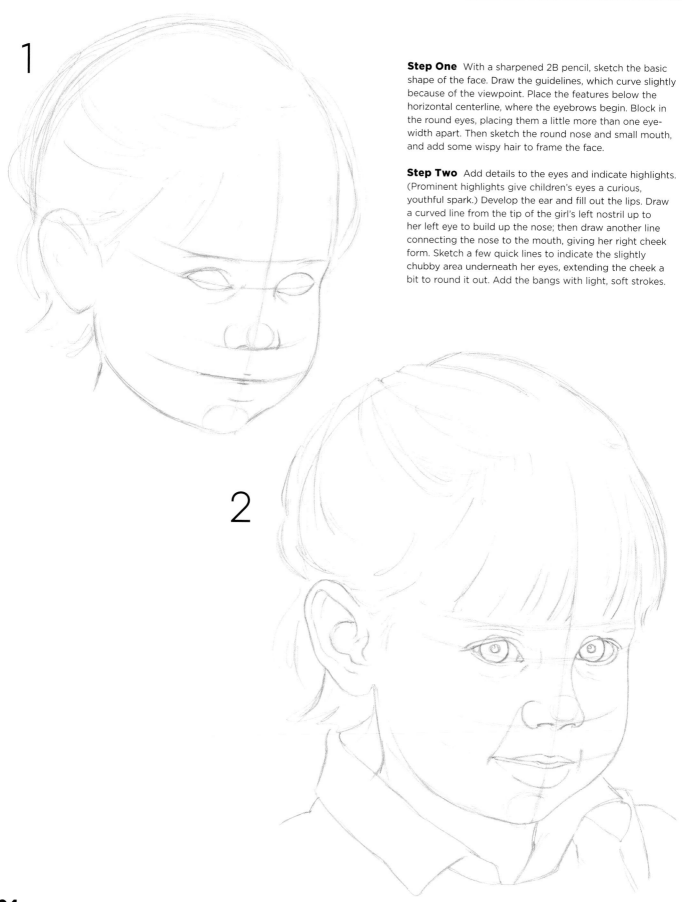

**Step One**  With a sharpened 2B pencil, sketch the basic shape of the face. Draw the guidelines, which curve slightly because of the viewpoint. Place the features below the horizontal centerline, where the eyebrows begin. Block in the round eyes, placing them a little more than one eye-width apart. Then sketch the round nose and small mouth, and add some wispy hair to frame the face.

**Step Two**  Add details to the eyes and indicate highlights. (Prominent highlights give children's eyes a curious, youthful spark.) Develop the ear and fill out the lips. Draw a curved line from the tip of the girl's left nostril up to her left eye to build up the nose; then draw another line connecting the nose to the mouth, giving her right cheek form. Sketch a few quick lines to indicate the slightly chubby area underneath her eyes, extending the cheek a bit to round it out. Add the bangs with light, soft strokes.

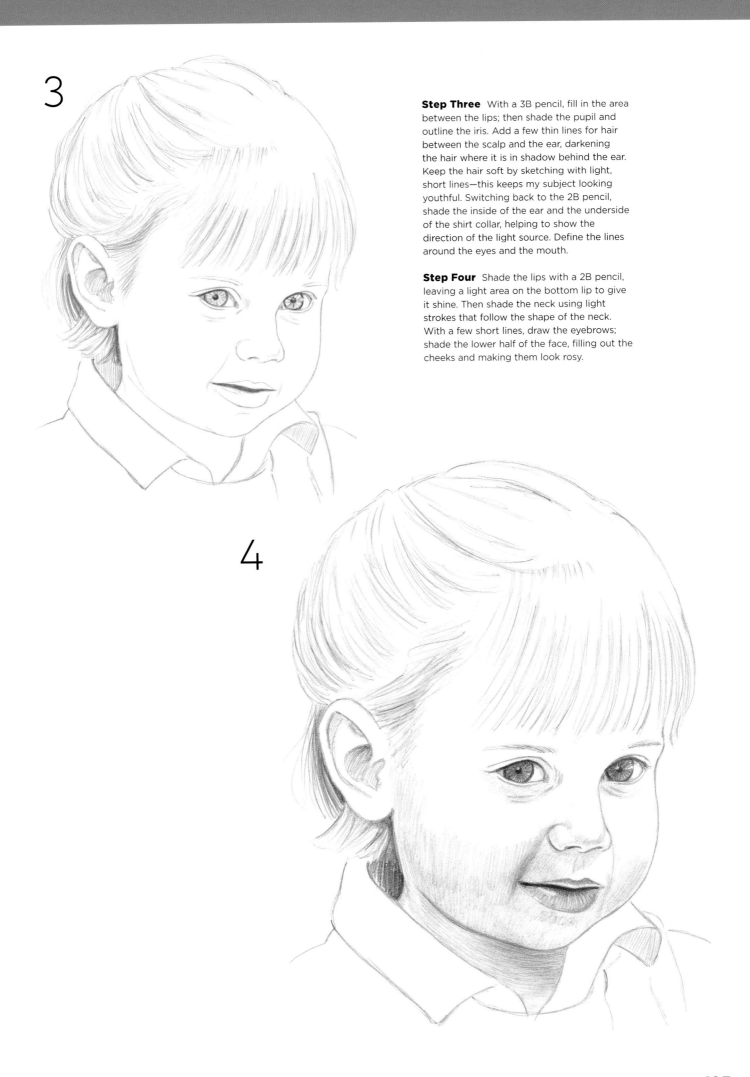

**3**

**Step Three** With a 3B pencil, fill in the area between the lips; then shade the pupil and outline the iris. Add a few thin lines for hair between the scalp and the ear, darkening the hair where it is in shadow behind the ear. Keep the hair soft by sketching with light, short lines—this keeps my subject looking youthful. Switching back to the 2B pencil, shade the inside of the ear and the underside of the shirt collar, helping to show the direction of the light source. Define the lines around the eyes and the mouth.

**Step Four** Shade the lips with a 2B pencil, leaving a light area on the bottom lip to give it shine. Then shade the neck using light strokes that follow the shape of the neck. With a few short lines, draw the eyebrows; shade the lower half of the face, filling out the cheeks and making them look rosy.

**4**

**5**

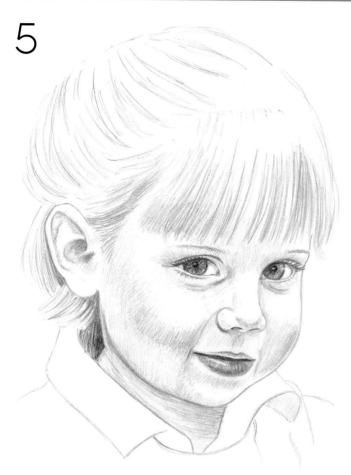

**Step Five** Over each eyelid, sketch a series of small lines curving up to the eyebrows to show the youthful chubbiness. Add eyelashes using curved pencil strokes. To keep the subject looking young, draw very light, almost nonexistent eyebrows. Shade the forehead in an up-and-down motion, and then give her right cheek more form by darkening the areas around it. Use sweeping strokes to build up the bangs, leaving the paper white in areas for a shiny look.

**Step Six** Still using the 2B pencil, build up the ear. Shade a small area between the bottom of the nose and the top of the lips to suggest the indentation, and add shading to the creases around the mouth. Create more dark strokes in the back of the hair to show where the hair is layered. Then draw a flower pattern on the shirt collar. Adding youthful patterns to your subject's clothing helps define their age.

**6**

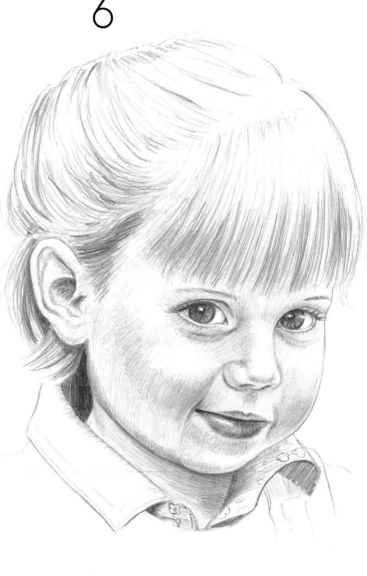

## Drawing from a Different Angle

Because of the way this young girl's head is tilted back, you see more of her chin and neck than you do the top of her head. The ears appear a bit lower on the head, and you see more of the bottom parts of her eyes. Even when drawing children from a different angle, the features remain rounded and childlike; for example, you can still get a sense of this girl's wide-eyed, curious expression, although you see less of the eyes than you would in a forward-facing view. And although the nostrils are a little more prominent in this view, they still retain their soft, smooth shape.

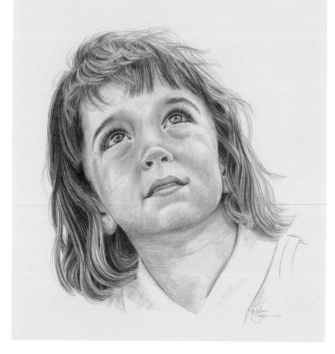

7

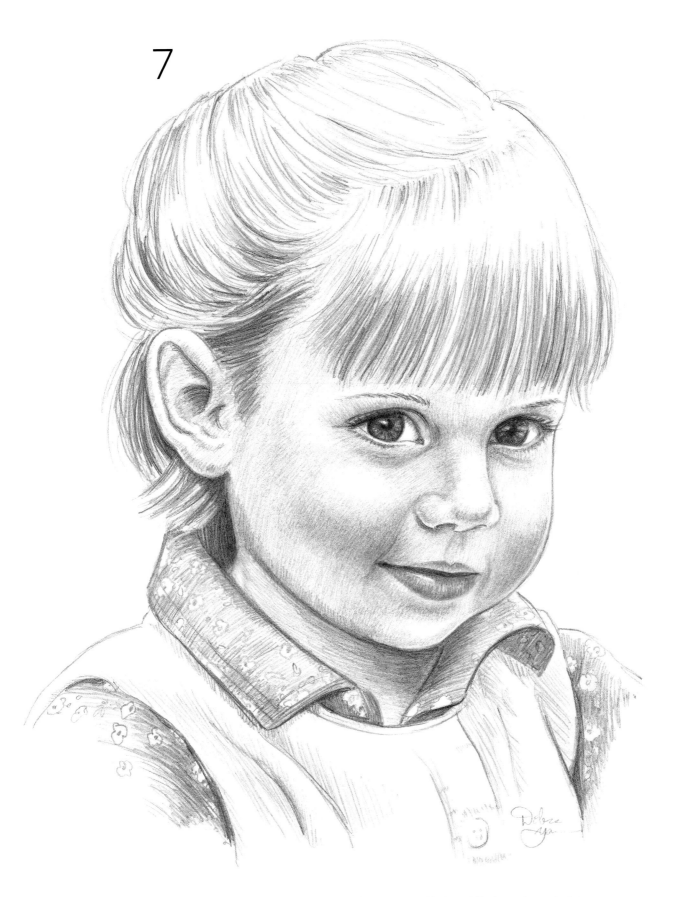

**Step Seven** Carefully drag the edge of a kneaded eraser across the top of the bangs to create the appearance of blond hair. Using the 3B pencil, create texture on the jumper and shirt by spacing the lines of the corduroy slightly apart from one another. Develop the floral pattern on the sleeves of her shirt and draw a small button. Stand back from the portrait and make sure the transitions from light to dark values are smooth and that there are no harsh or angular lines that might make the subject appear older than she is.

# CHOOSING A PHOTO REFERENCE

If you're using a photograph as a reference while you draw, it's usually best to have several different photographs from varying angles and with different light sources to choose from. Not only does this give you a wider selection of poses and lighting options, it also allows you to combine different elements from each photograph. For example, if you are satisfied with the lighting in one photograph but you're drawn to the facial expression in another, you can combine the best parts from each for your portrait.

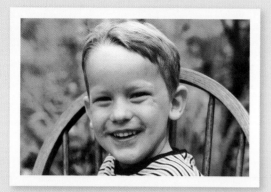

A

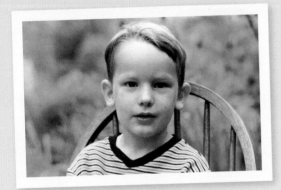

B

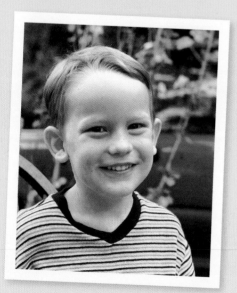

C

**Finding the Best Pose** In photo A, the subject's eyes are squinting a tad too much. In photo B, the subject's pose seems stiff and stilted. But in photo C, his pose and expression are natural and relaxed.

1

**Step One** Block in the outline of the face, the guidelines, and the features.

**Step Two** Continue to sketch the details.

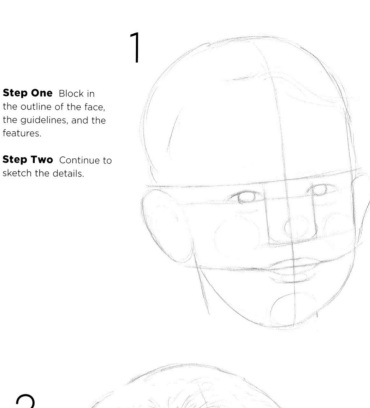

2

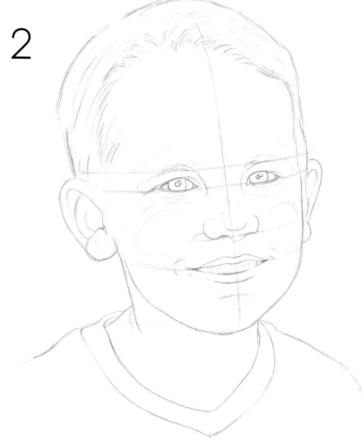

**Step Three** Erase old guidelines, and then use a 2B pencil to add details to the eyes and eyebrows. Next shade the lips and cheeks. The light source is coming from above, so leave the lightest areas at the top of the head and create the darkest values on the bottom half of the face and neck.

**Step Four** Darken the hair by firmly shading with a 2B. Continue evenly shading the face and the neck; then add a few light freckles with the tip of the pencil. Darken the inside of the mouth to give the teeth form and add detail to the shirt by stroking on horizontal stripes and shading the neckband.

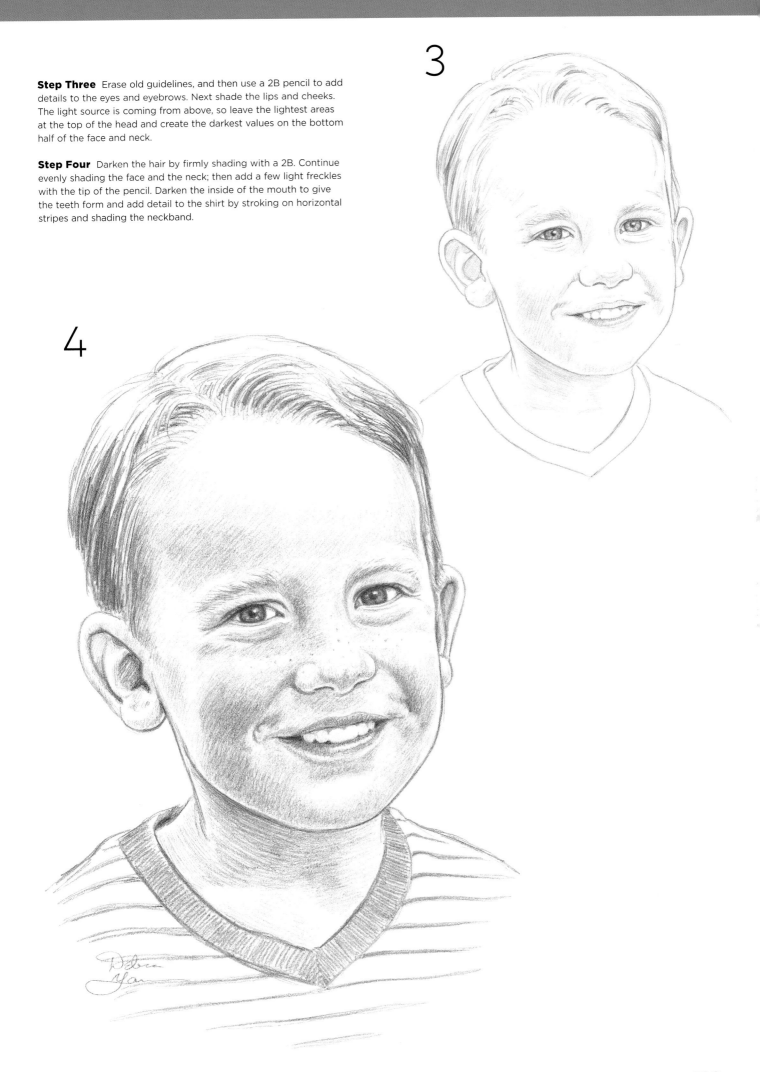

# DRAWING A BABY

Drawing babies can be tricky because it's easy to unintentionally make them look older than they are. The face gets longer in proportion to the cranium with age, so the younger the child, the lower the eyes are on the face (and thus, the larger the forehead). In addition, babies' eyes are disproportionately large in comparison to the rest of their bodies—so draw them this way!

1

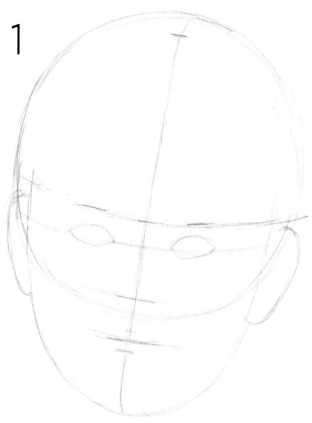

2

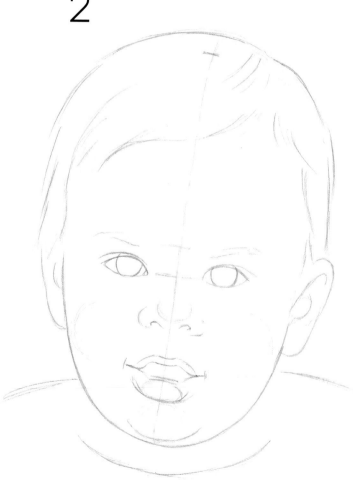

**Step One** Using an HB pencil, block in the cranial mass and the facial guidelines. The head is tilted downward and turned slightly to the left, so adjust the guidelines accordingly. Place the eyebrows at the horizontal centerline and the eyes in the lower half of the face.

**Step Two** Create the fine hair using soft, short strokes and a B pencil. Draw the open mouth with the bottom lip resting against the chin. Then add large irises that take up most of the eyes and suggest the small nose. Draw a curved line under the chin to suggest chubbiness; then indicate the shoulders, omitting the neck.

3

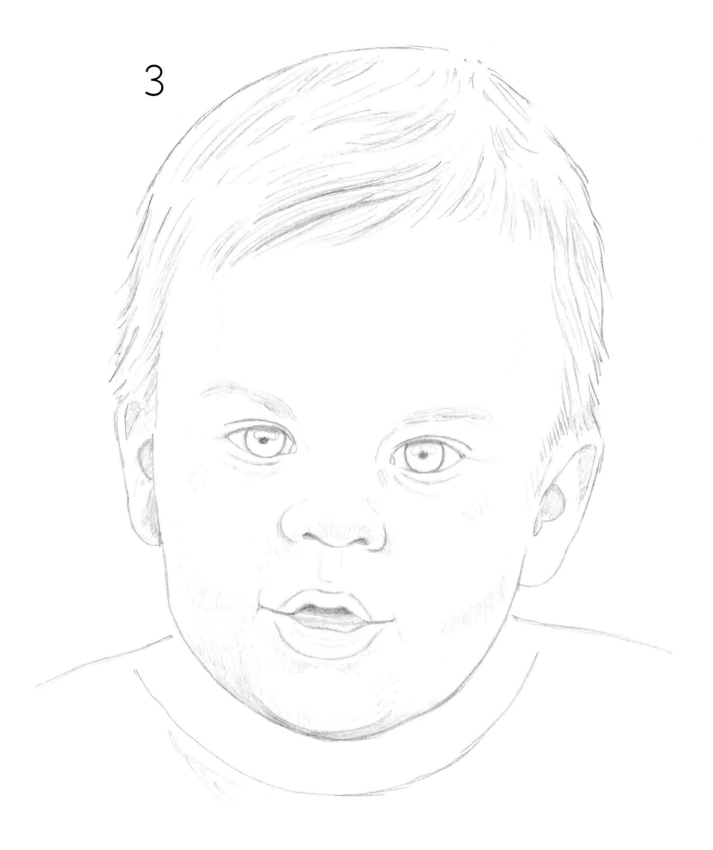

**Step Three** Erase old guidelines as you draw. Add pupils and highlights to the eyes with a B pencil. Lightly sketch more of the hair and eyebrows; then shade under the chin to give it form. Shade inside the ears. Then connect and refine the lips, shading the upturned corners to suggest the pudgy mouth. Shade the inside of the mouth, showing that there aren't any teeth; then define the neckline of the shirt.

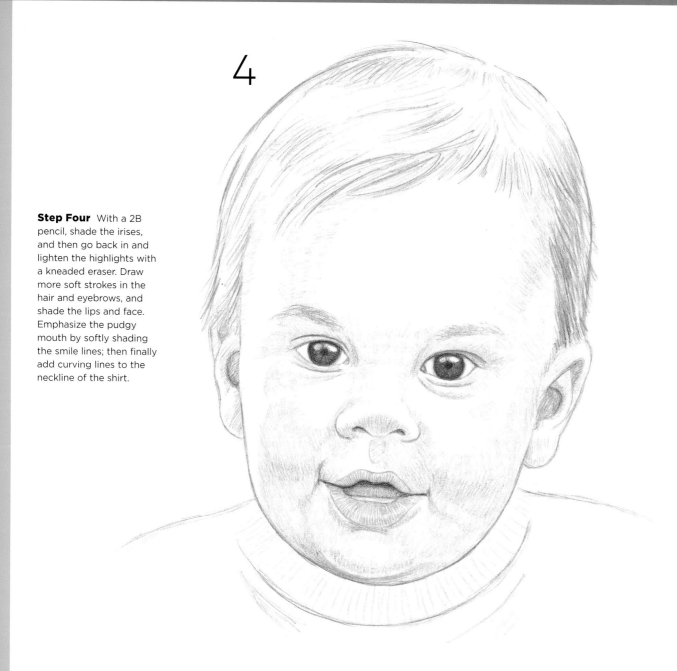

**Step Four** With a 2B pencil, shade the irises, and then go back in and lighten the highlights with a kneaded eraser. Draw more soft strokes in the hair and eyebrows, and shade the lips and face. Emphasize the pudgy mouth by softly shading the smile lines; then finally add curving lines to the neckline of the shirt.

## Drawing a Baby's Features

Babies often have wide-eyed, curious expressions. Try curving the eyebrows upward to create the appearance of childlike curiosity; pull out highlights in each eye to add life and interest to your drawing. A baby's lips have a soft, pudgy appearance, and the mouth usually is not as wide as an adult's. Adding highlights is important to convey a smooth texture, and creating creases at the corners of the mouth will help indicate youthful chubbiness.

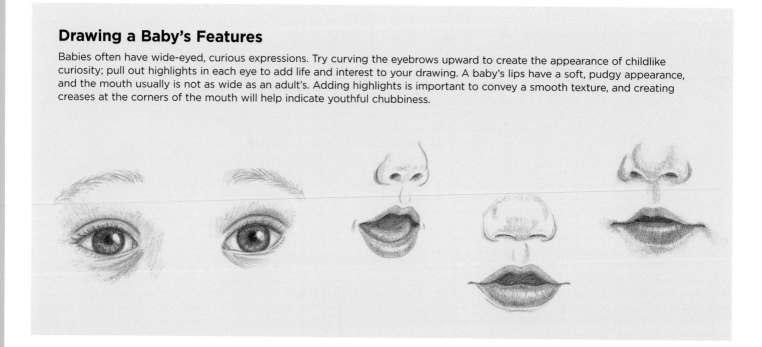

5

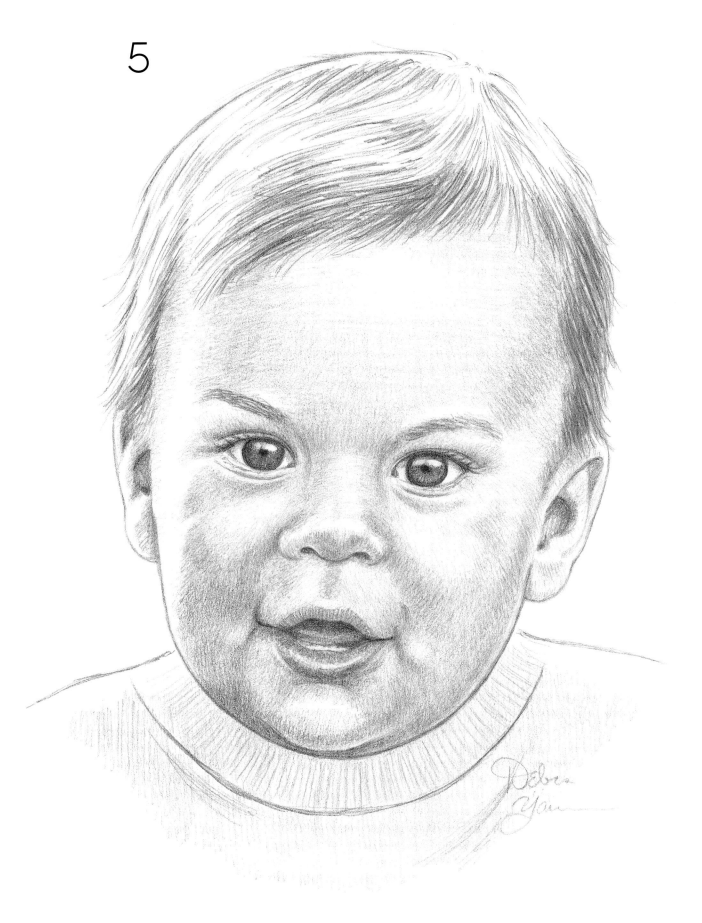

**Step Five** Continue shading the face, and then add another light layer of shading to the lips. Use the end of a kneaded eraser to pull out a highlight on the bottom lip. Then draw some very light eyelashes. Create darker values in the hair and eyebrows and round out the outline of the face. Lightly shade the shirt. Use a tortillon to softly blend transitions to make the complexion baby smooth.

# CAPTURING DETAILS

When drawing a subject with a fair complexion, keep your shading to a minimum; apply just enough medium and dark values to create the illusion of form. Outline the general shape, adding a few carefully placed strokes to suggest the hairstyle and create some dimension.

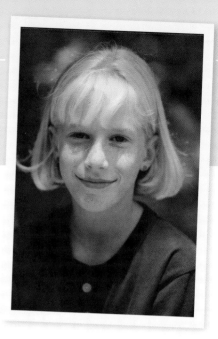

**Shading Fair Skin and Hair**
In this photo, the overhead light makes the bangs, nose, and cheeks look nearly pure white.

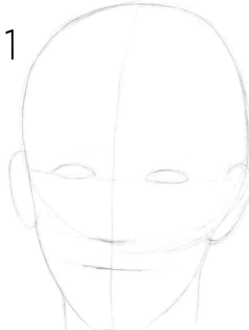

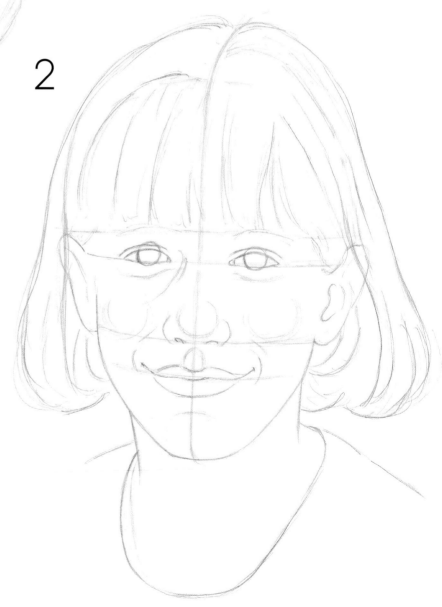

**Step One** Lay out the face with an HB pencil. The face is slightly tilted to the subject's left, so shift the vertical centerline to the left a bit. Lightly place the eyes, nose, mouth, and ears; then block in the neck.

**Step Two** Switching to a 2B pencil, develop the features.

3

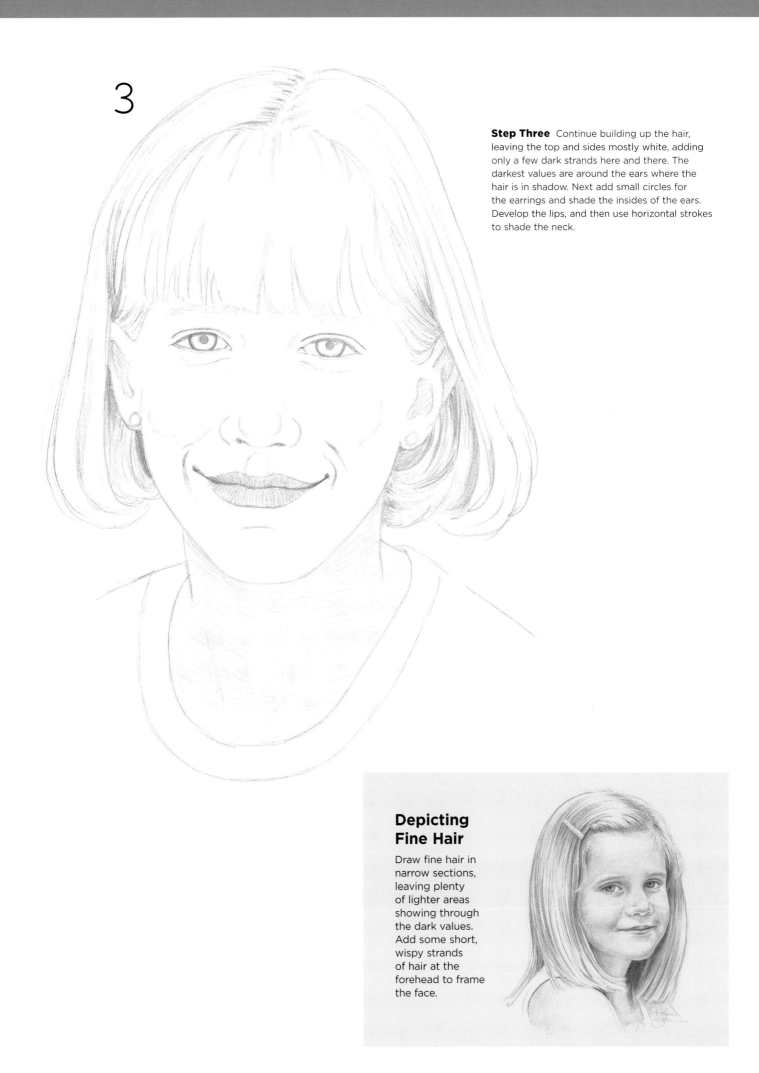

**Step Three** Continue building up the hair, leaving the top and sides mostly white, adding only a few dark strands here and there. The darkest values are around the ears where the hair is in shadow. Next add small circles for the earrings and shade the insides of the ears. Develop the lips, and then use horizontal strokes to shade the neck.

## Depicting Fine Hair

Draw fine hair in narrow sections, leaving plenty of lighter areas showing through the dark values. Add some short, wispy strands of hair at the forehead to frame the face.

**Step Four** Shade the face with light, soft strokes to depict the subject's skin. Make short, quick strokes for the eyebrows, keeping them light and soft to indicate blond hair. Next shade the irises using strokes that radiate out from the pupil. Add some hatching strokes to the neckband of the shirt.

4

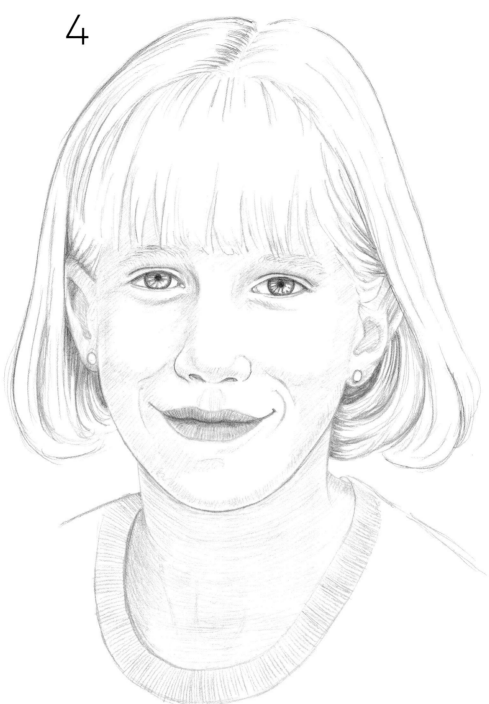

## Creating Realistic Freckles

To draw freckles, space them sporadically, in varying sizes and distances from one other. You don't have to replicate every freckle on your subject's face—just draw the general shapes and let the viewer's eye fill in the rest.

**What to Do** Make sure some of the freckles overlap, and make some light and some dark by varying the pressure you place on the pencil.

**What Not to Do** When drawing freckles, do not space them too evenly or make them equal in size, as shown here. These freckles look more like polka dots!

5

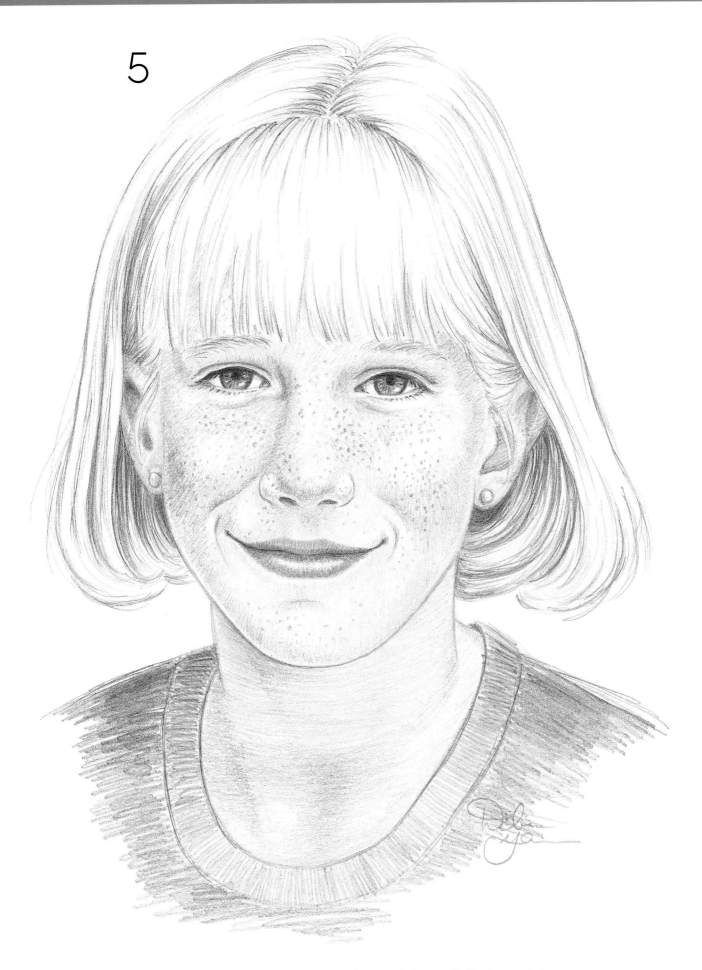

**Step Five** Using a kneaded eraser, pull out a highlight on the bottom lip. Create more dark strands of hair and further develop the eyes and eyebrows. Add freckles, making sure that they vary in size and shape. Finally, shade the shirt, using relatively dark strokes.

# ESTABLISHING VALUES

When shading a portrait, vary the direction of your pencil strokes to follow the different planes of the face. Darken shadowed areas and leave highlights light to make the face appear three-dimensional. Pay attention to the value of the skin tone and how it compares with the values of other facial features.

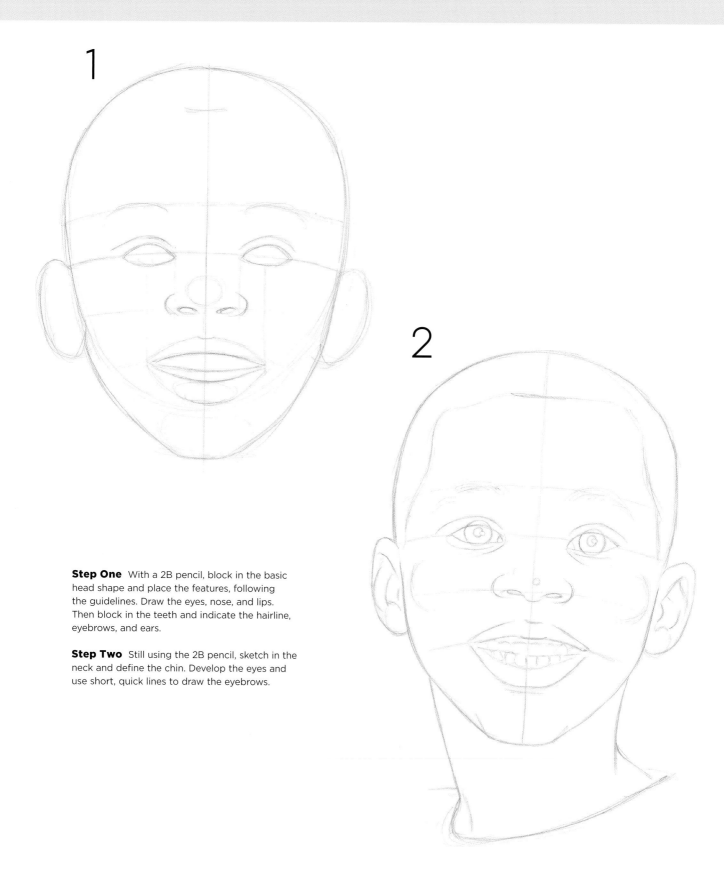

**Step One** With a 2B pencil, block in the basic head shape and place the features, following the guidelines. Draw the eyes, nose, and lips. Then block in the teeth and indicate the hairline, eyebrows, and ears.

**Step Two** Still using the 2B pencil, sketch in the neck and define the chin. Develop the eyes and use short, quick lines to draw the eyebrows.

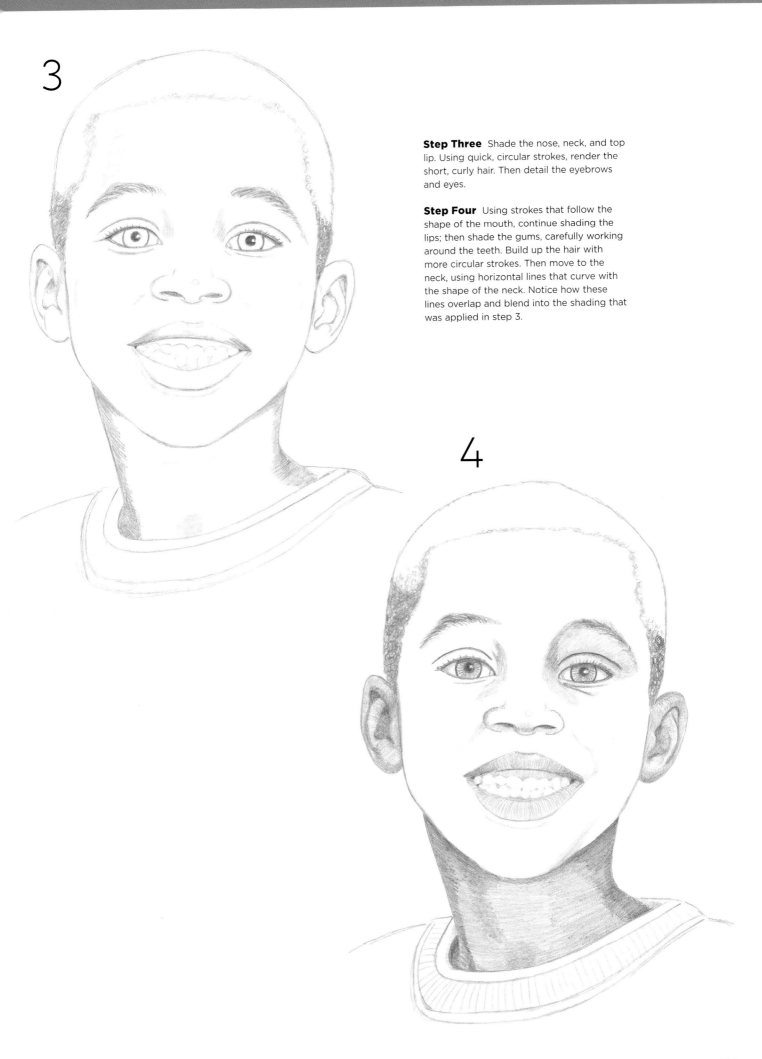

3

**Step Three** Shade the nose, neck, and top lip. Using quick, circular strokes, render the short, curly hair. Then detail the eyebrows and eyes.

**Step Four** Using strokes that follow the shape of the mouth, continue shading the lips; then shade the gums, carefully working around the teeth. Build up the hair with more circular strokes. Then move to the neck, using horizontal lines that curve with the shape of the neck. Notice how these lines overlap and blend into the shading that was applied in step 3.

4

**Step Five** Apply a light layer of shading over the entire face, always varying the direction of strokes as necessary to follow the shapes of the different planes.

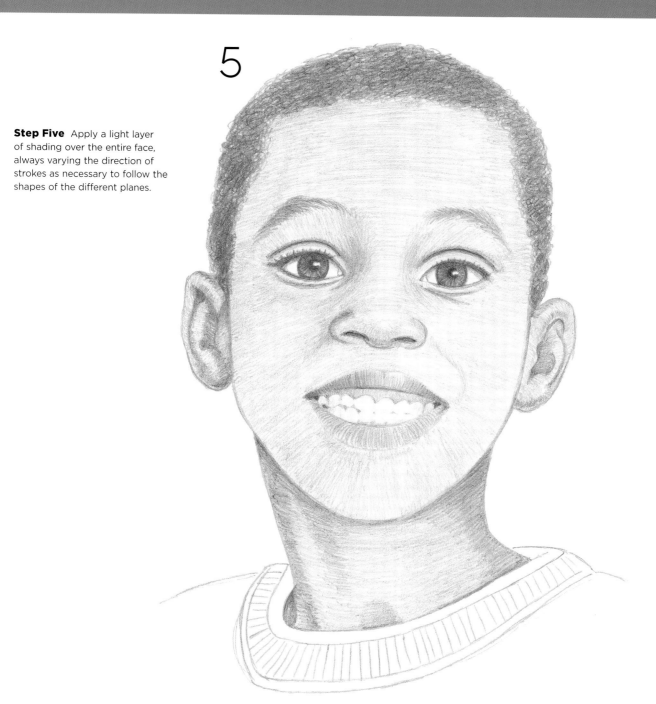

## Establishing Values

Every skin tone is made up of a variety of values—when drawing in graphite pencil, you can accurately capture these differing tones using varying degrees of light and shadow. Before you start drawing, be sure to study your subject to establish the richest darks and brightest lights.

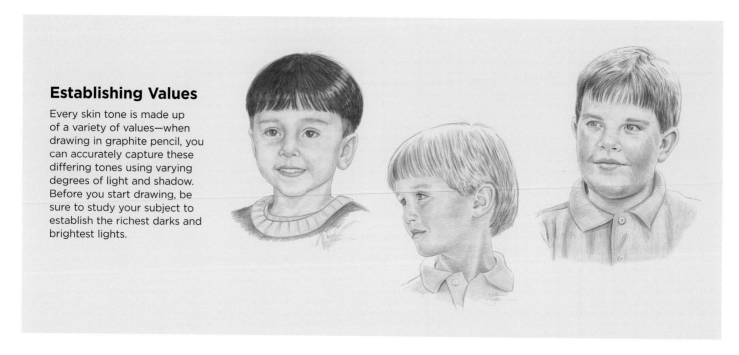

6

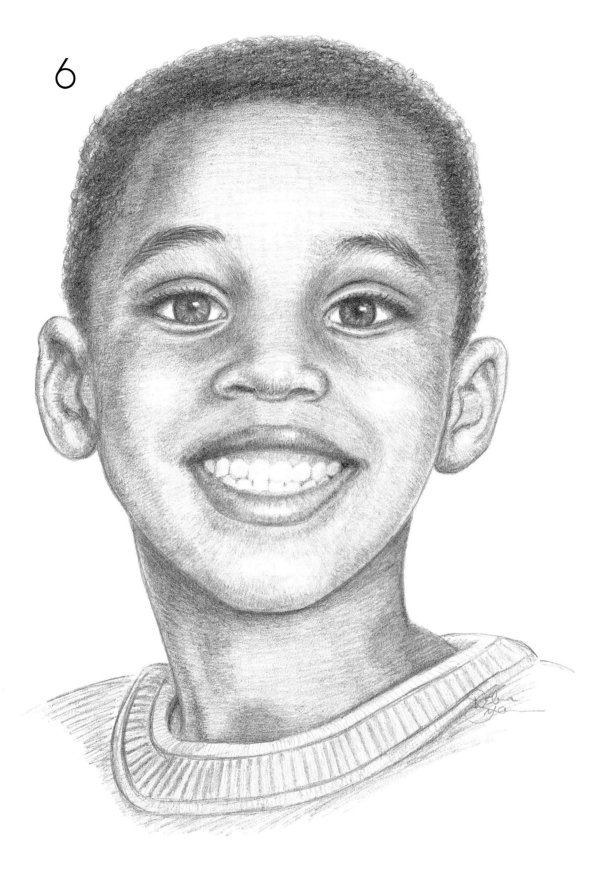

**Step Six** Continue shading, making the sides of the forehead a bit darker and leaving the middle area lighter to show where the light hits. Refine the shirt, curving the strokes as they go around the back of the collar. Add shading to the lips; then pull out a highlight on the top lip with a kneaded eraser. Soften the transitions between values by very lightly blending them with a kneaded eraser.

# CHILDREN'S BODY PROPORTIONS

Children's proportions are different than adults', and children's proportions change as they age. For example, a baby's head is extremely large in proportion to the body—but as the child grows up, the head becomes smaller in proportion to the body. Additionally, a child's head is wider than it is long, so it's rounder than that of an adult.

**Proportion Scale for Growth Years** Infants' bodies are short, making their torsos and limbs appear proportionately thicker. As infants grow into toddlers, their faces and bodies begin to elongate. By age five, children are about half as tall as they will be as adults; and by age eight, growth spurts will add another 1 to 2 heads in height. By the early teens, the face has elongated and the eyes are almost at the centerline of the face; the change in proportion results in a less chubby look. Most people reach their full adult height between the ages of 18 and 20; musculature is still developing, but adult proportions have been achieved.

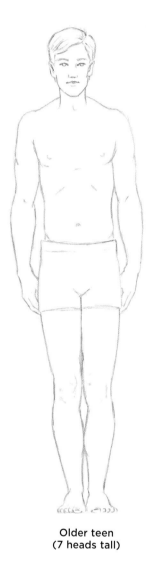
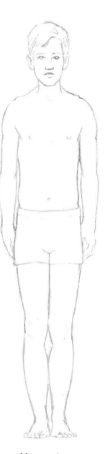
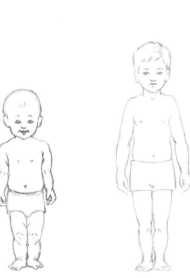
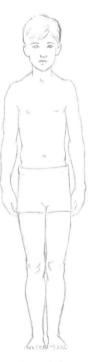
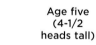

Toddler
(3-3/4
heads tall)

Age five
(4-1/2
heads tall)

Age eight
(6 heads tall)

Young teen
(6-1/2 heads tall)

Older teen
(7 heads tall)

## Toddlers' Limbs

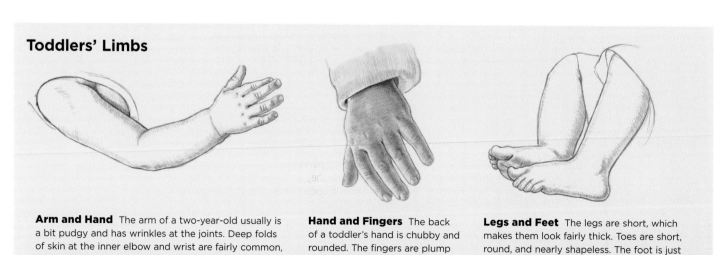

**Arm and Hand** The arm of a two-year-old usually is a bit pudgy and has wrinkles at the joints. Deep folds of skin at the inner elbow and wrist are fairly common, as are dimples on the elbow and knuckles.

**Hand and Fingers** The back of a toddler's hand is chubby and rounded. The fingers are plump and fleshy, even at the tips.

**Legs and Feet** The legs are short, which makes them look fairly thick. Toes are short, round, and nearly shapeless. The foot is just starting to form an arch at this stage.

# CHILDREN IN ACTION

To capture children's actions, train your eye to quickly assess the essential elements of the movement. First determine the line of action from the head, down the spine, and through the legs. Then sketch general shapes around this line. As you can see here, a quick sketch is all you need to capture the main gesture—and you always can add details later.

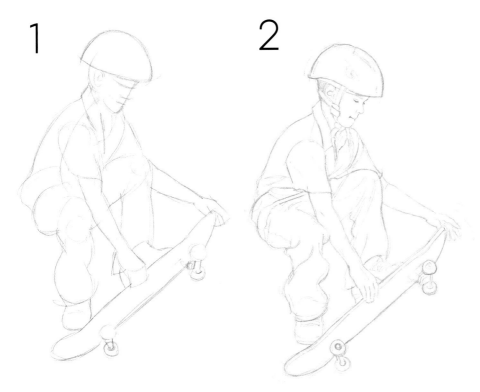

**Step One**  Draw the line of action down the spine, sharply curving through the left thigh. Then add the arms and the right leg for balance. Keep the head in line with the spine.

**Step Two**  Minimal shading and detail are the best ways to keep the movement from looking stiff. Loose speed lines around the boy's helmet, hand, and skateboard also indicate motion.

**Step One**  This pose has two lines of action: The main line curves with the torso and runs down the left leg; the secondary line starts at the left hand and flows across the chest, down the right arm, and through the right hand. Most of the weight is on the left leg; the right leg is extended for balance. If the basic gesture isn't correct, the figure will look like she's falling over.

**Step Two**  When blocking in and refining the shapes of a complicated pose such as this one, it's important to keep in mind many of the concepts you've learned in this book, including the head and body proportions and how foreshortening affects them.

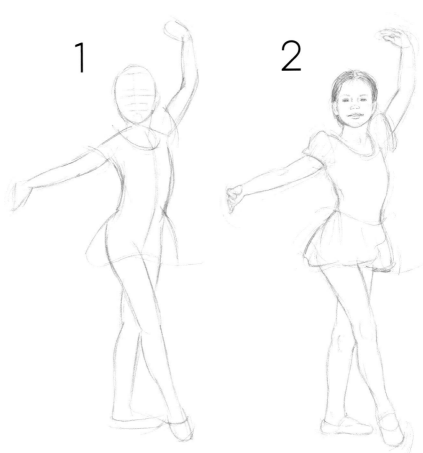

# CHOOSING A POSE

Look for poses that are natural and balanced, not stiff or boring. Some movement or tension can make the pose more interesting, but your subject should look stable and comfortable in the position. Unless in motion, the model should not have his or her arms and legs stretched out in all directions; instead, he or she should be more compact and relaxed. The pose should reflect the personality or interests of the subject.

1

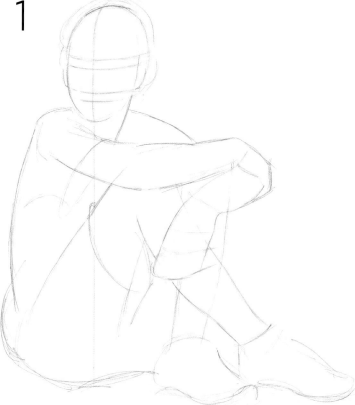

**Step One** Using an HB pencil, block in the figure. Place the head above the center of the main body mass, as indicated by the vertical line. Sketch the shapes of the arms and legs, "drawing through" the overlapping body parts for correct placement. The vertical centerline on the head shows the three-quarter view. Add the horizontal guidelines for the facial features. Sketch the general shapes of the shoes and the lines for the ends of the shorts and the shirt sleeve. Be sure the pose and proportions are accurate before adding any details.

**Step Two** Place the facial features on the guidelines. Indicate the hair, and sketch in the clothing, showing some of the folds and wrinkles. Sketch in the shapes of the fingers of his left hand and the elbow of his right arm. Refine the shapes of the shoes, and indicate laces.

2

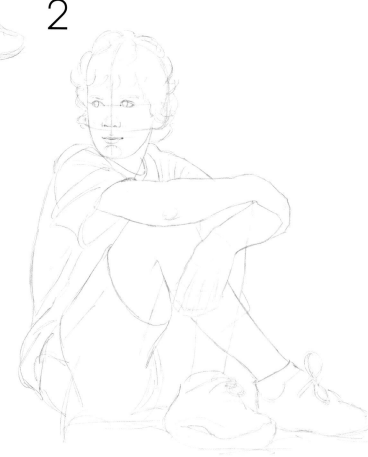

3

**Step Three** Erase the guidelines. Then use a B pencil to refine the facial features and the hair. Give the fingers a more precise shape, and add the fingernails. Refine the shapes of the arms, legs, and clothing, removing unneeded lines with a kneaded eraser.

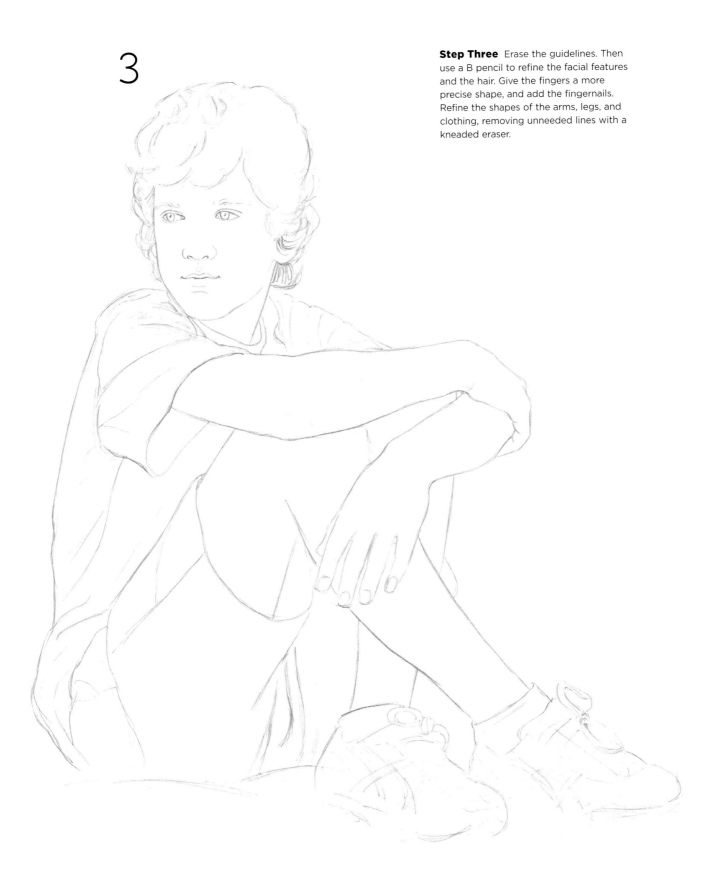

4

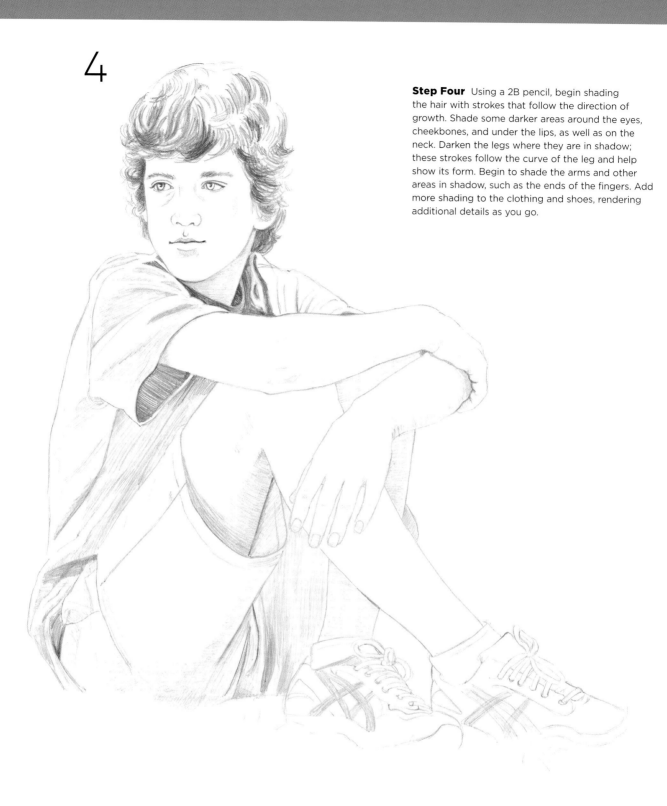

**Step Four** Using a 2B pencil, begin shading the hair with strokes that follow the direction of growth. Shade some darker areas around the eyes, cheekbones, and under the lips, as well as on the neck. Darken the legs where they are in shadow; these strokes follow the curve of the leg and help show its form. Begin to shade the arms and other areas in shadow, such as the ends of the fingers. Add more shading to the clothing and shoes, rendering additional details as you go.

## Shading the Forms

Shading with varying values—from black through all shades of gray to white—enhances the illusion of depth in a drawing. Effective shading also adds life and realism to a drawing. When shading cylindrical elements, such as the arms and legs, make sure your pencil strokes follow the curved forms. The illustration at right has been exaggerated to demonstrate the different directions the shading lines should follow; your strokes, of course, will be smoother with subtle gradations and highlighting.

5

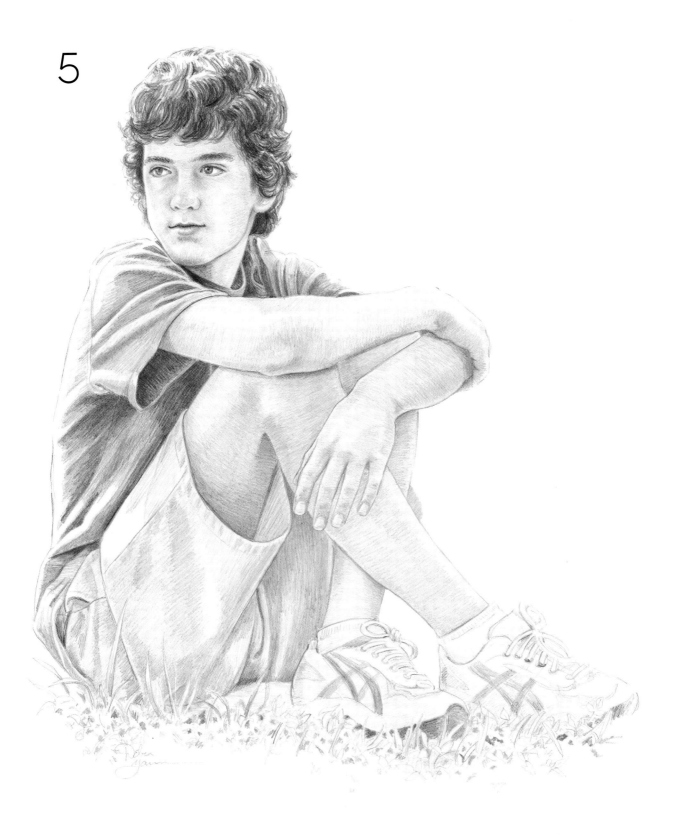

**Step Five** Using a sharp 2B pencil with light pressure, shade the face, leaving white highlights on the nose, chin, and on the side of the right cheek. To show the delicate form of the face, place your shading strokes very close together and follow the contours of the face, often changing direction. Shade the arms and legs using a little pressure for the lighter areas; press harder for darker areas. Use a 3B pencil to add some dark areas in the hair and in the darkest areas of the clothing before switching back to the 2B pencil. The shoes receive a little more refining and shading. Add some grass, leaves, and a little shading to show that the boy is sitting outside.

# ABOUT THE AUTHORS

**Walter T. Foster** was born in Woodland Park, Colorado, in 1891. In his younger years, he worked as a sign painter and a hog medicine salesman. He also performed in a singing and drawing vaudeville act. Walter invented the first postage-stamp vending machine and drew political caricatures for several large newspapers. In the 1920s, while running his own advertising agency and instructing young artists, Walter began writing self-help art instruction books. The books were first produced in his home in Laguna Beach, California, where he wrote, illustrated, and printed them himself. In the 1960s, as the product line grew, he moved the operation to a commercial facility, which allowed him to expand the company and achieve worldwide distribution. Walter passed away in 1981, but he is fondly remembered for his warmth, dedication, and unique instruction books.

**William F. Powell** is an internationally recognized artist and one of America's foremost colorists. A native of Huntington, West Virginia, William studied at the Art Student's Career School in New York; Harrow Technical College in Harrow, England; and the Louvre Free School of Art in Paris, France. He has been professionally involved in fine art, commercial art, and technical illustrations for more than 45 years. His experience as an art instructor includes oil, watercolor, acrylic, colored pencil, and pastel—with subjects ranging from landscapes to portraits and wildlife. He also has authored a number of art instruction books including several popular Walter Foster titles. His work has included the creation of background sets for films, model making, animated cartoons, and animated films for computer mockup programs. He also produces instructional painting, color mixing, and drawing videos.

**Debra Kauffman Yaun** discovered that she had a knack for drawing people when she was a young girl growing up in Tampa, Florida. After graduating from the Ringling School of Art and Design in Sarasota, Florida, Debra worked as a fashion illustrator. Debra's artwork has been published in several art magazines and books, and she has won numerous awards, including an international award. She is a signature member of the Colored Pencil Society of America, having served as president of the Atlanta chapter, and she is a juried member of the Portrait Society of Atlanta. Debra's work is featured in four Walter Foster titles: *Drawing: Faces & Features* and *Drawing: People with Debra Kauffman Yaun* in the How to Draw and Paint series; and *Colored Pencil Step by Step* and *Watercolor Pencil Step by Step* in the Artist's Library series. Debra and her artist-husband have two grown sons and reside in Georgia.

**Diane Cardaci** is an award-winning artist who has been drawing and painting since she was a child. She developed her classical art training while studying at the Art Students League of New York City, Parsons School of Design, and the School of Visual Arts. Her passion for both realism and nature led her to start her professional art career working as a Natural Science Illustrator in New York City. Commissioned portrait work soon became an important part of Diane's artwork, and she is a signature member of the American Society of Portrait Artists. Diane's work has been exhibited both nationally and internationally and hangs in private, public, and corporate collections. To learn more, visit www.dianecardaci.com.

# ALSO FROM WALTER FOSTER PUBLISNING

978-1-63322-363-9    978-1-63322-364-6    978-1-63322-643-2    978-1-63322-695-1

**Visit www.QuartoKnows.com**